exploring

the **ELEMENTS**
of **DESIGN**

exploring

the **ELEMENTS**
of **DESIGN**

Poppy Evans
Mark Thomas

THOMSON

DELMAR LEARNING ™ Australia Canada Mexico Singapore Spain United Kingdom United States

Exploring the Elements of Design
Poppy Evans and Mark Thomas

Vice President, Technology and Trades SBU:
Alar Elken

Editorial Director:
Sandy Clark

Acquisitions Editor:
James Gish

Development Editor:
Jaimie Wetzel

Marketing Director:
Cindy Eichelman

Channel Manager:
Fair Huntoon

Marketing Coordinator:
Mark Pierro

Production Director:
Mary Ellen Black

Production Manager:
Larry Main

Production Editor:
Thomas Stover

Art/Design Coordinator:
Rachel Baker

Technology Project Manager:
Kevin Smith

Editorial Assistant:
Marissa Maiella

Library of Congress Cataloging-in-Publication Data

Evans, Poppy, 1949–
 Exploring the elements of design/ Poppy Evans and Mark Thomas.
 p. cm.
 ISBN 1-4018-3286-5
 1. Graphic arts. 2. Commercial art.
 I. Thomas, Mark (Mark Andrew). 1952–
 II. Title.
 NC997.E94 2003
 741.6—dc21 2003020002

NOTICE TO THE READER

M. T. To Erica and Ryan—my angels, my reasons.

P. E. To Jay for his support and encouragement;
to my parents for funding my education and letting me
stay up past my bedtime to read, write, and make art;
and to Evan for just wanting his mom to be happy.

contents

CONTENTS

OSCAR E. VÁZQUEZ

INVENTING THE

ART COLLECTION

PATRONS, MARKETS, AND THE STATE

IN NINETEENTH-CENTURY SPAIN

| preface |

preface

INTENDED AUDIENCE

Understanding how design elements and principles work together to create effective communication is at the core of what every graphic designer needs to know. *Exploring the Elements of Design* is intended to teach visual fundamentals and examine the psychology and visual processes that are the basis for visual communication. This text explains design fundamentals and how they work in the context of the design industry, supported by custom diagrams and examples from professionals in the field. Additional chapter content includes the use of color in design, type basics, and professional profiles. *Exploring the Elements of Design* may be used by introductory- to intermediate-level design majors and non-design professionals who need a primer of design essentials.

BACKGROUND

Exploring the Elements of Design is an attempt to bridge the gap between the theoretical and the practical. Design has traditionally been taught as basic theory supported with visual examples that demonstrate these fundamentals in their simplest form. This approach has led to textbooks filled with diagrammatic examples and projects that engage students in design decisions that are limited to simple shapes, linear elements, and colors. Although these methods work well for introducing rudimentary material, students often have a problem making the leap from visual basics to more complex projects in the professional realm. This text combines diagrams with professional examples to demonstrate how design fundamentals are put to effective use in the real world.

TEXTBOOK ORGANIZATION

This book is structured so that students are introduced to design fundamentals at the beginning of the book and progressively work their way step-by-step through understanding all aspects of design.

In Chapter 1, students learn about how design works as a visual language built on fundamental principles and elements. The primary principles of unity, variety, hierarchy, and proportion are explained as they affect a design composition as a whole. Scale, balance, rhythm, repetition, and proximity are presented as support principles that govern internal design relationships within a composition. The design elements of shape, space, line, size, color, texture, and typography are also introduced as compositional content.

Chapter 2 addresses graphic devices and techniques that support visual relationships and organization. The psychological effect of design is also explored, as well as how design can best be used in support of a communication goal.

Color's role in design is explored in Chapter 3. Students learn about how color is perceived and processed by the eye and brain, and they are introduced to basic color terminology. Color systems and color psychology are explored, as well as strategies for choosing effective color schemes and using color effectively in a composition.

Chapter 4 addresses typography's role in design and familiarizes students with basic terms and measurement systems. Students also learn how to select typefaces appropriate to a project's design and communication goals and use type effectively in a design composition.

In Chapter 5, students develop an understanding of imagery's role in design. This chapter explains how symbols, logos, and trademarks function as an aspect of image representation. Students also learn how to choose appropriate imagery and make the most of it in a design composition.

Chapter 6 addresses career opportunities. An overview of the industry and career options is included, as well as advice on self promotion, portfolio preparation, and interviewing strategies.

FEATURES

The following list provides some of the salient features of the text:

- Objectives clearly state the learning goals of each chapter.

- Contemporary examples of graphic design from leading design firms are given.

- Color visuals are used to explain and analyze design fundamentals in graphic and verbal terms.

- The elements of design—line, shape and texture, color, size, and value—are defined and examined.

- The principles of design—unity, variety, hierarchy, proportion, scale, balance, rhythm, repetition, and proximity—are reviewed and explained.

- How typography and imagery can be used successfully in design is explored.

- Profiles of successful graphic designers are included, along with their important industry advice and inspiration.

- Articles by leading professionals in the field give valuable insight into the creative process.

- Review questions and in-depth assignments reinforce material presented in each chapter.

INSTRUCTOR'S GUIDE ON CD-ROM

This electronic manual was developed to assist instructors in planning and implementing their instructional programs. It includes sample syllabi for using this book in either an 11 or 15 week course. It provides answers to the review questions found in the text, tips for assessing completed exercises assigned in the book, and a list of additional resources. It also includes PowerPoint slides that highlight main topics and provide a framework for classroom discussion.

ISBN 1-4018-3287-3

ABOUT THE AUTHORS

Poppy Evans is an award-winning writer and graphic designer with over twenty years of experience in the design industry. She is currently an assistant professor in the Communication Arts department at the Art Academy of Cincinnati. A former art director for an international trade magazine and managing editor for *HOW,* an influential design magazine, Evans is an authoritative voice in design education. She has written twelve books on design and frequently writes articles for *Print, HOW* and *Step* magazines. She holds a B.F. A. in Fine Arts from the University of Cincinnati.

Mark Thomas is an experienced design educator and designer. He is associate professor and chair of the Communications Arts department at the Art Academy of Cincinnati, where he has taught graphic design and illustration for more than eighteen years. Thomas has designed and curated numerous design exhibitions and has designed and illustrated nationally distributed board games for education and the film industry. He has presented papers on design education at national conferences. He holds a B.S. and M.F.A. in fine arts and design and completed doctoral studies in design education at the University of Cincinnati.

ACKNOWLEDGMENTS

Much thanks to Glenn Rand for introducing us to James Gish at Delmar Learning. Our appreciation to the following professionals for their support and expertise: Christian Moore, Rob Ruben, Wayne Williams, Rebecca Seeman, Gary Gaffney, and Patrick Schreiber.

The work and insightful voices of these professionals will forever resonate in our practice of designing and teaching: Lawrence Goodridge, Malcolm Greer, Hermine Feinstein (*in memoriam*), Gregory Wolfe, Roy R. Behrens, and Dennis Puhalla.

Thanks to our Delmar Learning team of professionals who offered support, ideas, guidance and trusted us to write the book we believed in: Jim Gish, acquisitions editor; Marissa Maiella, editorial assistant; Thomas Stover, production editor; and Rachel Baker, art and design specialist. A thanks also goes to Shepherd Incorporated, especially Larry Goldberg and his team, who handled the editing and production of this text with great care and expertise.

A special thanks to Jaimie Wetzel, our developmental editor, for her support, patience, and trust. Finally, to the many talented and accomplished designers, illustrators, and artists whose works appear throughout this book, our sincere thanks.

Delmar Learning and the authors would also like to thank the following reviewers for their valuable suggestions and technical expertise:

Cece Cutsforth
Chair, Graphic Design Department
Portland Community College
Portland, Oregon

Sam Grant
Design Technology Department
Miami-Dade Community College
Miami, Florida

Tara Gray
Visual Communications Department
Allentown Business School
Allentown, Pennsylvania

Robert Koffler
Graphic Design Department
Art Institute of Philadelphia
Philadelphia, Pennsylvania

Heidi Nielson
Visual Communications Department
Katherine Gibbs School
New York, New York

Stewart Parker
Graphic Design Department
Pratt Institute
New York, New York

Gil Rocha
Art Department
Richland Community College
Richland, Illinois

QUESTIONS AND FEEDBACK

Delmar Learning and the authors welcome your questions and feedback. If you have suggestions that you think others would benefit from, please let us know, and we will try to include them in the next edition.

To send us your questions and/or feedback, you can contact the publisher at:

Delmar Learning
Executive Woods
5 Maxwell Drive
Clifton Park, NY 12065
Attn: Graphic Arts Team
800-998-7498

Or the authors at:

Art Academy of Cincinnati
1125 St. Gregory Street
Cincinnati, OH 45202
513-562-8777
Poppy Evans: poppy@one.net
Mark Thomas: merj@fuse.net

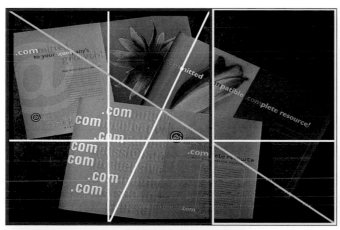

SPECIAL FEATURES

▶ Objectives

Learning Objectives start off each chapter. They describe the competencies the readers should achieve upon understanding the chapter material.

▶ Get Creative

The creative process is important for anyone in an artistic field to understand. These articles are included to help readers understand how to tap into their creativity and get the creative juices flowing.

▶ The Designer at Work

These career profiles are interspersed throughout the text. Each features a successful designer in the field.

objectives

Understand design as a visual language that is built on fundamental principles and elements.

Learn how the primary principles of unity, variety, hierarchy (dominance), and proportion affect the design composition as a whole.

Learn how the supporting principles of scale, balance, rhythm, repetition, economy, and proximity affect internal relationships of the elements within a design composition.

Discover the uses of the design elements shape, space, line, size, color, texture, and typography as compositional content.

introduction

Design is a visual language that is built on fundamental principles and elements. The principles are the organizational rules used in conjunction with the elements to create order and visual interest. The principles are presented as two related sets. The primary principles are those affecting the design as a whole, and support principles are those that affect the internal relationships of the elements. Principles can be thought of as the unseen forces that create interaction among the elements. The elements of design constitute the content of a graphic design. The elements are seen and exist on the surface or picture plane of a composition.

Each of the principles and elements is defined and discussed with an accompanying analysis using actual designs and illustrated diagrams.

DEFINING THE LANGUAGE

COLOR MY WORLD

richard palatini

Richard Palatini is Senior vice president and associate creative director at Gianettino Meredith Advertising. Rich is also an instructor of Visual Communication at Kean University in New Jersey.

People are affected and influenced by color in many obvious and not-so-obvious ways. We use color to describe feelings: "I'm in a blue mood," "She's green with envy," and "He's got me seeing red." It's used to identify everything from military organizations (navy blue), to businesses (IBM, "Big Blue"), to life stages (baby blue). Beyond words and images, color communicates instantly and powerfully. A world without color would be a world without emotion.

THE "LIFE" OF COLORS

People develop feelings about color that change and evolve as they reach different life stages and they also relate to color in different ways during each stage. For example, red and blue are colors to which young children are most responsive. Adolescents are drawn to colors that are most outrageous, intense, and used in unusual ways (think green catsup!). The same red that children are drawn to is the color that adults perceive as danger.

THE WIDE WORLD OF COLORS

When considering use of a color, we also need to understand how well it "travels." And, more specifically, how does a specific culture perceive a color or color combination? Historically, white has been associated with mourning by the Chinese, yet, in America, white is the color of wedding gowns. Because each culture has its own color symbolism, perceptive designers I know will often research countries and regions of the world to more fully understand what specific colors represent to them.

Be aware that in today's mobile global society, people will bring their color "baggage" with them on their travels. Still, individuals can also seek to assimilate into their new societal environment by emulating the new colors they find there. It's most important to consider all these factors when making color decisions that have "international travel" on their itinerary.

COLOR WITH FEELING

Think of the emotional response you want to elicit from your audience. Is it serene, sensual, exciting, powerful? Whatever it is, there are colors and color combinations for each and every one. Using light to mid tones of greens, lavenders or blues and in combination will communicate that peaceful, serene feeling. Dense purples, deep reds and intense pinks are sensually provocative. Combining them with black will only increase the sensation. And, while black is THE power color, combining it with another hue can be even more powerful, such as black with a regal purple or royal blue. Many colors can bring feelings of excitement, but these should be warm and vivid. If your audience is young, consider vibrant warms and cools from every color family especially in combination.

CRIMES OF COLOR

Sometimes, breaking the laws of color can be the right thing to do. In creating a distinct identity it's better to be different than to use the right symbolic color. Car rental companies are a perfect example of this. Hertz's color is yellow, Avis is red, and National is green. Each has created it's own distinct, yet appropriate color personality. Remember, it's OK to be different but it must be with a clear purpose in mind.

Color can be the most direct and memorable way of making your communication, whatever it may be, effective and successful. Consider your audience, their emotions, and culture and life stage. Understand how colors communicate your message best, and when necessary, break the rules.

Copyright Richard Palatini 2003

the standard color wheel was developed more from views of human perception and psychological response to color than any scientific theory.

The trick is to learn how to use color psychology as a determinant in making effective color decisions. Each of the basic colors embodies a distinctive set of associations that can be translated into words. Knowing these associations will inform your color choices. Let's examine some of the basic hues with regard to their universal meanings.

Purple is royal, sophisticated, cultivated, and, because of its deep value, has an enigmatic quality (see Visual 3–39). It is associated with valor as in the Purple Heart. It is a hue that is associated with distinctive aromas derived from fruits such as plums, grapes, and berries. Purple can have ominous qualities especially when mixed with gray or black.

Blue is expansive, serene, and reliable, as in "true blue." It is used extensively in business as a color for banks and brokerage firms. IBM's nickname in the financial world, for example, is "Big Blue." The sky and water are its most familiar associations. Psychologically speaking, when a person is blue, they are sad, lonely, or depressed (see Visual 3–40). In most surveys blue is the top pick for favorite color.

Green is growth, nature, and life giving. Forests, fields, and farms are dominated by green. On the other hand, it is also the color of money as in "greenback." It has been studied as the easiest of all colors to live with, especially as a shade or

THE DESIGNER AT WORK

jerry kathman

You're on a learning journey that will never end. Learn to love the ride. Commitment to learning and personal development is the only thing that will give you the career you're looking for.
—Jerry Kathman

Jerry Kathman is president and chief executive officer of Cincinnati-based Libby Perszyk Kathman (LPK). Recognized as one of the nation's largest independent design firms or consultancies dedicated to brand identity and package design, LPK initially built its business on local clientele, including corporate giant Procter & Gamble. The company's long-standing relationship with Proctor & Gamble includes ongoing and recent work for megabrands Olay, Pringles, Pantene, and Pampers.

During the 1990s, the company expanded into developing and managing brand identities on a global basis. It now serves other Fortune 500 companies and includes among its clients well-known brands such as IBM, Microsoft, Valvoline, and Heinz. Expanding into these markets resulted in rapid growth for the firm. LPK now employs a staff of 200 that includes graphic designers, copywriters, production specialists, industrial and product designers, and brand and marketing specialists, as well as accounting, finance, and administrative personnel.

Shortly after receiving his bachelor of fine arts degree in graphic design from the University of Cincinnati in 1976, Kathman joined what was then called Cato-Johnson, a Young & Rubicam company. Kathman and four other partners purchased Cato-Johnson from Young & Rubicam in 1983 to form LPK. His managerial and team-building skills quickly led Kathman to a point where he was managing important client relationships and forming creative teams within LPK.

As president and CEO, he's challenged now with the task of running the company. In addition to assuring there's enough revenue to support the firm and talent on hand to satisfy client needs, Kathman has other responsibilities and concerns. "I have to anticipate what the client will want," he states. "I also need to make sure that this is a nurturing and supportive environment where ideas thrive and designers want to work."

LPK partnered with Hallmark to create a brand identity that reinforces the greeting card company's reputation for delivering emotional messages to consumers. A component of its brand strategy is imagery that stresses loving connections.

In creating a brand identity for Pantene haircare products, LPK developed a logo, packaging, and imagery that has helped to position Pantene as the world's number one haircare brand.

▶ Sidebars

Sidebars appear throughout the text, offering additional valuable information on specific topics.

▶ Review Questions and Projects

Review Questions and Projects are located at the end of each chapter and allow readers to assess their understanding of the chapter. Projects are intended to reinforce chapter material through practical application.

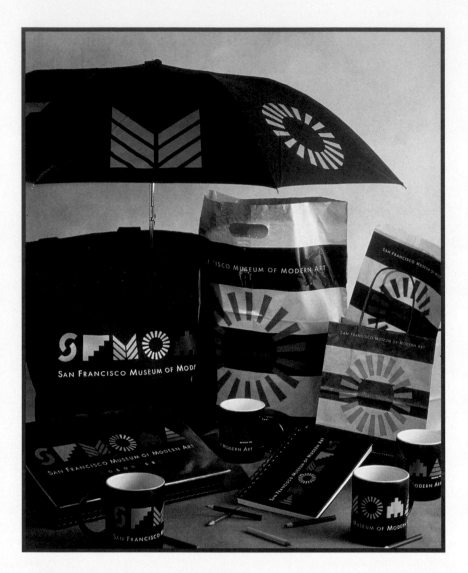

| defining the language of design |

objectives

Understand design as a visual language that is built on fundamental principles and elements.

Learn how the primary principles of unity, variety, hierarchy (dominance), and proportion affect the design composition as a whole.

Learn how the supporting principles of scale, balance, rhythm, repetition, economy, and proximity affect internal relationships of the elements within a design composition.

Discover the uses of the design elements shape, space, line, size, color, texture, and typography as compositional content.

introduction

Design is a visual language that is built on fundamental principles and elements. The principles are the organizational rules used in conjunction with the elements to create order and visual interest. The principles are presented as two related sets. The primary principles are those affecting the design as a whole, and support principles are those that affect the internal relationships of the elements. Principles can be thought of as the unseen forces that create interaction among the elements. The elements of design constitute the content of a graphic design. The elements are seen and exist on the surface or picture plane of a composition.

Each of the principles and elements is defined and discussed with an accompanying analysis using actual designs and illustrated diagrams.

PRINCIPLES AND ELEMENTS OF DESIGN

The human psyche seeks harmony and resolution in everyday life. We use our senses of touch, smell, hearing, taste, and sight to perceive and navigate in the world. When we perceive that our living or work environments have become too disorderly, we are motivated to organize these environments so that we can again function productively in them. We see disorder and act to reorganize or rearrange it. On a basic level, this is a form of visual organization, the activity of designing. The more familiar we are with the environment we want to change, the more manageable is the task of changing it.

Graphic design is the art of arranging pictographic and typographic elements to create effective communication. It is a complex discipline that requires skillful and sensitive use of the eyes for navigating, the hands for crafting, the left brain for analytic reasoning and logic, and the right brain for creative, intuitive thinking. Directing these functions of the mind and body is a very demanding human activity. In fact, research in higher education ranks studying visual arts second behind medical school in its overall demand of the learner. Design is not a collection of formulas that, if followed and applied, ensure effective results. It is a fluid process that is guided by the designer's sense of intuition, reason, and aesthetic judgment.

To manage the process, successful designers have learned there are fundamental principles that can be used to guide their own creative design decisions. The principles provide a structure for combining the common elements of design in a composition by serving as the relationship between the parts or design elements involved. It can be useful to think of the elements of design using familiar analogies, such as the ingredients in a recipe, the parts of a machine, or the materials needed to build a house. Individually, these components have limited use. But when skillfully combined, they work together to form something useful. When a measure of creativity is added, the result can be not only useful but also pleasing to the senses. Design works in a similar way.

We can understand how by first defining an inventory of principles and elements of design. Then we can see why they work by examining examples of design that emphasize a particular principle or element. There are many lists of principles and elements of visual organization that are widely acknowledged and have been written about in books on art and design theory. Most of these principles and elements are universal to any of the visual arts. The principles are often grouped together, suggesting that they have an equal role or importance. However, some principles have a more dominant function whereas others serve a supporting role. They have been organized here as primary and supporting principles to help you see their function and relationship. It is important to know that in any given design, one principle can be emphasized over another.

The primary principles that *affect the design as a whole* are unity, variety, hierarchy, and proportion. Support principles that *affect internal relationships of the design* include scale, balance, rhythm, repetition, and proximity. The elements of design include shape, space, line, size, color, texture, and typography. Typography is included as an element because in addition to having verbal meaning it also functions in design in the same manner as shape and line.

Primary Principles

Through the study and practice of making works of design, you will become more familiar with the processes and strategies that govern it. A working knowledge of the principles and elements of design provides a foundation for managing design decisions. It is important to keep in mind that the principles and elements are interrelated. You will see how in the discussion of each.

Unity and Variety

In the eye and mind of a viewer of any designed image, there is a need to be able to understand what is being seen. An objective of any design plan is to create a sense of unity through the organization of the compositional parts. Unity is an overriding principle that is served by all others (Visual 1–1). Unity is the control of variety. Often the content used in a design varies in kind and can include different typefaces, graphic elements, photographs, or illustrations. A complementary principle to unity, variety is necessary to create visual interest. Managing variety is the art of balancing visual contrasts. It is combining elements that don't appear, on the surface, to have much in common. Unusual combinations of elements directed at the message are often the most inventive and successful design. Too much variety however, or random use of it, can cause confusion (see Visual 1–2a and Visual 1–2b).

visual | 1–1 |

In this range of merchandise from the San Francisco Museum of Modern Art, unity is achieved in several ways. The logo's individual letterforms are strong identifiers that are repeated on each item. The consistent use of a distinctive, saturated color palette also unifies each product. Changing the scale of the logo elements to accommodate the changing size of each souvenir is a fresh, bold approach to variety. The horizontal bands on the bags mimic the banding effect of the logo applied to other items, and they create a layering effect that adds depth. The result is a variety of merchandise applications that tie in with each other and make a unified presentation. *(Logo and merchandise design by Michael Osborne Design)*

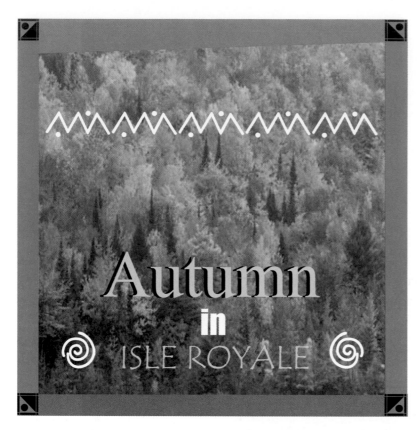

At a glance, the design seems colorful and lively. But a closer examination reveals that this design is struggling for its identity and unity. The photograph of a fall landscape captures a rich, delicate patchwork of color that serves as a backdrop for type and graphic elements. Competing with the photo are three different typefaces as well as two different uses of icons. Although the colors in the border frame relate to the photograph, they overpower the delicate quality of the image. Too much variety has created a dysfunctional design.

visual | 1–2b |

This solution uses two styles of the same typeface, creating a subtle and more unified statement in keeping with the photograph. The green rule implies the word *in* and minimizes clutter. Eliminating the graphic icons also gives the photograph more visibility. A full color border has been replaced by a color rule at the top and bottom of the design. This implied border opens up the photo as though it could continue beyond the left and right edges of the design. Finally, the decorative band at the top, which mimics qualities of the petroglyphs that can be found on the island, has been reduced in size. Its color coordinates with that of the type. In this revision, unity is achieved through economy. Economy is the idea of distilling the design to its most essential parts while striving to be sensitive to visual relationships. The type, graphic elements, and photograph are now working in concert to enhance and support each other.

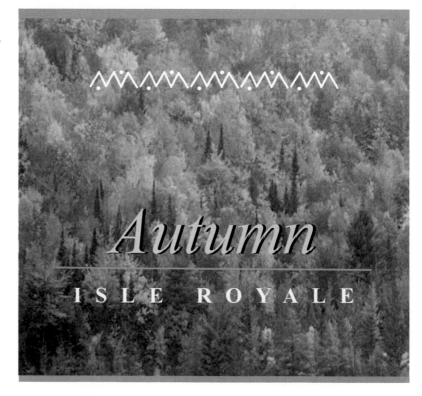

Hierarchy

An important function of unity in design is managing visual hierarchy in composition. Hierarchy refers to an arranged order. Dominance, the prevailing influence of one element over another, and emphasis, stressing the importance of one element over another, are commonly included as principles. But they are really more simplistic, related functions of hierarchy. Hierarchy is the established order, importance, emphasis, and movement given to visual elements, from those that are dominant to those that are subordinate. A designer must manage the size, placement, and balance of the elements used so that the viewer can read the image and extract the intended meaning. Controlling hierarchy determines the path the viewer's eye takes as it first scans and then studies a design composition.

If you look at any work of design or art repeatedly, you can experience an eye-movement path. For the first few seconds of each viewing, the path is the same. Areas of high contrast, faces or unusual shapes can immediately attract the eye. Once you loop a few times around the dominant elements in a work, you become familiar with them and break away from the familiar elements to consider other features and elements that support the main ones (see Visual 1–3).

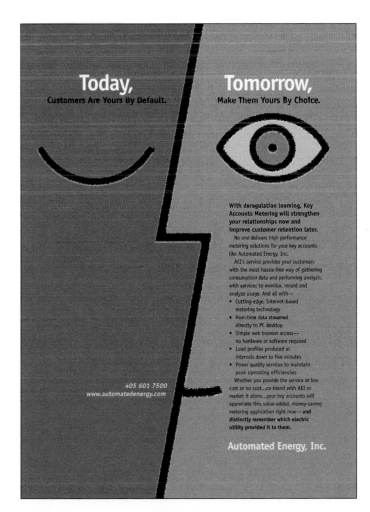

visual |1–3|

By determining hierarchy, a designer can control the path a viewer's eye will take when scanning a design composition. In the case of this ad, the viewer is first drawn to the prominent, open eye and then to the suggestion of a face. The headlines "Today" and "Tomorrow" are the first type elements that are read. The zigzag vertical line pulls the eye down to the smaller blocks of text. Two clever graphic effects in this image are the dual read of the face from a frontal view to a profile and the completion of the mouth with typographic elements. *(Ad for Automated Energy by Steve Walker)*

Lack of clear visual hierarchy is the reason many designs fail to attract and hold a viewer's attention. It is important to practice the art of critical analysis or deconstructing design compositions. A critical analysis begins by examining the parts of a design to see how they function. This activity can help identify the visual hierarchy and the subsequent eye-movement path. Identifying the most dominant elements in a design, as well as secondary and other support elements, reveals the meaning in the message. Sharpening this skill will serve your own design.

It is important to understand there is bias in the way certain cultural groups comprehend visual information. This has an impact on eye-movement tendencies. Designers must be sensitive to viewer partiality with regard to visual orientation, which is primarily influenced by the way written language is read. In Western culture, we read from left to right and top to bottom. Most Arab and Semitic writing is read from right to left but numbers are read left to right. Hieroglyphics, a pictographic writing that precedes alphabets, are read in different directions. Traditional Chinese calligraphy is read top to bottom and right to left, but modern Chinese newspapers and books are read left to right. Depending on the concept, graphic design can be read from middle to top, from bottom to top, up the side or down a side. The designer is in control of how a designed image is read by managing visual hierarchy (see Visual 1–4a, Visual 1–4b, and Visual 1–4c).

Proportion

Proportion refers to size relationships in a composition that serve as a transparent, underlying structure to the surface design. The outer dimensions of a two-dimensional design are its most basic proportion. A square, vertical rectangle, and horizontal rectangle all have unique proportions and affect particular qualities of a design. (see Visual 1–5a, Visual 1–5b, and Visual 1–5c). There are also numerous proportional formats with which designers and illustrators must work. The outer proportions or dimensions of a design have an important relationship to the internal divisions and alignments. As discussed in Visual 1–5a, Visual 1–5b, and Visual 1–5c, outer dimensions affect the orientation of the viewer and are often dictated by the nature of the design venue. Books and posters tend to be vertical in orientation, CD covers are square, billboards are horizontal, and three-dimensional surface graphics can assume many forms. Whether the proportions are a given or are determined by the designer, they must be considered as one of the first important considerations in a design plan.

The relationship between outer dimensions and internal divisions can provide a system for managing design decisions. There are proportional systems that have been used for centuries in architecture, art, and design. These systems are based on ratios—a comparison of one set of sizes or quantities with another. Although ratios are commonly expressed in mathematical terms, they can also be expressed as visual relationships. The golden section is a ratio that dates back to ancient Greeks. Its proportional harmony possesses both aesthetic beauty and structural integrity. The ratio of the golden mean (expressed mathematically as 1:1.618) is used to construct

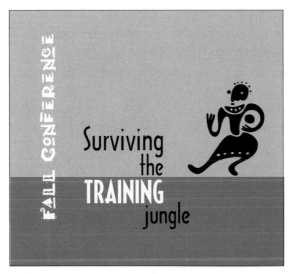

(a)

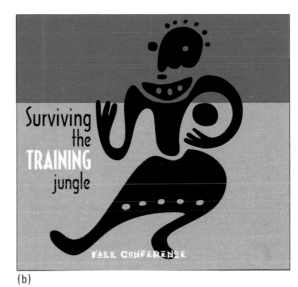

(b)

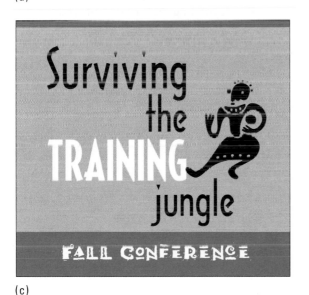

(c)

visual | 1 4a to c |

It's sometimes helpful to think of design elements as actors on a stage, with the designer determining which element will lead and which elements will support the lead. The examples are composed of three major players: the primary message or headline, "Surviving the Training Jungle"; a supporting illustration; and a qualifying tag line, "Fall Conference." In visual 1–4a, all three elements are equal. Changing the direction of the tag line adds a directional element and gangs the typographic information. The pockets of space give the visual room to interact with the type and background elements that is easy on the eye. The image in visual 1–4b places emphasis on the illustration. Its size dominates the typographic information, presenting bold curved shape edges that frame the headline. The composition seems balanced by placing the visual just to the right of center, using the rag left shape of the type to mirror the right side of the visual. In visual 1–4c, the headline dominates the communication message. The illustration functions as an accent element. The design employs an expected hierarchy that reads from top down.

the golden rectangle and is the same ratio found in the structure of plants and other life forms. The spiral order of leaves growing from a branch, the seed pattern in the center of a sunflower, and the spiral of a nautilus shell can all be expressed in terms of the golden ratio. Building a golden rectangle using the ratio requires no calculations. It is constructed using a series of extended relationships as described in Visual 1–6a. These relationships possess a strong aesthetic harmony because the internal proportions relate in scale to the proportions of the original square and its extensions. The golden section can be extended to construct the golden rectangle, which was used by the Greeks as the basis for much of their architecture including the Parthenon (see Visual 1–6b). Renaissance artists used it to create overall harmony and balance in

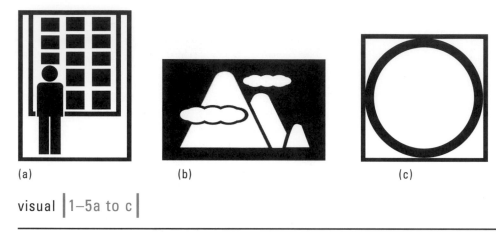

(a) (b) (c)

visual | 1–5a to c |

One of the first decisions a designer makes is to determine the overall dimensions. Because the internal relationships of the design composition depend on the proportions of the outer dimensions, this shouldn't be an arbitrary decision. The shape of a design format also possesses associative meaning. (a) A vertical rectangle, in contemporary Western culture, is associated with architectural metaphors such as a building, a window, or a door. It can also relate to the proportions of a standing human form. Magazines, books, print ads and most poster designs use the rising presence that a vertical rectangle offers. (b) A horizontal rectangle (center) has a long-standing association with the landscape. In contemporary culture, movie screens, computer monitors, and television all make use of this panoramic format. (c) A square configuration offers a stable, neutral format that allows the designer, illustrator, or photographer to influence the overall composition by controlling the relationship of internal elements. It can be a difficult format to design in because it doesn't offer the proportional shift of a rectangle. The square has a proportional relationship to the circle and equilateral triangle. These three shapes are considered primary shapes.

works of painting and drawing, and contemporary graphic designers use the rectangle as a format for print and digital media (see Visual 1–6c and Visual 1–6d).

Support Principles

As stated, the support principles affect the interaction among elements. They have an equally important role to the primary principles in establishing visual organization in a composition. There are support principles that have a direct relationship to a primary principle. Scale and proportion are a good example. But none of the principles exist alone. In any composition, multiple principles are at work. However, you will see that in the arrangements of graphic elements, successful design tends to stress the use of one or two.

Scale

Proportion and scale are related principles. Whereas proportion is the size relationships of the design as a whole, scale refers to size comparisons of the internal parts of a composition—the visible elements that can be seen on the surface. Scale is the relationship of size or a comparison of size from one element to another. We constantly compare size, distance, and configuration in the natural and constructed worlds. Comparisons based on a known constant provide a familiar orientation. The profile of a towering building or the mass of a mountain on the

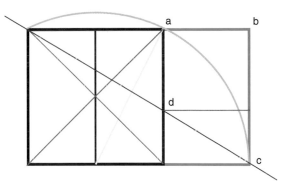

visual |1–6a|

The Golden Rectangle. The golden rectangle can be constructed by starting with a square. Find the center of the square by drawing intersecting lines through opposite corners, as shown in the gray X. From there, draw a vertical line through the intersecting point of the X. Place the point of a compass where the centerline intersects the base of the square and scribe an arc that intersects the top right corner of the square (Point a) and extends to the square's baseline. Complete the rectangle by extending the square to the point where the arc meets the baseline (Points b and c). A second golden rectangle can be formed by drawing a diagonal line (shown in red) that extends across opposite corners of the rectangle and drawing a horizontal line from the point where that line intersects the original square (Point d). This second rectangle and its parts are proportionate to the original rectangle and corresponding parts.

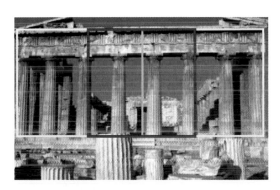

visual |1–6b|

The ancient Greeks found the proportions of the golden rectangle of great use in architectural design. Its proportions served them in the building of the Parthenon contributing structural integrity in columns used to provided support for the entablature and pediment. It also possesses aesthetic beauty in the overall proportional relationships of all the architectural components. The spacing of the columns related to their height and width, and the relationship of the column height to the distributed number of columns and the supported entablature fit into two golden rectangles that share a common square.

visual |1–6c|

Designers today find the proportions of the golden rectangle useful for organizing and arranging elements in a composition, as in the design of this page from an ad campaign for Growzone.com. The intersecting construction lines used to build the golden rectangle identify critical alignments and placement points in the layout. The random or casual arrangement has actually been carefully planned. *(Design by Erbe Design)*

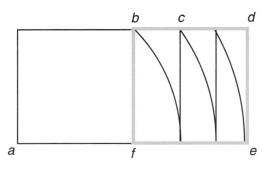

visual |1–6d|

The dynamic rectangle, though not as elegant as the golden rectangle, can also serve as a formatting device for organizing design elements. To construct it, begin with a square. Place a compass point in the corner of the square (Point a) and scribe an arc that intersects the opposite corner (Point b) down to the baseline of the rectangle. Draw a vertical line up to Point c and extend the rectangle. Continue by placing the compass point at Point a and scribe an arc through Point c. Extend the rectangle again. When you continue out to three extensions, a new square is constructed. Extend out eight extensions to construct a third square.

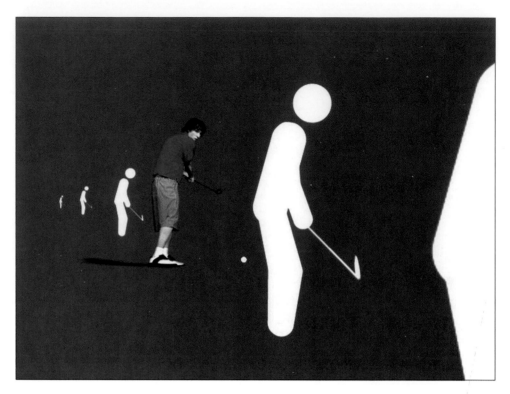

visual |1–7|

In this frame from a Target TV commercial, human scale fills the image area. There is an implied environment that is left to the viewer's imagination. The diminishing size of the human symbols suggests a distant perspective. *(Commercial concept by Peterson Milla Hooks, animation by Fuel)*

horizon can be difficult to judge in terms of size. However, being juxtaposed with a human visual, an automobile, or an animal can immediately establish a familiar comparison of size. Scale can be used to create variety and emphasis in a design and help establish a visual hierarchy (see Visual 1–7).

Balance

Balance is the visual distribution of elements in a composition. There are two types of visual balance: symmetric and asymmetric. In symmetric balance, elements are arranged the same or very similar on either side of a central axis. The elements appear to be projecting a mirror image, like a landscape projected in a still lake (see Visual 1–8a and Visual 1–8b). Asymmetric balance, sometimes referred to as dynamic symmetry, is the art of creating balance using uneven numbers, sizes, or kinds of elements. In the visual arts, dynamic symmetry is managing the relationship between negative and positive space and form and counterform (see Visual 1–9).

Physical balance is a functional demand of three-dimensional design. Physical balance can be achieved with a base as in a bottle of cologne, a lamp, or a computer monitor. It can also be designed through the use of legs or pods to support the central form as in a chair, coatrack, or easel.

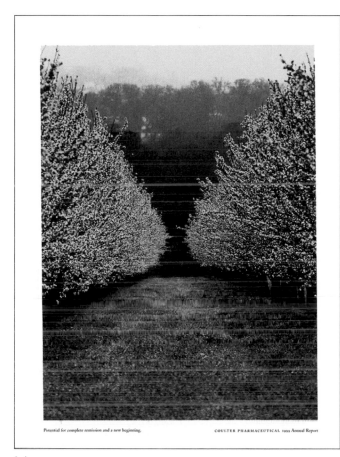

(a)

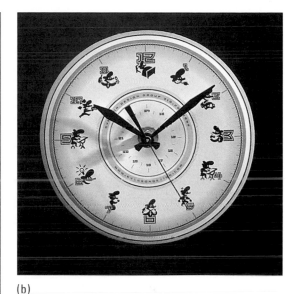

(b)

vIsual |1–8a and b|

Two types of symmetrical balance are represented in these compositions. (a) The annual report cover is a bilateral composition where, if an imaginary axis were drawn down the center, one side would mirror the other. (b) The clock design is an example of radial symmetry where elements are arranged and are equally balanced, as though they were spokes on a wheel. *(Annual report designed by Cahan Associates; clock designed by Evenson Design Group)*

visual |1–9|

In this poster design, asymmetrical balance is achieved by counterbalancing roughly equivalent amounts of positive and negative space, or form and counter form. In this case, the cloud at the top of the poster is counterbalanced by the negative space of the background beneath it. *(Poster design by Stefan Bucher)*

Rhythm and Repetition

The term rhythm is associated most often with music, defined as an alternating occurrence of sounds and silence. Repetition follows a pattern of related or juxtaposed elements. Rhythm in the visual realm can be described in the same way. Replace sound and silence with form and space and the same description works for graphic design (see Visual 1–10a and Visual 1–10b). Creating a rhythm with visual elements is the choreography of graphic design. In a sense, rhythm and repetition are transparent to the design. They exist as a pattern defined through the arrangement of graphic elements. The pattern takes the form of the arrangement, giving movement and natural flow to related elements in the composition. This can be achieved through the use of linear elements and varying shapes, sizes, and colors. Rhythms can be regular and static (see Visual 1–11) or pulsating and full of exaggerated gesture (see Visual 1–12).

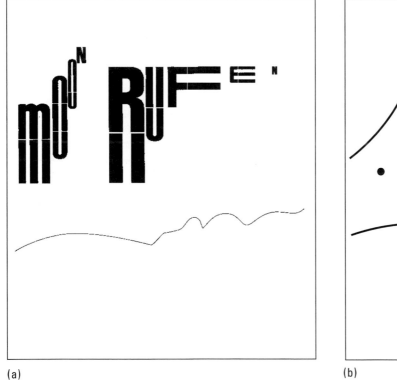

(a)

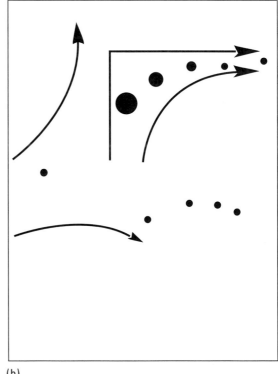

(b)

visual |1–10a and b|

(a) The rhythmic pattern that is established with the typography in this poster design is echoed in the treatment of the line below it. (b) A diagrammatic breakdown gives a more basic representation of this rhythm. *(Poster design by Wolfgang Weingart)*

visual |1–11|

In this turn-of-the-century poster, a regular, rhythmic pattern is established to provide a backdrop for the typographic information. *(Poster design by Joseff Hoffmann)*

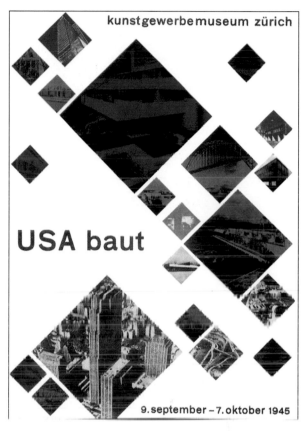

visual |1–12|

In this poster, scale and color shifting creates a pulsating effect. Placing the units on the diagonal results in a dynamic rhythm that moves in and out of space. S and Z configurations were used as compositional devices to create dynamic, diagonal movement and structure. (*Poster design by Max Bill*)

Proximity

One of the most critical decisions a designer makes is where to place design elements. Proximity is the position and space given to the placement of elements in a composition. The placement of elements together and apart from one another is a function of proximity (see Visual 1–13). Controlling the relative size and distance from one element to another based on common increments or shared attributes establishes visual continuity and aesthetic harmony. Designers look for ways to align images, text, and other graphic elements based on these attributes. Grid systems play an important role in determining placement, whether the message calls for regularity or counterpoints to create visual interest (see Visual 1–14).

With its *g* placed strategically in the bottom left portion of the circle, the asymmetrically balanced Gymboree logo demonstrates the importance of placement. Centering the *g* within the circle would have resulted in a static, predictable composition.

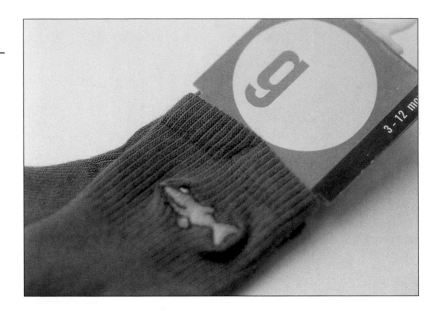

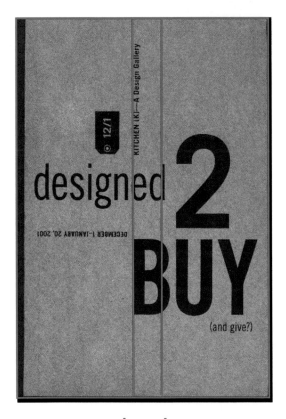

A grid (shown in blue) serves as the underlying placement guide for the graphic elements on the cover and interior pages of this publication. From there, the alignment of common edges such as the number *2* and letter *U* on the cover as well as other shared attributes guided the designers in their design decisions. *(Brochure design by Kinetik Communication Graphics Inc.)*

The space between two or more elements affects their relationship. As they move together, a visual tension can result. When they touch, new hybrid shapes can form. And, at some point as they move apart, they can become disassociated with one another (see Visual 1–15). You could think of design as a conversation in which the elements talk to each other. The conversation can be quiet and understated, or it can be loud and chaotic. The

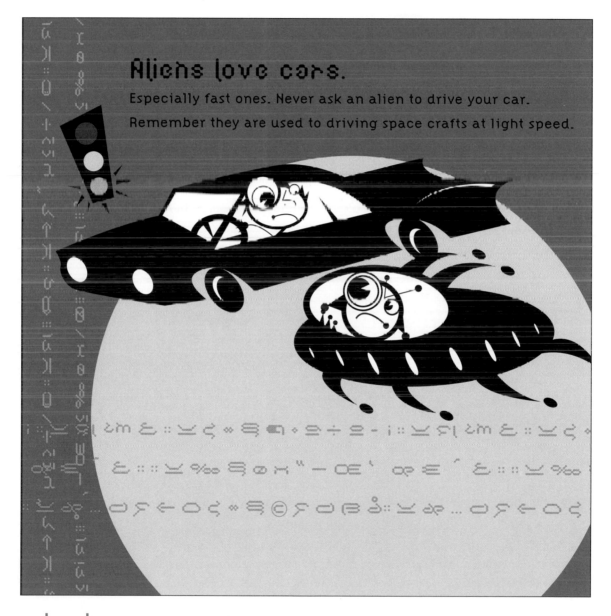

visual | 1–15 |

This illustration from a book about aliens demonstrates how important the space between two design elements can be. Notice how the background becomes activated and new shapes are formed as the alien ship approaches the car. *(Image by Morris Creative)*

CREATIVE INTIMACY

FOUR STAGES TO UNLEASHING THE CREATIVE SPIRIT

denise m. anderson

Denise Anderson, president and design director of DMA—a design firm producing award winning corporate programs for national and international clients—is also coauthor of Creative Jolt *and Creative Jolt Inspirations by North Light Books.*

Imagine that the act of creating is like falling in love. Have you ever designed a project that was beautiful but lacked a meaningful concept? Did you ever fall in love "at first sight" and find years later that those feelings have not changed? Like love, creativity can either be superficial or it can have purpose. Neither comes into reality without action. If no effort is taken to move through the four stages of developing the creative spirit, there are no rewards.

STAGE 1: INSPIRATION
Your pulse quickens, your hands sweat and butterflies dance the tango in your stomach. Out of the sky (from where ideas fall), you suddenly experience an overwhelming attraction to a person or an idea. If you make the decision to explore the attraction and nurture your interest, feelings of lust can emerge and you may find yourself dismissing a need to eat or sleep. At this stage, you convince yourself that this person you found or this idea you came up with is the sexiest, greatest, most wonderful thing you have ever known. You tell yourself, "This is *the one.*"

STAGE 2: EUPHORIA
After you have regained your strength with a full night's sleep and a nutritious meal, you feel invincible. You awaken with a freshness and passion that you have never known. You are immersed in the thought of this idea or person, giving little regard for the eventual outcome as you plunge forward. At this stage, the unleashed imagination soars—until it arrives at its first roadblock: "doubt." Doubt is a pesky little voice whispering at the edge of your consciousness, observing and tallying each negative thought. As doubts begin to pile up, you realize that yesterday's euphoria has somehow evolved into full-blown fear.

resulting dialogue is affected profoundly by the positioning of the design elements and their number in the composition. Proximity groupings can create patterns, a sense of rhythm, or other relationships that elicit a response from the viewer. Keep in mind that the conversation must be in support of the communication goal or message (see Visual 1–16a, Visual 1–16b, and Visual 1–16c).

As a general rule, creating proportional variations in the proximity of visual elements results in a kinetic tension that brings interest and excitement to a work of art or composition, whereas equal spacing between graphic elements of equal size can result in a static, uniform composition.

STAGE 3: FEAR

Fear is the primary factor that can devastate creativity and arrest the development of new ideas or relationships. Fear invites the mind to question the heart and allows guilt, failure and past performance to smother the intimacy that is essential for connecting to ideas and people. If you have fallen in love, you begin to wonder if that person is right for you; if you have created a design project, you question if you are communicating the right message.

Fear and art are not strangers to each other. Painters such as Vincent van Gogh and Jackson Pollack lived tormented lives—their solution was to work through the fear and refuse to be paralyzed by it. Fear can greatly affect one's vision and the flow of intimate ideas and emotions, but its energy can be harnessed and utilized. Just as a bungee jumper repeatedly seeks out an adrenaline boost that changes from terror to thrill, truly creative and loving people take risks, because they know that the reward comes from overcoming fear, not giving in to it.

STAGE 4: TRUTH

True creativity and true love will happen only when one is committed to action. In relationships and with design, what looks easy probably isn't, because designing and loving are hard work. While euphoria can be decidedly more pleasant than fear, these fundamental emotions provide a balance and may actually result in a more realistic perception of the design or the relationship. After freeing yourself from the illusions that euphoria can inspire and overcoming the paralysis of fear that halts creativity, you move closer to the truth. With this newfound clarity, you can assess your condition and determine whether it still brings you joy. If not, you may need to return to the drawing board or just be friends.

IN CONCLUSION

Love is the emotion that inspires us to be intimate and creative, but neither intimacy nor creativity can flow without a commitment to imagination and to moving beyond our initial euphoria and fear. Working through tough emotions when you would rather walk away can ultimately be rewarding. The most creative individuals and the most successful relationships tend to defy convention, allowing themselves instead to trust intuition, to innovate, to love and to work with every ounce of the soul's passion toward making inspiration reality.

Elements of Design

The elements of design can be thought of as content— the design components. The elements discussed in this chapter are considered formal elements. Formal elements are general and abstract in nature; that is, they don't necessarily describe anything in specific terms. Formal elements can be used to represent or describe specific things. A line can represent a leaf, the human visual has shape, and a bowl of fruit has color. Described elements tend to be identified as what they represent, for example, a person rather than a shape. Studying the elements in formal terms is helpful in understanding how they function as descriptive components in a design composition.

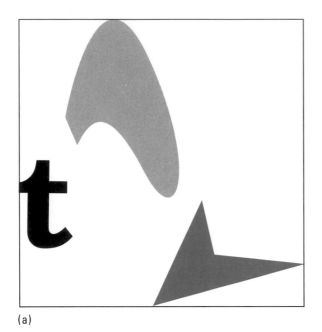

(a)

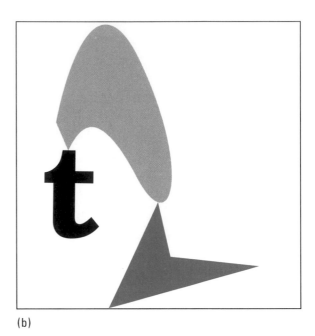

(b)

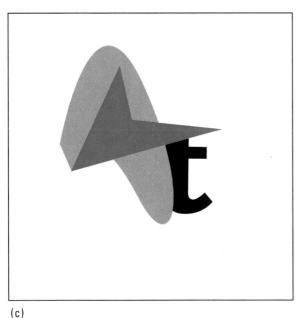

(c)

visual |1–16a to c|

In these three designs, size, color, and orientation of each design element is the same for each composition. However, changing the position of the elements changes their relationship and the resulting conversation. In visual 1–16a, the elements are independent of each other, but each is touching the edge of the composition. In this somewhat aloof conversation, the shape in the middle is trying to bridge the gap between the letter *t* and the chevron. Visual 1–16b brings the elements together, touching in a precarious grouping where the elements are dependent on each other in this curious balancing act. The resulting conversation is playful and mutually supportive. The elements in visual 1–16c have been carefully aligned and overlapped to create a new form that has three-dimensional qualities. The full identity of each element is concealed and each serves the newly created form.

Shape and Space

Shape can be defined as a figure or mass. In two-dimensional design, shapes possess width and length. When shapes possess volume, they move into the realm of three dimensions and are better described as form, which is mass that has volume. In either dimension, the configuration of the shape or form determines its meaning. For example, a shape constructed of soft, curved edges could be described as sensual; a shape constructed of angular edges and points could be considered crystalline. Shape configurations can be described on a basic level as geometric or organic (see Visual 1–17a and Visual 1–17b). Within these categories, other

categories that are more descriptive of the specific attributes of the shapes can be assigned. Examples include figurative, mechanical, or natural.

Shapes must reflect the intent of the message. Shapes exist as figures in or on a ground. Shapes are generally considered positive figures that displace space. This relationship of visual and ground—positive/shape, negative/space—is a fundamental association. But in a curious way, space around figures has shape too. To orchestrate a harmonic balance of the parts of a design, a sensitive relationship between its shapes, and the configuration of the space around the shapes, is critical. Experienced designers know the importance of paying equal attention to the shape of figures and the shape of ground. Chapter 2 covers in more detail various kinds of figure-ground relationships.

In the most fundamental terms, space can be thought of as an area activated by the other elements. Graphic design is a discipline concerned with the arrangement of elements in a given space. We tend to focus attention on the photograph, letterforms, or illustrated subjects in our design. But to present these graphic elements in a dynamic and visually interesting way, the space around the elements must also be designed. When a line or shape element is introduced into an area of space, it is said that the space is activated. Activating space can be attained subtly or overtly using line or shape (see Visual 1–18).

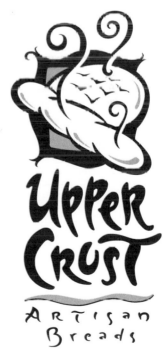

visual |1–17b|

The organic quality of the shapes, lines, and letterforms in this bakery's logo supports the natural ingredients and organic quality of its baked goods. *(Design by Morris Creative)*

visual |1–17a|

Shape is often used in support of a message. In this instance, Cahan & Associates uses geometric shapes and the circular motif of a microscopic view as a visual metaphor for genetic engineering within this annual report.

visual |1–18|

Amidst the arrangement of large scale shapes, the soft curved line projects a quiet influence as it activates the area within the blue plane. The color reversal in the *m* activates the background, creating a figure-ground reversal. The curves in the *m* are activated as they contrast points in the blue and ochre shapes.

Line

In formal terms, a line can be thought of as the moving path of a point. The path itself determines the quality and character of the resulting line. The path can be straight, it can meander and curve across itself, or it can follow the precise arc of a circle segment. The resulting lines from these point paths give a specific character and meaning to a line. Another aspect of line quality is determined by the tool that makes it—the sketched quality of a charcoal pencil line, the precision of a line drawn with a digital pen tool, the organic quality of a line brushed with ink, and so on (see Visual 1–19).

Lines of type can take the form of any configuration of a drawn line (see Visual 1–20).

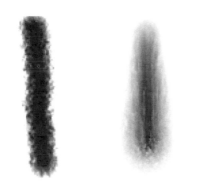

Lines can have different qualities, depending on the tool that was used. Shown here are three examples of lines drawn with (from left to right) charcoal, a brush, and a digital pen tool. Note the different characteristics of each: the charcoal line could be described as rough and gritty, the brush-stroke line seems loose and casual, and the digitally drawn line is clean and precise.

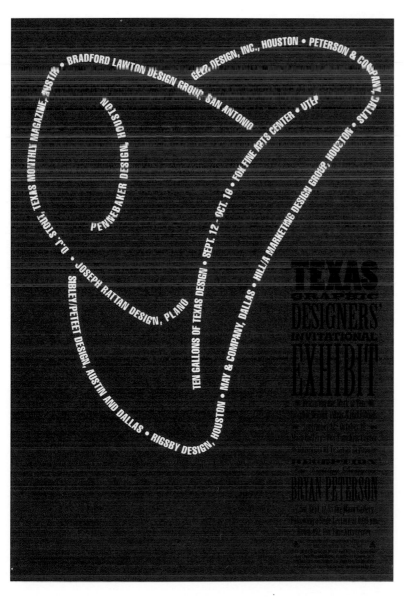

Type can also be used in a linear way to describe a shape or form as it does in this poster promoting a Texas design exhibition. The result is playful and has a memorable, graphic impact. *(Poster design by Mithoff Advertising)*

Another way to think of line is the idea of line as edge. A good example of this is a horizon line that exists as the line distinguishing land from sky. An edge line can exist along the side of any straight or curved shape or as the result of shapes sharing the same edge. You can see an example of line as edge in Visual 1–18.

Line can also be implied, meaning it exists as the result of an alignment of shapes, edges, or even points. Implying the existence of a line in this way can be very engaging for the viewer. Implying lines also activates the compositional space (see Visual 1–21).

Size

Size serves scale and proportion. Size refers to the physical dimensions of an element or format. Determining the size of a typeface or a photograph or the dimensions of a poster or display is a basic decision that needs to be made within the context of the overall design objective. For some design venues such as CD packaging, magazines, billboards, and Web sites, size is a given. Where and how they will be viewed is a determinant of size. In packaging applications, the size of the product determines the size of the package (see Visual 1–22).

In other situations, the designer may determine the size of a work. Most design is first consumed through the eyes and then manipulated by hand. Books, magazines, and other publications, and packaging and product design are good examples. In these instances, size is a

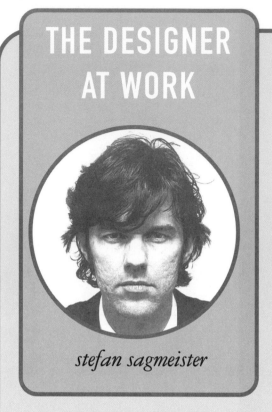

THE DESIGNER AT WORK

stefan sagmeister

Try to work for a company that does good work. If this is impossible, force yourself to do personal projects that you feel good about.

—Stefan Sagmeister

Stefan Sagmeister's work is characterized by innovative and unusual concepts. Many of his design solutions incorporate interactivity, controversial subject matter, or a visual surprise.

His approach is perhaps best exemplified by *Made You Look,* a monograph of his work that was published in 2001. Designed by Sagmeister and his staff, the book incorporates many of the optical tricks, surprises and interactivity of the designer's CD packaging. In fact, the book's cover, when placed in its red slipcase, portrays what appears to be a photograph of a friendly German shepherd. When the slipcase is removed, the dog's sweet countenance changes to reveal a vicious alter ego, foaming at the mouth.

A native of Austria, Sagmeister received his master of fine arts in graphic design from the University of Applied Arts in Vienna. He came to the United States as a Fulbright Scholar in the late 1980s, receiving his master's degree from Pratt Institute in 1990.

After working in the early 1990s at M&Co. under the mentorship of designer Tibor Kalman, he formed New York City–based Sagmeister Inc. in 1993. Since then, Sagmeister has become best known for designing graphics and CD packaging for popular recording artists such as the Rolling Stones, Pat Metheny, Aerosmith, and Lou Reed. In addition to winning many inter-national design awards, Sagmeister has been nomi-nated four times for the recording industry's Grammy award.

In addition to running a successful design studio, Sagmeister teaches at New York City's School for Visual Arts. He says that his students often inspire him, but they can also be his toughest critics. He was encouraged when a young designer responded positively to his book. "She said that after she read the book she wanted to do a lot of work. That's exactly how I felt when I was a student and I read a book I enjoyed," says Sagmeister. "I was very flattered."

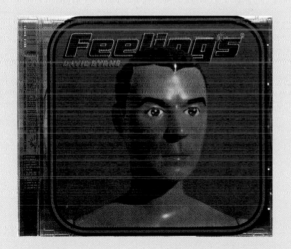

Much of Sagmeister's work involves entertainment graphics and CD packaging for high-profile recording artists such as David Byrne. For Byrne's "Feelings" release, Sagmeister had a model maker create a doll of Byrne as well as various heads with different expressions. When opened, the jewel case reveals a folded insert depicting the expressions and a disc with arrows that lets the user spin it to determine their current emotional state. The songs on the CD were color coded according to their emotional content, so that users could select a song appropriate to their mood.

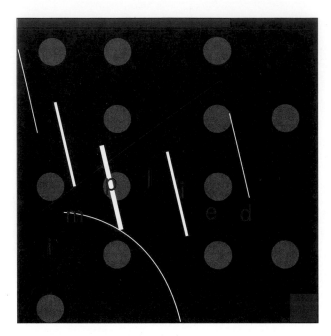

visual |1–21|

In this arrangement of shapes, letters, and drawn lines, there are numerous implied linear relationships. Some exist through alignment of end points; others exist from one point or shape to another. Study the composition carefully. See how many implied line relationships you can find.

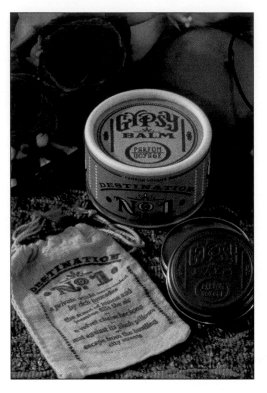

visual |1–22|

The intimate ritual of applying and wearing fine perfume is intensified in the design of this container and package. The diminutive size creates a precious quality, meant to be handled by fingers rather than hands. The small size allows the product to be easily portable. *(Design by Sayles Graphic Design)*

function of portability and hand-eye manipulation. In other situations, viewing the message from a distance dictates the venue's size (see Visual 1–23). Even when size is open for consideration, designers are forced to work creatively within externally imposed constraints. A savvy designer uses the comparison of sizes (scale and proportion) to control how the viewer perceives relative size (see Visual 1–24).

Color

Color describes the intrinsic hues found in light and pigment. Hues are distinguished in common discourse by names such as maroon, olive, or ochre. In industry, there are numerous systems designed to categorize, name, and classify color for various applications. As an element, color heightens the emotional and psychological dimensions of any visual image. Colors carry cultural meaning that immediately communicates without the aid of words or pictures (see Visual 1–25).

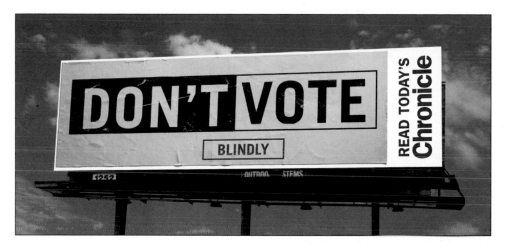

visual |1–23|

Designed to be viewed at a distance, the large scale of a billboard doesn't necessarily mean more room for more information. Billboards usually contain relatively little text and imagery because they need to deliver a message that can be perceived at a glance by passing motorists and pedestrians. Enhancing the readability of the message is an effective graphic device of reversing the type out of the background using high-contrast colors. *(Billboard design by Rives Carlberg)*

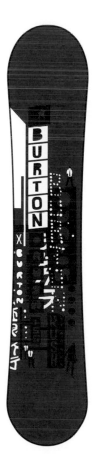
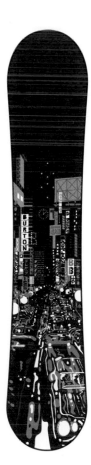
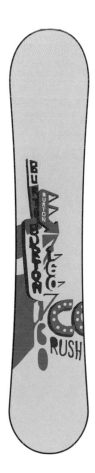

visual |1–24|

These snowboard designs use scale change and proportion to create variations on the theme of city nightlife. In the example at left the type and overlapping shapes create a sense of proportion with a human scale. The middle example uses a diminishing scale to create a sense of perspective and motion. At right, cropping and changing size of type establishes a scale that seems larger than the physical space it occupies. *(Snowboard design by Jager Di Paola Kemp)*

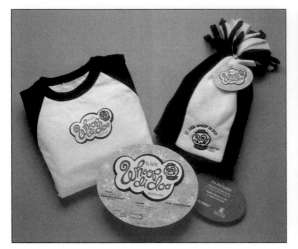
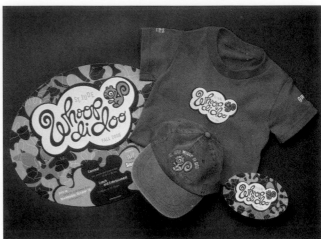

visual |1–25|

Color can support a seasonal theme as it does in these garment and invitation designs for independent fall and winter carnivals. Although the name and logo remain essentially the same for both events, the difference in color palettes immediately establishes each as a special, and separate, seasonally themed event. *(Event logo by Olika)*

Color can also convey an attitude or mood. Color enhances compositional space by controlling color contrasts. Color can have a role in supporting all of the visual principles and can be applied to the other elements (see Visual 1–26). It can help to create emphasis and variety, support an established hierarchy, and activate shapes and space. In Chapter 3 I go into more detail on how color can be used to manage a composition and convey an attitude or mood.

Texture

Texture refers to the quality and characteristic of a surface. Texture can be tactile and visual. Like color, texture cannot function as a design element on its own. It enhances the other elements, relying on shape and space to exist (see Visual 1–27).

Texture provides designers with an opportunity to create variety and depth in a composition and helps differentiate figure from ground when a design is complexly layered (see Visual 1–28). Lines of text, painted surfaces, or applications of dry media such as pencil or charcoal, or actual surfaces photographed or digitally scanned replicate actual texture but function as visual texture. Illustrators and photographers often make images that simulate real texture (see Visual 1–29).

There are instances in design in which texture is a tactile experience. Perhaps the most common example is the feel of paper surfaces within magazines and books or as it is used for business cards and letters, as well as on packaging and other products that are designed to be handled. The paper surface specified by the designer plays an important role in the way the user interacts with the product. A variety of materials such as paper, plastics, metal, glass, and

Color can be used to manage hierarchy by establishing position in space, as in this restaurant signage, where the brightly colored lime jumps forward in space, even though it is considerably smaller than the orange directly behind it. *(Restaurant signage design by Sibley/Peteet)*

visual |1–27|

Combining drawn line and shape elements with the clean lines and shapes in the radial designs results in a rich contrast of visual texture. These motifs were successfully used to communicate the rich, mid-eastern flavor of the music within this compact disc packaging. *(Package design by Sagmeister Inc.)*

visual | 1–28 |

In this poster a sense of dimension is created by adding layers of differing textured shapes that camouflage the type forms. The effect creates a delay in the read of the information. Textures and shapes create unity through variety in a visually active design. *(Poster design by Wolfgang Weingart)*

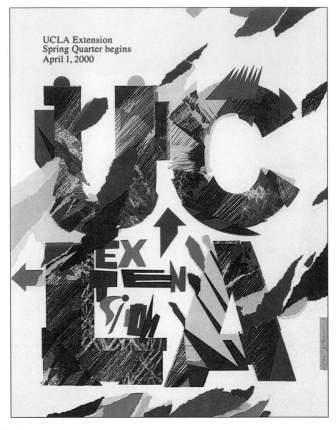

visual | 1–29 |

Artist Jim Carroll's illustration technique combines photography, layers of type, and painted and scratchboard surfaces to create rich, textural imagery.

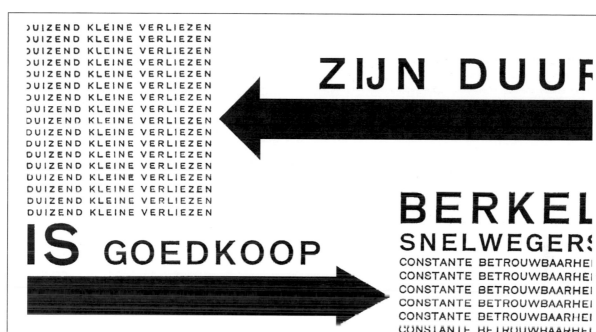

visual |1–30|

Blocks of text can create a textural quality. Changing the size and spacing of type changes the look of the textures in the design. *(Ad design by Paul Schuitema)*

wood play an important role in determining the perception of quality and function of the design. Texture can be arranged using its direction to create a pattern. Patterns of texture can be arranged to achieve visual tension and movement.

Typography

Typographic forms are elements unique to communication design because they play a dual role. On a formal level, they function as shape, texture, point, and line (see Visual 1–30). But, of course, typographic forms also contain verbal meaning. It is critical that word forms communicate a verbal message as well as function effectively as graphic elements in a composition. When typographic elements are managed only with regard to their verbal meaning, the design can lack visual impact. When type is manipulated with a treatment that enhances its message, that message is perceived on a sensory as well as an intellectual level (see Visual 1–31).

visual | 1–31 |

visual | 1–31 |

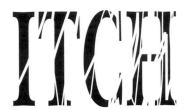

This comparison illustrates two treatments of the same word, with dramatic differences. In the example at top, the word *ITCH* is understood primarily by reading its verbal meaning. Beneath it, the same word is rendered with textural lines that communicate visually what the word says verbally. The verbal meaning "scratch the itch" is enhanced with a visual embellishment.

In primary and secondary school, we related to typography as words in books that contain information to be learned. We write letters to make words, sentences, and paragraphs that express our thoughts and ideas. This information is almost exclusively presented in horizontal lines, stacked in columns arranged on a sequence of pages. After years of relating to type in this way, it is understandably challenging to think of type as a visual form that can assume other configurations. Exercises that provide an opportunity to work with type in unusual and creative ways help reorient your thinking toward type as a potentially dynamic element in design composition. I further discuss typography in design in Chapter 4.

SUMMARY

The principles and elements of design function as a visual vocabulary. And, in that sense, learning to use them is like learning a new language. It can be overwhelming to understand how to use them in your own design. Study them individually at first and gradually learn to combine them in more complex ways. It also helps to study the work of contemporary designers and design through the twentieth century.

The exercises for this chapter stress one or two main principles, limiting the elements used to solve them. Once you have mastered the vocabulary of any language, you can communicate in that tongue. The visual language is complex and fluid. It is fluid because it is influenced by cultural, social, and technological change. Using it is an ongoing learning process, but the principles and elements do not change. When you have gained a working knowledge of them, you possess the means to powerful communication.

projects

Project Title Line Study Grid

Project Brief Draw a series of line sets of equal line length (approximately 2.5 inches long and 2.5 inches wide) and equal interval from each other. Change the interval from tight to more loose as you practice your control in each set. Generate 15 to 20 sets.

Cut the sets into 2-inch squares and arrange nine of them into a nine-unit grid. Strive for a variety of texture and value as you create this arrangement. Also, explore variation in the character and quality of the lines as you draw them.

Drawing is a critical skill for all designers. This type of drawing can be used as a warm-up for brainstorm sketching or design drawing.

Materials Use a quality drawing paper or Bristol board. Draw with fine to heavyweight markers, ebony pencil, medium to soft charcoal pencil, and graphite sticks. Adhere the final 2-inch squares to a two-ply Bristol board. Mount the final on a gray board with 3-inch borders.

Objectives

Gain control of hand-eye coordination in drawing.

Work with control of line quality in a variety of tools.

Work with a simple grid system to produce a composition.

Engage in a process of visual decision making to create a design.

Work with variety and contrast.

Project Title Interrupted Line Studies

Project Brief Develop a series of five line studies that are spaced and arranged according to the following criteria.

1. A regular-spaced interval—black and white are equal

2. Alternate the spacing interval—black is constant to itself and white varies dramatically

3. Black constantly increases and white remains constant to itself

4. Black increases as white decreases in width

5. Black and white increase constantly but at different rates

Use vertical, parallel lines and use no more than seven lines per study.

Materials Use black paper to cut strips (lines) and arrange them vertically on a white 5" × 5" piece of coverstock. Use a glue stick or rubber cement for an adhesive. Finish the studies by mounting them on a gray board with 3-inch borders.

Objectives

Work with basic relationships of line and space.

Hone critical, visual judgment skills.

Improve hand skills with a studio knife, straight edge, measuring, and cutting.

Translate verbal criteria into visual form.

Project Title Line, Letter, and Leaf

Project Brief Using a line, a letter, and a leaf, produce two contrasting compositions.

You may also use up to three planes or divisions in the background. Decide beforehand how the two compositions will contrast.

Materials Use color-aid paper for the planes, line, and letter. You can generate the letter from a computer or trace it carefully from a type book or magazine. The leaf can be pressed with an iron to flatten it. Consider large-scale changes between the line, letter, and leaf. Work with an image area of 9" × 9" coverstock. Rubber cement works best as an adhesive but glue stick or high-quality adhesive paste are options. Lay a clean sheet of paper over the design and roll a printer's brayer over the surface to press the paper to the adhesive. Trim the design and mount it on gray board with 3 inches of border. Black or white board may be better for mounting depending on the color scheme in the design.

Objectives

Work with more complex uses of the principles.

Manage design decisions using basic elements from the designer's toolbox.

Establish a hierarchy of elements that achieves unity.

Explore visual relationships based on closure, balance, and proximity.

in review

1. Which of the primary principles controls variety?

2. What is the distinction between proportion and scale?

3. What is the distinction between how the primary and support principles function?

4. What is the purpose of formal elements?

5. Which of the elements is unique to graphic design?

6. Which two elements can only exist in support of, or as an enhancement to the other elements?

7. Discuss various forms that line can take.

personification

September 27th, 7-10pm

Fig. 1

1997

| managing effective design |

objectives

Examine graphic devices and techniques that support visual organization.

Discuss key visual relationships that every designer must know.

Explore the impact of human factors on design decisions.

Define the foundations and functions of communication.

Demystify design as process by presenting a case study and its components.

introduction

By definition, design is organization. Designers determine which elements to use and how to use them effectively to create visual interest and communicate an intended message. Managing visual organization is taking an active, informed role in the design process. You are now familiar with the principles and elements of design. In this chapter you will be introduced to integral ways of using them to establish visual organization and artistic control.

You will also learn the role of communication in the design equation. Communication functions as a special design criterion and is central to the objective of any client-based project or student assignment. The layers that make the element of communication complex and dynamic are revealed and explained in direct terms using graphic diagrams and professional works. You will learn what professionals know about key visual and conceptual relationships that support effective design.

MANAGING EFFECTIVE DESIGN

VISUAL ORGANIZATION

Organization is central to good design. There are many factors to consider in achieving visual organization. But primarily you need to know how to manage the surface elements that are seen and "hidden" structures that are transparent in the composition. Lines, shapes, and color are seen. Format, orientation, grids, eye movement, and theme are transparent or sub-liminal structures that achieve harmony in the viewer's eye. It is also important to know something about how the viewer experiences visual information.

Our eye and brain work together to organize and make sense of the visual world as we see it. At the turn of the twentieth century a group of German psychologists studied the phenomenon of how humans perceive and organize the visual world. What they determined is that we tend to cluster shapes, colors, textures, and other visual cues in an attempt to process a whole image.

They coined the term *gestalt,* which translates from German to mean *"form"* or *"the way things come together."* They also coined a related phrase, *the whole is greater than the sum of the parts.* This means that, when viewed together, the interaction of design elements is more dynamic than each of the elements individually (see Visual 2–1).

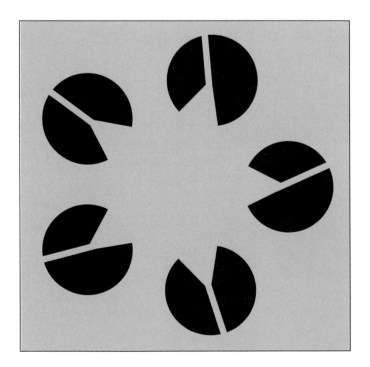

visual |2–1|

The parts in this pictogram include five black circles and a star with lines radiating from its points. The overlapping of the circles and star produces a new set of shapes and relationships. The positive and negative shapes have come together to create a whole image that transcends the presence of the individual parts. This graphic technique is often used to design logotypes and pictograms.

When we look at nature, we accept what we see as whole and harmonious. Perhaps this is why it has been such a popular subject for artists through the centuries. But when artists attempt to recreate nature in a painting, design a graphic image, or illustrate a book cover, attaining visual harmony and wholeness is the result of arranging and rearranging the elements until a "good gestalt" is achieved. What is learned here is that good organization in design results from an informed decision-making process that involves creative thinking, combined with an understanding of how visual organization works. A good place to begin is to learn the components of visual organization from outside, in.

Overall Organization

Overall organization involves four primary considerations:

- Format and orientation
- Grid systems
- Eye movement
- Theme

It is important from the beginning to the end that each design decision ultimately be supported by a rationale or reason. Often choices are made intuitively, because it "feels right." Although it is important to trust your instincts, it is equally important to test them. Testing your decisions is really a matter of questioning the relevance of each decision to the design objective. This is not always a linear, sequential process. Designers often work with components and elements that do not offer immediate resolution. But, by continually questioning and working the problem, the pieces ultimately fall into place.

Format and Orientation

In the design world the term *format* is used in two ways. It is the surface area that contains the design composition. The shape, size, and general make-up of the format is determined by the venue or kind of design, that is, packaging, publications, Web sites, posters, calendars, banners, and so on. Venues are aligned with a design objective, which means that formats are often determined outside the control of a designer. Unconventional formats, however, offer creative design challenges (see Visual 2–2).

In printing production, format refers to the arrangement of the design components as they will be printed, cut, scored, and assembled. It is important to consider the relationship between the design format and production format from the very beginning. Decisions that are made in a design are affected in the production stage. If they are not in tune with each other, the design will need to be reworked. It is a good practice to consult production services early to avoid problems later. Even if you are not taking your design to full production, it's important to think ahead about format sizes and construct prototypes and comprehensives

visual |2–2|

Venue formats are often outside the control of the designer and can have a huge impact on a design. In this example, the designer was challenged to conceive and apply a design with an Indian motif to the limited space of a watch face and band. *(Design by Doppelgänger Inc.)*

visual |2–3|

The wider panoramic format of the movie screen has a comfortable viewing proportion. Films that are presented on a conventional television lose action that occurs on the sides. The proportions of letterbox and CinemaScope are 2.35:1, although they optically appear different in this illustration because of the signature band adjustment at the top and bottom. HDTV has a less panoramic proportion of 16:9.

(comps) of your designs. Laser printers, large-format plotter printers, boards used for mounting, and other preparations for presentation of work are affected by formatting decisions that need to be thought of early in the design process.

Orientation is the point of view determined by the designer, and it is the way the viewer is meant to relate visually to a design or image. However, orientation begins with thinking about how the viewer relates to the world. Humans generally perceive the world standing or sitting perpendicular to the ground. This is a fundamental, stable viewpoint by which every nonperpendicular relationship is measured. Our brain is so conditioned to this perpendicular relationship that even when we tilt our head to view any environment or image, our brain perceives it as perpendicular to the ground.

A person's field of vision is an oval shape, with the width roughly double the height. The film industry screen formats of *Cinemascope* and *letterbox* are designed to mimic the same proportions (see Visual 2–3). Although our field of vision is oval in nature, we tend to view the world in a rectangular frame. This is culturally reinforced by the overwhelming use of the rectangle in architecture, art, design, and technology (see Visual 2–4).

ArCHiTEcTURE WEEK

visual |2–4|

Architectural forms tend to be perceived as vertical rectangles. This perception serves as the basis for the logo design for *Architecture Week,* where the rectangularity of the letterforms and their elongation, reminiscent of a skyline, reinforces the periodical's focus on architecture. *(Design by Atelier Works)*

The proportions and configuration of a format set up a psychological association that affects the way an image will be read. A horizontal format is associated with the horizon, nature, and serenity. Vertical represents contemporary, architectural qualities and a square implies a neutral, stable feel (see Visual 1–5a, Visual 1–5b, and Visual 1–5c in Chapter 1).

Grid Systems

Grids have been used for centuries as a means of scaling smaller images to larger works, or to break down the observed world into smaller, more manageable sections. Graphic artists today for the same reasons use the grid, but because design is more about arranging, they are also used to help achieve good organization. Grids can be built from square (arithmetic), rectangular (geometric), triangular, and even varying sized units. The square arithmetic grid is composed of equal-sized square units arranged in a series, 1, 2, 3, 4, and so on. The geometric grid is composed of units that are built using multiples. Units might be 1×2, 1×1.5, and so on. Grids can also be built from arithmetic progressions such as, 1, 3, 5, and 7. What makes this a progression is that the difference between each number in the progression is constant. In these examples, the numeric values can be translated into a visual figure used to build a grid (see Visual 2–5a, Visual 2–5b, Visual 2–5c, Visual 2–5d).

Grids are useful for defining key alignments and intersecting points within a composition. They also provide a means of organizing and determining where to place graphic elements, imagery, and text, and they often function as one of the underlying structures that is transparent to the eye (see Visual 2–6). It is particularly useful to use a grid when there are many elements to organize in a composition.

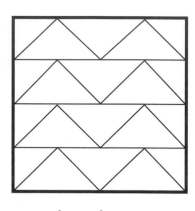

visual |2–5a|

visual |2–5b|

visual |2–5c|

In this arithmetic grid, the 16 larger units have been subdivided into 64 smaller units. Subdividing grids identifies dominant and subordinate intersecting points to use for the placement of elements.

Geometric units are rectangular and in this case have a one by two proportion. This grid provides a different set of relationships from the arithmetic grid. The alignment of intersecting points creates an angle that is more gradual than in the arithmetic grid.

A grid built of triangles offers a departure from rectangular grids. Here, the grid suggests a strong sense of overlapping and depth with a bias toward diagonal alignments.

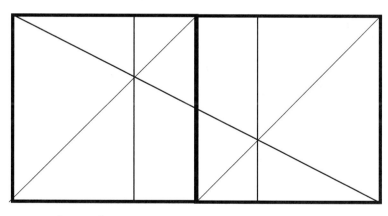

visual |2–5d|

This grid is useful for page layout. It is built from a series of intersecting lines. Begin with two rectangles or squares, which in this example serve as pages for a publication. Draw a line diagonally through either set of opposing corners. Now draw a line through the corners of the individual rectangles. Draw a vertical line through each of the intersecting points created by the intersecting diagonals. The resulting vertical rectangles can be used as areas for the placement of text and images in publications.

Grid systems can also be combined to establish a hierarchy to manage both the outer proportions and internal placement of design elements. For example, a golden rectangle could be used in conjunction with a set of simple arithmetic and geometric grids that subdivide the squares and rectangles. The resulting grid hierarchy begins to suggest internal relationships and a direction for eye movement (see Visual 2–7).

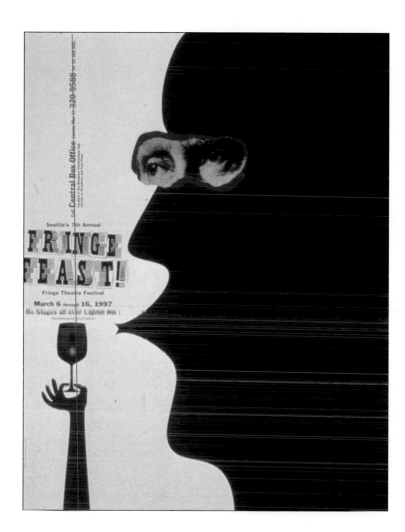

visual |2–6|

A grid provides a system or format for organizing the elements in a composition. It can be a simple division as the invisible line that serves as a means of aligning visuals in this poster design. *(Poster design by Modern Dog)*

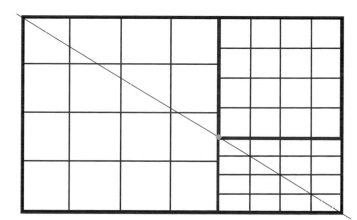

visual |2–7|

Combining systems can suggest scale changes, movement, and emphasis, as in this grid, which begins with a golden rectangle and is further divided. The subdivided grids are a mix of two arithmetic and one geometric. As the units decrease in size, a sense of spiraling movement is created, established around a pivoting focal point identified by the green diamond.

Eye Movement

The human eye is a wonderfully complex instrument. The eye works in conjunction with the brain to perceive the world. Physiologically speaking, it provides us with neural impulses that are recorded on the brain's visual cortex. The best analogy is that the eye and brain work like a movie camera. The lens works like the eye and the film is like the retina on the visual cortex of the brain, recording the world as it is perceived. One distinct difference between the eye and a camera lens is that the eye is continually moving or quivering, allowing the images we perceive to be recorded on the retina.

This quivering or rapid scanning of the eye is a built-in survival feature of human physiology that helps us distinguish shape, pattern, and color. It is therefore difficult to maintain a fixed stare on any point within a picture. Our tendency is to want to move our eyes around scanning various features in an image. When our eyes are fixed on a point in a picture, we can only perceive the rest of the image in our peripheral vision. The longer we stare, the more faded are the images in the periphery. Therefore, the bias is for the viewer's eye to want to scan, and so it does. Controlling eye movement in a composition, then, is a matter of directing the natural scanning tendency of the viewer's eye.

But what kinds of arrangements, alignments, and shapes attract and move the eye? The eye tends to gravitate to areas of most complexity first. In pictures of people, our eye is always attracted to the face and particularly the eyes. The combination of the graphic complexity in a face and the fact that the face embodies the essence of human expression leads our eye to examine it for clues about meaning (see Visual 2–8).

Light and dark contrasts create distinct shapes and line edges that attract the eye. Vertical and horizontal lines or edges are stable, functioning as constant axes. Angled lines, edges, and alignments that operate counter to the vertical and horizontal guide eye movement (see Visual 2–9). Isolated elements set in neutral areas away from more complex patterns or grouped elements also attract attention.

It is an effective strategy to establish a visual hierarchy to direct eye movement. Create a rhythmic loop that takes the eye on a journey over the surface and into the depths of the composition with built-in resting places, or white space. Textures and graphic details can offer the eye a reason to sustain interest, examining the picture over again (see Visual 2–10).

Theme

Theme in design is a subject or topic being represented. It can also be thought of as the quality or character of a represented idea. As such, a visual theme determines what elements to use and appropriate ways to use them. Theme serves as a conceptual scheme for making organizational decisions. Theme may be presented as the premise of a story, a symbolic association, or the use of a visual metaphor.

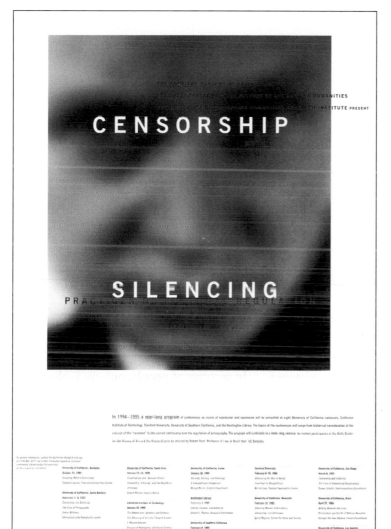

In this poster promoting a series of lectures on censorship, the eye is immediately drawn to the face, particularly the eyes and mouth where the poster's primary message is delivered. *(Design by Adams Morioka)*

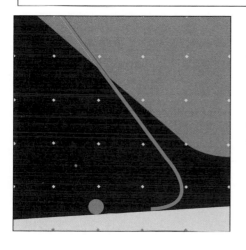

In this composition, eye movement tends to follow the light blue line and the edges of the orange and yellow against the dark blue. The angles are countered by the regular placement of the yellow diamonds. The yellow diamonds and the dark blue area bring attention to the conspicuous circle and the isolated orange diamond. The grouped row of orange diamonds along the bottom edge call briefly for the viewer's attention.

visual |2–10|

This poster promoting a gallery exhibition opening features samples from work by each artist represented in the exhibition. This imagery and the typographic content about the opening and exhibition are strategically scaled and positioned to create a well-balanced composition, supported by neutral areas of black-and-white space that leads the viewer's eye from one design element to the next. *(Design by The Partnership)*

Motif is an element related to theme. The appearance of the overall image in a design is referred to as motif. There are three general kinds of overall images: nonobjective, abstract, and realistic.

Nonobjective, or nonrepresentational, images have no resemblance to anything recognizable. These images are built from geometric and natural elements that make no attempt to depict the real world. Nonobjective images function mainly on a formal level, concerned with general relationships of basic elements. Conveying a theme with nonobjective imagery is convey-

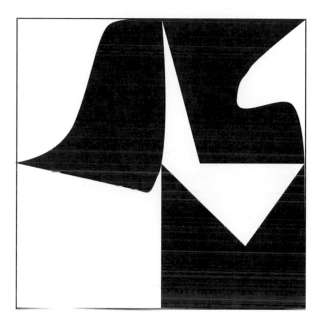

visual |2–11|

Nonobjective imagery relies on shape relationships and a formal visual vocabulary to communicate. This composition is about the tension created between points and edges and the precarious balance of the shapes. The shapes also seem stuck in their position with no room to move. The prevailing feeling conveyed here in the relationship between the shapes is a sense of confinement and incompatibility.

visual |2–12|

These two symbols rely on the use of abstraction to directly communicate the essence of each organization. Each combines two main, graphically simplified elements, utilizing a figure-ground reversal. The "V" and leaf represent Vanderbilt University. The leaf symbolizes the beginning of the school year in autumn. The mast and whale's tail was designed for the New Bedford Whaling Museum. The simple abstracted curves create an active rhythm within the image and around the outer edges. *(Symbol design by Malcolm Grear Designers)*

ing a quality or feeling that is interpreted rather than described (see Visual 2–11). Abstract images resemble the physical world but are a simplification or distortion of the things in it. In theory, all images are abstract because they are re-creations of the physical world. But within the realm of the visual arts, images are classified by their degree of coherence with the world we see and live in (see Visual 2–12).

Realistic or representational imagery replicates the real world in a descriptive manner. Represented objects have defined and nameable referents to the real world (see Visual 2–13).

Theme and motif are used in design to create a graphic look that promotes the overall idea. Often the theme is given as part of the design problem, but it can sometimes be the job of a designer to determine a theme. In either case, a theme must be researched and developed so that the imagery used to represent it is appropriate, accurate, and ultimately understood by the audience.

A theme is most always generated with a word concept that can be translated into graphic form. Some common thematic categories include animals, industry, music, seasons, places, sport, weather, holidays, culture, and historic periods. Narrowing a broad theme to a specific concept can provide more pointed communication. For example, winter might be narrowed to snow, and more specifically translated to snowflake, as a motif or symbol used to represent the broader, original theme.

Visual Relationships

Controlling the relationships of visual elements is the art of aesthetic judgment. Controlling graphic continuity, determining the character and quality of the elements, and deciding questions such as "how much is enough?" and "what kind should be used?" are the type of issues that make art of design. The arrangement of elements also taps artistic sensi-

THE DESIGNER AT WORK

dave plunkert

While it's impossible to be successful in either design or illustration without some degree of compromise, it's important to know where your line of compromise is and always try to move as far from it as possible.

—Dave Plunkert

Dave Plunkert is proof that it's possible to work successfully as both an illustrator and designer. A love of creating comic books and some freelance logo assignments during high school led him to pursue a degree in graphic design at Shepherd College in West Virginia where he graduated in 1987.

Plunkert landed a position with a design firm in Baltimore shortly after graduation, but the job was ill-fated. After being laid off in 1992 as a result of downsizing, the need to acquire freelance work to support himself as quickly as

possible led Plunkert to put together a design portfolio as well as a portfolio of illustrations—work that represented his personal experimentations with collage. Plunkert's collage technique of combining old photographs into bizarre new images quickly captured the attention of editors and art directors, and his illustration assignments soon began to equal his design assignments.

Plunkert and designer Joyce Hesselberth both free-lanced successfully during the early 1990s doing a combination of illustration and design. They decided to combine their businesses in 1994 to form Spur—a full-service design firm. Serving design and illustration

clients that include *Business Week,* Gatorade, Maryland Institute College of Art, Mid Atlantic Arts Foundation, MTV Networks, *Time,* and UPS, the award-winning firm currently employs six.

Spur's combination of design and illustration provides the firm with steady income. "Illustration keeps the cash flow—something coming in every month, whereas design is a long-term process," Plunkert relates. Doing projects that involve both disciplines also satisfies Plunkert's creative instincts. Says Plunkert, "We've always loved doing illustration, but at the same time, Joyce and I cut our teeth on corporate design."

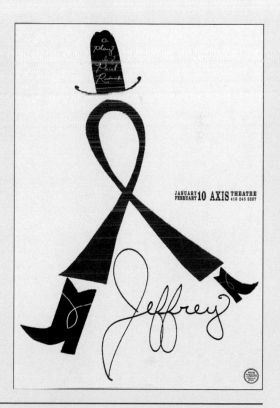

When Axis Theatre asked Spur to design posters promoting its performances, Plunkert and his team were given a limited budget. Their solution was to screen print the posters themselves, saving hundreds of dollars on the posters' printing. Hand-rendered type and edgy illustrations by Plunkert and firm partner Joe Parisi characterize Spur's style: a unique blend of design and illustration.

visual |2–13|

This illustration for *The New York Times* Book Review is an example of realism or representational imagery, which often involves exaggeration to project an editorial point of view as in this caricature of Neil Young. *(Illustration by C. F. Payne; art direction by Steven Heller)*

bilities. Making decisions about where elements should be placed and how they should interact requires a measure of intuition and logic. The essential objective is to create visual interest. Investigative studies allow for the exploration, development, and refinement of visual relationships and compositional arrangements that will engage the eye and mind of the viewer.

Figure and Ground

The relationship between figure and ground is perhaps the most fundamental in design composition. Shape and contrast affect the figure-ground interaction most profoundly. Keep in mind that the ground, or space around a figure, has shape as well. Visual shapes can exist in-

visual |2–14|

The playful use of typography and illustration for this self-promotion relies on a simple figure-ground relationship. All of the elements are placed against a neutral background to allow the distinctiveness of each element to read clearly with the others. *(Self-promotion design by Scorsone/Drueding)*

dependently, overlap one another, or have a transparent quality depending on the figure-ground arrangement. There are three basic arrangements.

Simple figure-ground arrangement is the coherent, independent presence of a shape juxtaposed in a space that serves as the ground. The space can be compressed or shallow, or it can create the illusion of depth. In simple figure-ground arrangement, the figure is positive and generally active, and the ground is negative and generally passive (see Visual 2–14).

Figure-ground reversal is a graphic affect in which figure can function as ground and ground as figure. Shapes form in the space between figures and create a visual inversion. The reversal can be a dynamic way to activate neutral space in a composition (see Visual 2–15).

visual |2–15|

This clever and elegant logotype was designed for a composer. The figure of a musical note is reversed onto a pen nib. The image reversal yields a visual solution that offers economy by combining two images into one. (*Logo design by Dogstar*)

Ambiguous figure-ground arrangement finds the viewer uncertain about the relationship between form and space. The trick to controlling figure-ground ambiguity effectively is to create an arrangement that is disorienting yet comprehensible (see Visual 2–16).

Closure

Closure literally refers to the condition of being closed. A form that is entirely closed can be thought of as fully described or complete (see Visual 2–17a and Visual 2–17b). However, a form can be interrupted or incomplete and still be understood. There is a limit to how incomplete a form can be represented yet still comprehended.

Visual 2–18a, Visual 2–18b, Visual 2–18c, and Visual 2–18d present a sequence of illustrations of the St. Louis Arch. The question is "how much can be removed from the arch, yet still have it read as complete?" In Visual 2–18a, Visual 2–18b, and even Visual 2–18c there is enough information for the eye to complete the form. In Visual 2–18d, however, it is difficult to complete the form in the way we recognize it. In this case, closure is about presenting form in a way that permits viewers to complete it in their mind's eye. This visual relationship is widely used to create visual interest for the viewer.

visual | 2–16 |

Figure-ground ambiguity is what designer McRay Magelby had in mind when creating the graphics for this Earth Day poster. The positive image of the mother, the profile of the head, and the resulting kiss are intertwined, engaging the viewer in a visual mystery of form and concept. *(Poster design by McRay Magelby)*

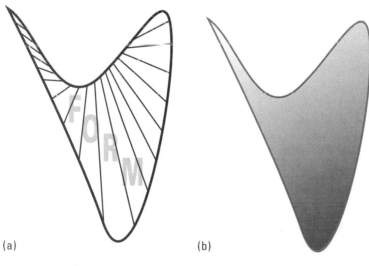

(a) (b)

visual | 2–17a and b |

Forms can be described as open or closed. In visual 2–17a, the open form is seen as transparent, functioning like wire framework that you can see through. Closed forms are opaque and built from solid planes like the one in visual 2 17b. Both forms shown are examples of complete or described closure.

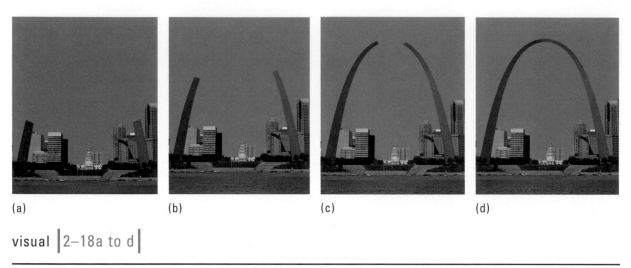

(a) (b) (c) (d)

visual | 2–18a to d |

This series of images of the St. Louis Arch provide an example of incomplete closure.

visual | 2–19 |

The *e* and adjacent angle can be associated with the other letterforms and angles by similarity. But because of the distant proximity, they do not appear as though they belong to the rest of the word. Their proximity needs to be adjusted closer to complete the word *closure* and the star shape. Presenting the five component angles of the star apart from one another allows viewers to participate more actively by completing the star shape in their mind's eye.

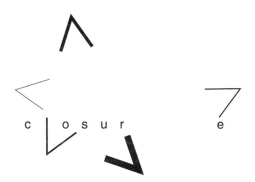

Closure also depends on relative position, that is, the distance from one object or shape to another. If related shapes are too far apart they have no relationship, but when they are positioned closer to each other, the relationship can become meaningful. They can exist as complements or create a visual tension. A classic example of this type of closure from art history is in Michelangelo's painting of *The Creation of Adam*. In this famous scene, God reaches his pointed finger outward toward the finger on Adam's hand. The fingers almost touch, which promotes a sense of birth or creation. If the fingers were farther apart or touching, the quality of the relationship would be much different (see Visual 2–19).

Contrast

When we think of contrast, we think of a relationship between light and dark. This is of course one kind of contrast, but there are many others. A related term used often in the vi-

(a)

visual |2–20a to c|

(a) In the context of a series of straight vertical lines, the curved line creates a tension that makes it appear more curved. (b) When placed on a complementary color field, the contrast of the blue *B* and square are heightened as compared with the neutral gray ground. (c) In a more subtle contrast, the regular rhythm of the circle and rectangle shape is countered by the intermittent rhythm of the small circle and zigzag line.

(b)

(c)

sual arts for contrast is juxtaposition, which refers to a relational, comparative placement of two or more elements. The possibilities are endless: negative versus positive, jagged versus straight, geometric versus organic, serene versus chaotic, rough versus smooth, random versus orderly, saturated versus pastel, static versus kinetic, monumental versus diminutive, and so on. These contrasting relationships can be visually articulated using combinations of the elements of design. Contrast serves the higher principle—variety. Achieving unity through variety is the art of arranging unlike elements and making them work together. Contrast of size, order, weight, direction, configuration, value, color, texture, and form creates visual interest by presenting an opposing context that allows one to complement the other. Curved looks more curved when placed in proximity to straight. Blue looks more blue surrounded by its complement, orange. Regular looks more regular when an irregular element is present (see Visual 2–20a, Visual 2–20b, and Visual 2–20c).

Anomaly

Visual anomaly is the presence of an element or visual relationship that is unlike others that dominate a composition. It functions as a particular type of contrast—a contrast of nonconformity. Anomaly can create a lively, animated quality. It can be subtle or prominent. It often brings a playful attention to the point where it occurs. When it is skillfully aligned with a communication message, the use of anomaly can make an otherwise ordinary design completely unique (see Visual 2–21).

Emphasis and Focal Point

Look at any visual image and, as your eye scans it, you may notice that it tends to return to one point—a point of emphasis. As you attempt to find meaning in the image, the point of emphasis or focal point usually contains the key to understanding the intent. It is where the artist wants to lead your eye. Often the element that dominates the visual hierarchy of a composition is located at the focal point. A place where lines converge, a light figure in an area of

visual |2–21|

This logotype uses four-unit grid arrangement with one different element. The diagonal unit is an example of visual anomaly. It serves as the focal point and focus of the communication for an orthodontist whose business is straightening teeth. The designer makes a subtle but critical decision to soften the corners of the square units to represent the qualities of a tooth. *(Logotype design by Charlene Catt-Lyon, Catt-Lyon Design)*

darkness, an area of complexity, detail in an otherwise uncomplicated field, or, as we have just discussed, a visual anomaly create visual points of interest. Emphasis serves hierarchy. The focal point is often the most dominant element that is supported in the hierarchy by contrasting support elements. Once the focal point is located, the viewer tends to read all other elements in relationship to the main element of emphasis. It is important that the main element supports the communication objective (see Visual 2–22a, Visual 2–22b, and Visual 2–22c).

It is worth noting that all designs do not rely on emphasis and focal point. Decorative arts such as textile design rely on a regular pattern of equally distributed elements.

(a)

(b)

(c)

visual | 2–22a to c |

The arrangements in visual 2–22a, visual 2–22b, and visual 2–22c contain the same basic elements. The dominant element in each one is the orange ball. The support elements are words that communicate an action practiced with a ball. The word elements interact with the ball, which functions as the focal point in each arrangement. In visual 2–22a, isolation brings attention or emphasis to the ball. It fits precisely into the center of the *T*, supporting a subliminal relationship to the word elements. In visual 2–22b, the size of the ball as compared with the words is what calls the viewer's attention. Its scale seems to be expanding as it presses against the words *throw* and *catch*. The diagonal orientation suggests a circular motion that reinforces the ball as a focal point. Visual 2–22c presents an arrangement of the word elements as lines converging toward the ball. Convergence is a function of perspective that leads the eye to a point in space that by definition creates a focal point.

COMMUNICATION AND PROCESS

The incorporation of a communication objective distinguishes graphic design and illustration from other visual arts. Managing effective design is managing both the visual elements and accompanying communication objectives. A package or book cover must represent the contents within. A corporate logo must represent the image and nature of a company's business. An advertisement must deliver a pointed message about a product or service. Communication directs design decisions. What needs to be said by the designer and understood by the audience is the essence of visual communication. It is important to understand what needs to be communicated and what to use in the design to support it.

Class assignments have many of the same components as a real design project. You are given a set of objectives, limitations, and a time frame to complete the work. Study the objectives. Gain an understanding of what you are being challenged to do. Objectives generally contain the information you need to establish your direction. Most important, determine the communication components before you begin to explore visual solutions. In beginning design assignments, these components are more basic, but they provide the conceptual framework that serves as the communication criteria.

It is important to understand that whether presented by an instructor or a client, the element of communication is a given that originates from the outside. It is the job of the student and the practicing designer to understand the nature of the need and develop a plan to incorporate it into an effective design solution. Once incorporated, the communication message often serves as the design objective (see Visual 2–23).

visual | 2–23 |

The objective of this advocacy design is to promote voting. The final design is a curious but effective message. It relies on the words and the image together to communicate the intended message. The essence of the illustration is saying, "You have no voice." When combined with the words, the message is complete.
(Poster design by Modern Dog)

Visual Communication

Visual communication begins with verbal language. Advertising, marketing, publications, packaging, multimedia, and the images needed to support these communication venues all rely on concepts that are first considered as written or spoken messages. Communication artists must learn the skills necessary to translate verbal language into visual communication. In some ways, the verbal message is a conceptual element that must be considered in conjunction with the visual elements. Verbal messages drive the decision-making process that ultimately determines graphic content and the form it needs to take. Translating verbal concepts into visual form is a matter of testing ideas. Sometimes, it is obvious that a verbal concept has little potential as an image. For example, *rational thinking,* as it reads, would be a challenging concept to illustrate. Having to work with such a message may require brainstorming sessions to rethink an approach that is workable.

The concept *ancient drummer* is inherently rich with visual potential. However, because there are many ways to interpret this concept, it is important to consider the audience, possible venues, and the communication message to guide your design decisions. This requires a clarification of the concept that can be determined by developing a series of related questions. For example: What culture does the drummer represent? What does a drum from that culture look like? What point of view is most dramatic? These questions define and refine the concept so it can be worked in an appropriate way.

Foundations and Functions of Communication

Understanding relationships between verbal language and visual communication gives designers and illustrators important tools for communicating with an intended audience. An audience is a group of people with a specific profile. To understand any group you need to consider the psychological foundations that influence its members. They include how people behave, how they think, how they feel, and how they interact with each other. Communication specialists in the advertising and marketing fields understand these psychological foundations. They use them in conjunction with other profiles such as age, gender, ethnicity, geography, and income to create messages and imagery that will reach the target.

Designers and illustrators take the messages and craft them into visual concepts. To develop effective graphics from potential concepts the artist must know what the communication specialist knows about the nature of the message and the audience who will receive it. A connection, then, needs to be made between the human psychology that drives marketing and advertising, and how communication functions in design.

There are four categories of communication in design that relate to the psychological foundations of human activity. These categories also determine the way the communication message will be delivered to an audience.

Persuasive design attempts to persuade an audience to think or behave in a deliberate, sometimes different, way from what they are accustomed. "Support the Arts," "Be a Subscriber,"

visual | 2–24 |

Designing charts and graphs is a challenge that involves the delivery of accurate information combined with graphics that are engaging. In this example, color, point of view, and playful illustrations present factual information in an entertaining and palatable manner. *(Information graphics by Clement Mok and Saul Wursman)*

Percentages of the categories of bachelor's degrees conferred

and "Buy This Brand" are messages intended to persuade. Advertising, promotional and social advocacy design are examples of this category.

Information design presents ideas and concepts with the intent of educating the audience. Textbook design, exhibit design, annual reports, charts, and diagrams all deliver information that is graphically organized and designed to assist the audience in their understanding of specific content (see Visual 2–24).

Directional graphics help people find their way through architectural or environmental spaces. Theme parks, retail centers, public spaces, and transportation systems all rely on typographic and pictographic design that can speak to broad audiences that often include an international population (see Visual 2–25).

visual | 2–25 |

In this wayfinding program for downtown Wichita, brightly colored, playfully illustrated pictograms serve to direct and identify destinations and points of interest. *(Signage system by Hunt Design Associates)*

Enhansive design embellishes the look of a design venue. Enhansive graphics can also add a measure of entertainment value to a design application. Theme parks, retail industry, games, advertising, editorial, and electronic media all rely on enhansive graphics to present a more visually interesting and compelling product (see Visual 2–26).

It is important to realize that these functions are interrelated. In fact, many design applications incorporate several of these categories in their concept and design. For instance, a packaging design needs to persuade the consumer to choose the product from the shelf and, at the same time, give them information about the package's contents. A magazine or book needs to compel an interested consumer to pick it up for examination and offer entertainment value in the design and graphics.

Design as Process

Getting started on working a design problem can be an overwhelming task with many decisions to make. Breaking down the problem into manageable tasks can be helpful but doesn't

visual |2–26|

A bright color scheme and playful illustrations are used to enhance the function of this board game design. *(Design by Morris Creative)*

insure that the design will be successful. It requires work and skill to arrive at a solution that solves the problem. There are some key factors that must be carefully considered:

1. **Define the design objective.**

 Design objectives are specific to the project or assignment. Are you promoting, informing, directing, or enhancing? Getting consumers to buy a product, letting them know of an event, teaching them about a subject or procedure, helping them navigate in the world, or making that world a visually more interesting place is the type of fundamental language used to develop a design objective.

2. **Define the communication objective.**

 Communication objectives are specific to behavioral outcomes of the audience. What is the main message? How will the message be crafted? Will the communication be delivered with words, imagery, or a combination of both? These basic questions are central to defining the communication objective. In many cases it is determined by a team that includes the client, an account representative, an art director, a copywriter, a designer, and an illustrator or photographer. Everyone involved must keep the objective in mind as they work toward a solution. Student assignments often have a built-in message. As previously discussed, be sure you understand the assignment objectives. Work to determine a resolution between the main message and the visual forms used to present it.

3. **Define the target audience.**

 This is the group toward whom you are directing your message or communication. The audience can be narrow or broad. The audience, referred to in marketing as target audience, always has a profile. Even broader audiences are specifically defined. Demographics are specific data that offer a profile about a given population. These data are critical information about human activity, that is, individual and group behavior, attitudes, and beliefs. Attitudes and beliefs have their foundation in four distinct human activities: thinking, feeling, behaving, and interacting, as discussed earlier in this chapter. To achieve the desired outcome of your objectives, you must research your audience and target one or more of the four foundations.

 Hard demographic research is compiled through the use of marketing surveys, focus-group observation, and empirical or scientific research studies. Market-driven communication relies on this type of information.

 Soft demographic research can be obtained by observing what's out there, applying existing research data to your situation, or making inferences about social and cultural trends from the information in media sources such as newspapers, television, the Internet, and periodicals.

4. **Research the subject.**

 Know your subject. Research it. Find existing references or produce your own by photographing subjects; collect artifacts that are related to the subject; and research the history of a subject or concept to determine appropriate color schemes, typefaces, and cultural and social references. Working exclusively from your head will limit your ability to solve the problem accurately and creatively.

5. **Brainstorm potential ideas.**

 Brainstorming is another word for visual thinking. To manage a visual idea you must get the idea from your mind, where it exists in an abstract state, into the visual world, where it is concrete. Once in the visual world, it can be developed and refined and described to others.

6. **Choose the right media and venue.**

 In the field of communication arts, the term *media* refers to various communication industries that include publishing, television, film, digital, and printing. Within these industries are specialized venues. A venue is the place where the communication occurs or the place where the user engages the communication. For example, magazines and books, commercials, Web sites, billboards, brochures and packaging are design venues that, in part, constitute the media listed previously. Each venue has its own capabilities for reaching an audience with a message. Function, cost, and viability are the key considerations when selecting an appropriate venue.

7. **Develop a graphic design strategy.**

 A strategy is how you plan to produce the design. It involves managing time and the work or tasks that you need to complete. It helps to work backward from the due date to determine what needs to be done and when you need to do it. Allow additional time to do work that is new to you. For example, there will be a learning curve to acquire the skills to manipulate new media and studio materials.

Visual Thinking Is a Process

It may seem odd to suggest the idea of giving structure to creative thinking, but using thinking exercises or brainstorming models to guide the creative process can be very useful for generating ideas.

Ideas generally begin in the mind, manifested by our imaginations. Attempting to re-create an idea directly from our mind into visual form often brings disappointment.

Visual thinking is the process of working and managing an idea that begins in the mind into the visual word using drawing, paper cutting and folding, sources of color, and other studio media.

> Determine a fixed time. Ten minute sessions to generate ideas.

> Work quickly to generate as many ideas as possible.

> Do not judge any ideas at this phase.

⟵ *EVALUATE*

> Review your ideas and choose two or three to pursue further.

⟵ *EVALUATE*

> Narrow to a single idea and produce a number of variations.

⟵ *EVALUATE*

> Refine and refine again.

⟵ *EVALUATE*

> Prepare the refined idea for final execution.

⟵ *EVALUATE*

Apply the principles and elements of design to your plan. As we have discussed, the principles and elements function as the components of visual language. Applying them as you make creative decisions will help you control the relationship between the communication message and the design itself.

8. **Evaluate the decisions as you go.**
 We tend to think of evaluation as something that occurs at the end of a project. It can be more valuable to assess the direction of a project in progress. It is important to establish points to stop and assess the development of the work in progress. Consider asking the following evaluative questions during the progress of a project: Is the design still aligned with the objectives? Is the communication message represented in the design? Do you need to consider more ideas, or is it time to narrow choices? Have you received enough feedback? Is the project on track to meet planned deadlines? These questions need to be asked and answered before the project can be ultimately evaluated.

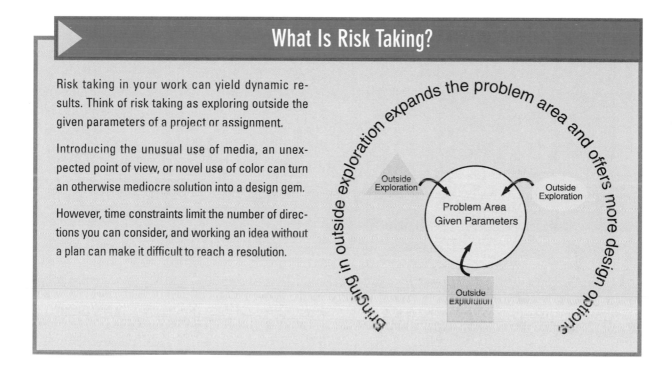

What Is Risk Taking?

Risk taking in your work can yield dynamic results. Think of risk taking as exploring outside the given parameters of a project or assignment.

Introducing the unusual use of media, an unexpected point of view, or novel use of color can turn an otherwise mediocre solution into a design gem.

However, time constraints limit the number of directions you can consider, and working an idea without a plan can make it difficult to reach a resolution.

Bringing in outside exploration expands the problem area and offers more design options.

Outside Exploration

Outside Exploration

Problem Area Given Parameters

Outside Exploration

9. **Creative Risk Taking**

In the early stages of developing a concept, don't forget to take creative risks. Think outside of the problem or approach it with a playful mind-set.

Generate many potential solutions. Resist judging your ideas at the beginning. Some of them may seem ridiculous, but a truly creative solution often runs counter to expectations. Once you have narrowed the possibilities to a single approach, apply the principles and elements as you bring the design components together.

SUMMARY

Organizing visual elements and information into a cohesive, engaging graphic image is the work of graphic designers. Consideration must be given to the manner in which the graphic communication reaches the audience and projects the intended message. The key is to question and evaluate design decisions at every turn in the process.

Work to achieve a resonance among all the elements as they come together, like the individual sounds in a symphony. The aspects of overall organization, format, orientation, grid systems, eye movement, and theme function together like a transparent stage for the performance. The elements are combined to create visual relationships such as figure and ground, closure, contrast, anomaly, emphasis, and focal point, which give form to the idea. The designer is the conductor, ensuring that the communication message and the visual form it takes work in concert to serve the same composition.

projects

Project Title Contrast Studies

Project Brief Design two contrasting compositions based on one of the following sets of complements: negative/positive, jagged/straight, geometric/organic, serene/chaotic, rough/smooth, random/orderly, saturated/pastel, static/kinetic, monumental/diminutive. Use primarily basic geometric and nonobjective shapes and lines. Strive for economy in the compositions.

Choose three to study in preliminary marker sketches. The format for the sketches is 4″ × 4″. Choose one of the sets of sketches to develop into a final compositional study. The final study is two 8″ × 8″ images presented together to illustrate the two contrasts. (Refer to the discussion of contrasts in this chapter.)

Materials Use a bristol board—two-ply or four-ply for the final images. Work with black-and-white designer gouache to paint the final boards with flat and round paint brushes. Mount the final studies on gray board with a 3-inch border. Present them together.

This assignment could also be done as a cut-paper assignment with black-and-white coverstock.

Objectives

Explore a variety of forms of contrast in the compositions.

Achieve visual unity by managing variety in two contrasting compositions.

Work with a design process that includes preliminary study of elements, composition, and application of materials.

Work with a process that involves the refinement of hand skills to draw and paint a design image.

Develop a visual vocabulary of lines and shapes from verbal content.

Work to achieve economy in the relationship and arrangement of elements.

Communicate a concept using nonobjective imagery.

Project Title Proportion Study with Line, Point, and Edge

Project Brief Create a composition using a golden rectangle and grid systems as an underlying system to convey visually a force of nature theme using line, point, and edge. Begin with a golden rectangle 11 inches on the shortest side. Subdivide the three main areas into smaller grid units using arithmetic, geometric, or triangular grids. Ink this proportional grid system on coverstock with a fine marker and use it as a template for a design. Work to create implied alignments with elements placed in the grid system. Choose a force of nature: wind, rain, snow, flood, and so on as a theme. Using layers of tracing paper over the grid system, begin generating design elements that illustrate the chosen theme using lines, points (dots), and edges (shapes). Edit and refine the drawn elements and produce a final precisely drawn tracing of your composition. Carefully transfer the design to illustration board and paint the final with black gouache. Do a color translation as an extension of the assignment.

Materials Tracing paper, black markers, compass, straight edge, pencil, 16" × 20" illustration board, designer gouache, fine round and flat brushes, graphite paper (for transfer).

Objectives

Work with external and internal proportions.

Use a grid to place design elements in a composition.

Explore a refining process of generating elements.

Work with repetition, scale changes, proximity, quantity, motif, and closure to produce a design composition.

Communicate a theme in an abstract composition using basic elements.

Project Title Letterform Study

Project Brief Produce a composition composed of nine smaller letterform compositions. Begin by generating 20 to 25, 3" × 3" black-and-white studies using a variety of single letterforms. Variety is the key—variety of typefaces, scale changes, figure-ground relationships, orientation, proximity in the small compositions. Cut the small studies carefully into a 3-inch square. Create a new, larger composition using 9 of the small studies arranged in a 9-unit grid, 3 studies across by 3 studies down. Work to create overall continuity (unity) and rhythm from one unit to the next.

Hint: Partially obscure the identity of the letterforms through cropping, rotating, or reversing them within the small compositions.

Materials Generate type from a computer or photocopy from printed sources. For the final, use clean, good-quality laser prints or photocopies. Use a studio knife and metal straight edge to cut small studies. Glue the 9 studies in a square grid arrangement on coverstock and mount to a piece of gray board with a 3-inch border.

Objectives

Make compositional decisions using letterforms as design elements.

Study type as shape.

Work with a variety of high-contrast visual relationships.

Manage a variety of figure-ground relationships in the same composition.

in review

1. What does the Gestalt phrase, "The whole is greater than the sum of the parts," mean?

2. Discuss two ways that format is used in graphic design.

3. What are the unique implications of horizontal, vertical, and square formats?

4. What are the advantages to using a grid in design compositions?

5. Discuss the various visual relationships that control eye movement.

6. What are the three general classifications of motif?

7. How does figure-ground reversal differ from figure-ground ambiguity?

8. What are the four functions of communication? Give an example of a design venue for each.

9. What is the distinction between a design objective and a communication objective?

notes

RESTYLE *Event*

| designing with color |

3

objectives

Explore the dimensions of color related to issues of visual communication.

Explain how color is perceived and processed by the eye and brain.

Identify key color systems and describe their relevance to graphic art.

Define color terminology using visual examples.

Present significant color theories that are useful in contemporary design.

Investigate color psychology, symbolism, and cultural influences as they affect our understanding and use of it.

Reveal strategies for choosing color schemes.

Discuss the impact of color in composition.

introduction

The role of color in visual communication is complex. It is undoubtedly the most researched, most visually powerful, and, since the advent of computers, the most technical of all the elements of design. It enhances the viewer's response on a variety of levels; it heightens our perception and intensifies emotional and psychological reaction. It is certain that to become proficient with color, you must spend time studying it and working with it.

In this chapter the fundamental dimensions of color related to science, theory, language and practice are examined. Crucial components of color, an exploration of color relationships, and ways of applying this knowledge to the practice of design will be presented.

DESIGNING WITH COLOR

COLOR SYSTEMS

Numerous color systems have been developed that attempt to order color so it can be more easily comprehended. Some of the systems are relatively simple and others are technical. Some systems, such as the color wheel, are theory based, explaining the phenomenon of color relationships or to order thinking about color. Other systems, such as Munsell's color solid, was designed based on human perception, as a standard for organizing color for industry.[1] His model and others influenced the 1931 Commission Internationale de l'Eclairage (International Commission of Illumination) in the development of a global color standard for science and industry. The result was the CIE chromaticity model, which is used to measure hue, value, and chroma. This model also serves as the basis for computer color. Other color systems function as tools for specifying color as ink formulas for the printing industry. We discuss these systems and others, but before we do it is important to understand how color is perceived at the source.

Color Perception

Chapter 2 discusses in simple, general terms how the eye and brain work together to make the world visible to us. The retina, the light-sensitive surface lining on the back of the eye, can be compared to film in a movie camera. Within the tissue of the retina are receptors referred to as rods and cones. Rods detect lightness and darkness, or tones, and cones detect color sensations, or hues (see Visual 3–1).

[1]See A. H. Munsell. *A Color Notation,* 12th ed. (New Windsor, NY: Munsell Color Co., 1975).

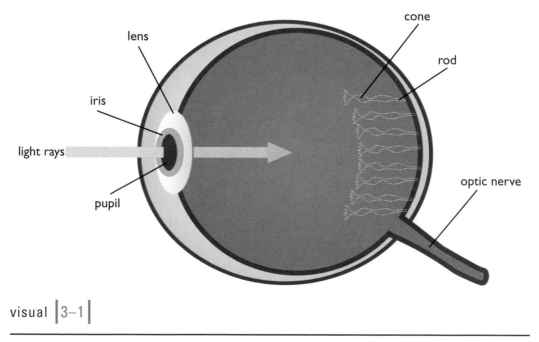

visual |3–1|

The eye sends visual information to the brain for processing via the optic nerve. Some of the features in this diagram are larger than actual scale to illustrate their appearance.

Rays of light illuminate objects in the world of vision and reflect them back into the eye. The eye functions like a lens, which perceives the light information that is then carried to the brain via the optic nerve. Hundreds of thousands of light messages are sent through the optic nerve at the same time. The brain processes these messages to provide us with an apparently seamless view of the world. It is remarkable that the color we perceive on objects is not tangible. That is, what we see is not actually color, but vibrating wavelengths that are emitted from the surface of every object. For example, a red ball is reflecting red wavelengths and absorbing all other wavelengths. In fact, the wavelengths being absorbed can be thought of as the perfect light complement to the color wavelength being reflected.

Wavelengths are a form of energy that makes up the visible spectrum. They are part of the electromagnetic field, which also produces microwaves, radio waves, infrared radiation, and X rays. Each color hue has its own wavelength. Wavelengths also determine a color's intensity, which is dependent on the amount of available light (see Visual 3–2). You can observe the intensity of a color diminish in an object by watching it during a sunset or by dimming artificial light.

Additive System

Having discussed how the human eye perceives light, it is appropriate now to introduce the additive color system, which is dependent on light (see Visual 3–3). The additive system makes all colors visible. It is the color system of white light. The light necessary to see color can come from the sun, a natural source, or from artificial sources such as incandescent, florescent, and halogen. It is important that artists and designers pay attention to the source of light in which they work. The different light sources can significantly change the effect of color in a design image.

ELECTROMAGNETIC FIELD

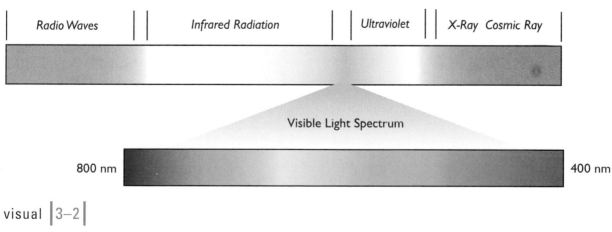

visual |3–2|

The visible light spectrum is a narrow band in the electromagnetic field.

visual |3–3|

The spectral blended color scheme used for this CD package is transparent, which heightens the effect of color light. The banded color mimics the visual effect experienced when visiting the Web site for the Pleats Please clothing line. *(Jewel case design by Sayuri Studio)*

Isaac Newton was perhaps the first person to study light. He performed an experiment in 1666 using a prism and a ray of light to discover what, in essence, is the additive color system. He discovered that white light is composed of a blend of red, green, and blue primary hues. Mixing any two of these will yield a secondary hue. Blue and green yield cyan, the complement of red. Blue and red yield magenta, the complement of green. Red and green yield yellow, the complement of blue. Therefore, the secondary hues in the additive system are cyan, magenta, and yellow (see Visual 3–4).

Many of the principles of the additive system, such as green and red mix to make yellow for example, run counter to our intuitive sense of how color works. That's because we first learn about color from grade school on, mixing paint and crayons, which is color pigment. Remember that the medium for the additive system is light. It is the system that forms the basis

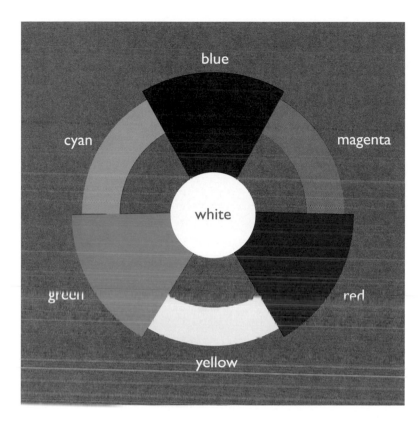

visual |3–4|

Mixing the three primary colors in the additive system yields white (white light). The colors seen here are not as vibrant or luminous as viewed on a computer monitor.

for color photography, film and video, computer imaging, and television. The principle behind all of these media is the projection of a fine blend of red, green, and blue light. Varying the amount of each primary hue projected yields a varying intensity, which re-creates the full spectrum of color in our eye. You can see this effect by looking closely at the edge of a TV screen (see Visual 3–5).

Subtractive System

The subtractive color system is based on mixing color pigments. As colors are mixed, they render a subtracting effect, which essentially filters the light striking its surface. When two colors are mixed, a new color is created because the mixing has changed its wavelength.

The additive and subtractive systems are interdependent. The secondary hues of the additive system are the primary hues of the subtractive system. Cyan (blue), magenta (red), and yellow are the subtractive primaries. In color printing, cyan, magenta, and yellow are referred to as process primary colors. As they are recombined on a printing press, with the addition of black to enhance value, they recreate the color we know in the visible, natural world.

In the world of mixing paint and other forms of pigment, the blue and red we consider as primary hues differ from the hues cyan and magenta. Cyan is lighter and leans more toward a blue-green than the primary blue we learned about in school. Magenta is lighter and more

Television screens and computer monitors display three separate patterns of red, green, and blue dots called pixels. They form a lattice of individual colors emitting points of light that creates a picture.

C 90
M 10
Y 0
K 0

C 0
M 50
Y 80
K 0

visual |3–6|

This blend from blue to orange illustrates the many colors that exist between the two hues. Because these hues cross the color wheel, the colors seen in the middle area approach neutral gray.

pink than the rich reds achieved in most pigments. Yellow is slightly lighter and brighter. Keep in mind that there are many hue shifts within each hue and between sets of hues (see Visual 3–6).

Traditional color wheels have been used for centuries to explain and illustrate subtractive color relationships. Johann Wolfgang von Goethe is responsible for developing the first color wheel using blue, red, and yellow as primary and purple, green, and orange as secondary hues (see Visual 3–7). Models such as Goethe's are valuable for understanding color relation-

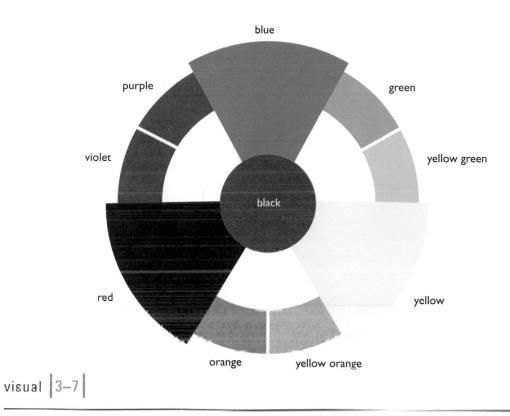

visual |3–7|

This color wheel identifies primary, secondary, and tertiary hues. The black is actually an equal mix of 50% cyan, magenta, and yellow.

ships. But the theory on which they are based does not always translate well into the practice of mixing color. In Goethe's model, for example, when blue, red, and yellow are mixed together it is supposed to yield black. But you know from experience that mixing the primaries makes a grayish-brown color.

The secondary hues of mixing pigments are purple, green, and orange. The purple, green, and orange you get depend on the parent hues used to mix them (see Visual 3–8).

Hues found between primary and secondary are called tertiary. Red-purple, yellow-orange, and blue-green are examples. In addition to tertiary colors, intermediate hues can be made by mixing secondary and tertiary hues to achieve theoretically all the colors in a spectrum. Any two primary hues and the colors between them are called analogous hues. All primary, secondary, tertiary, and intermediate hues are fully saturated pure color—they are pure in the sense that they contain no white, black, or gray.

visual |3–8|

Purple on the left and violet on the right are mixed from the same two parent colors—blue and red. Purple has slightly more blue and violet has slightly more red.

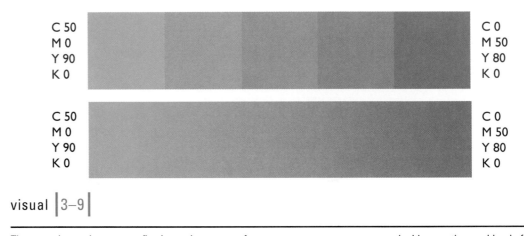

C 50
M 0
Y 90
K 0

C 0
M 50
Y 80
K 0

C 50
M 0
Y 90
K 0

C 0
M 50
Y 80
K 0

visual |3–9|

The top color study presents five intermittent steps from green to orange as compared with a continuous blend of the hues below.

Other models have been developed that use variation of color groupings as primary and secondary hues. Most of these models do a poor job of representing the full color range between any set of hues. They present a limited window of the many hues that exist between two colors. This is evident in Visual 3–8, which represents only nine of the limitless number of hues that exist between the primaries. Continuous blends, achieved electronically, better illustrate the range between any two colors (see Visual 3–9).

There are other aspects of the color wheel that limit our comprehension of color relationships. We learn for example, that the complements are blue and orange, purple and yellow, and red and green, and so they are. But many other hue relationships can be complementary. Turquoise, similar to cyan, and red-orange have a complementary relationship, so does yellow-orange and blue-purple and infinite opposite pairs found on a color wheel.

Color systems such as the color pyramid in Visual 3–10 have added black and white as primary colors.

Remember that simple color names such as blue or green are arbitrary when attempting to specify colors. What one person may have in mind when thinking of blue is likely different

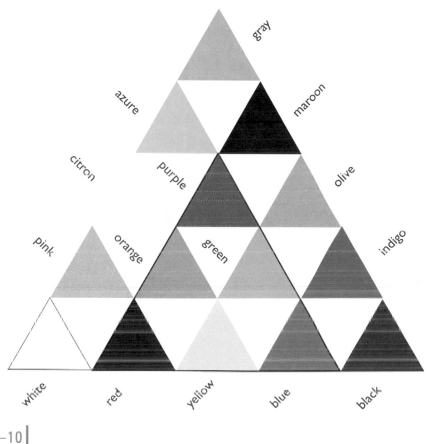

visual |3–10|

The result of this model yields color mixes with expanded color names that are more useful than the simple generic names most of us learned in grade school. Any two colors on the bottom row can be followed diagonally to the color swatch they make. The inner triangle contains the basic primary and secondary hues.

from another person's perception. That is why, in design, color is specified by precise systems or by comparing color swatches or pigment samples.

Specification Systems

Choosing the right color or color scheme is a process of narrowing a general idea of color to more precise color specifications. There are a variety of color specification systems that designers use from early ideation to final production. A designer may begin with an intuitive idea for a color scheme, for example, yellow ochre and blue, as a general concept. Early in the development of the design, markers or cut paper swatches may be used to visualize color for the design. But when it is time to prepare the design for electronic or print production, more accurate color specifications are necessary. Graphic design software offers a variety of color systems that are integrated with the printing industry and digital multimedia design. The electronic color systems can be cross-referenced to swatch books of printed color to ensure

color accuracy in print design. Let's examine the color specification systems individually, beginning with those used in the printing industry.

Printing is based on two types of color systems, CMYK and match systems. CMYK is cyan (blue), magenta, yellow, and black. (The K, which stands for *key,* is used for black which also distinguishes it from blue.) CMYK is more often referred to as process color, or four-color process. Digital or conventional reflective art is prepared by breaking down or separating it into each of these four colors. The separation process filters the cyan, magenta, yellow, and black one at a time. Then, each separation is converted to a dot pattern that is recorded onto metal plates. The four plates are then fastened to drums located at four separate stations on a four-color printing press. Sheets of paper are run through the press, receiving an impression of ink from the plate at each station. The four colors are printed on top of each other, recombined to reproduce the color in the original design. Four-color process is used when the original art is continuous or blended tones.

Match systems are used when the color is solid and isolated within shapes or backgrounds (see Visual 3–11). As the name suggests, desired color areas in the original design are

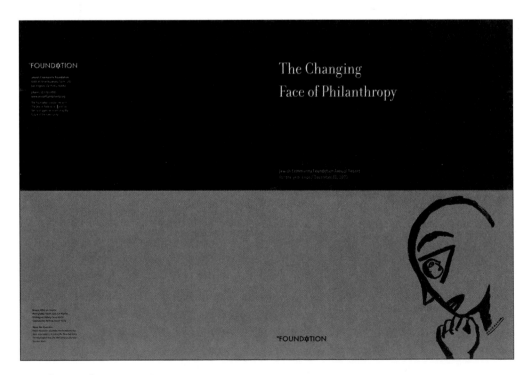

visual |3–11|

Two match colors, orange and black, constitute the printed color in this annual report design. The white type is the color of the paper. When one color is printed in the area of another, it is referred to as reversed out or knocked out. The black creates a sense of confinement to the lower half of the composition. *(Annual report design by KBDA)*

matched to an ink formula. These formulas are selected from a book that has a printed swatch accompanied by a number. The number is provided to a printer and the corresponding ink formula is used to print only those areas specified. The color numbering system that is the worldwide industry standard is the PANTONE MATCHING SYSTEM® (PMS)(see visual 3–12). Other systems include TRUMATCH®, TOYO®, and FOCOLTONE®. These and other similar systems work the same as PANTONE® (see Visual 3–13). These color systems are all generally available for specifying color in electronic media. You may be familiar with some of these systems if you have used graphic software.

Design and imagery that is created and produced digitally can be prepared in any of the systems mentioned previously. Most design software provides the CMYK system by default.

Colors often appear different on a computer monitor from when they are printed. That is because they differ in the way they are viewed. Colors can be specified and cross-referenced to a

visual |3–12|

Match color, also called a "special color" can be specified for area color fill in typography, graphic elements, and borders. Each swatch provides the color number (the *u* indicates uncoated paper) and the ink formula prepared by a printer.

visual |3–13|

These four violet-purple hues were specified from swatch libraries in Adobe® Illustrator.

WEB 255/204/0
WEB 255/255/0
WEB 102/204/153
WEB 102/51/204
WEB 204/51/102

visual |3-14|

The hexadecimal color system is intended specifically for Web design. The range of color choices seems limited but actually provides a decent palette. By limiting the palette, Web pages open more quickly. This system is set up in increments of 51 units each of RGB (red, green, blue).

printed swatch to ensure color integrity from digital to printed form. It is important to note that match colors are more vibrant than CMYK process color because there are limits to what the CMYK mixes can achieve. It is particularly evident in blues and purples, some deep reds, and, of course, florescent colors. But CMYK for the most part does a good job of re-creating a full color range. To clarify, CMYK and match systems are used in printing. Both systems are available in digital software and in printed swatch books for specifying color.

Color used for multimedia design or Web design requires the red, green, and blue (RGB) system. RGB is the primary hue system of light. Any media venue that relies on projected light such as photography, DVD, video games, computer and television monitors, and film depends on RGB. The RGB system is the default palette for most photo- and multimedia-based graphic software. Each hue—red, green, and blue—can be adjusted in 1-point increments of brightness from 0 to 255. Because there is not a translation of color from digital light to printed ink, what is seen on the screen is generally what you get. The variance occurs between the designer's monitor and the user's monitor or projection screens.

Designing for the Web has a specific color limitation. Web graphics are often designed on Mac systems and consumed on PC systems. For the color to be consistent from one platform to another, the hexadecimal system was developed. There are 216 common colors derived from the system that constitute the Web palette. Most Web software provides the colors from the hexadecimal system. RGB colors can be used and converted to this system (see Visual 3–14). RGB colors are brighter than CMYK colors—projected light is luminous, pigments are reflective. You can see the difference by converting color from RGB to CMYK in electronic design. Most software provides an option to convert color in a document from one color system to another and from color to gray scale.

THE LANGUAGE OF COLOR

The language of color has evolved from research in theory, technology, and the practice of design. Sometimes the terms speak about specific aspects of color, and sometimes color speaks its own language—with symbolic, cultural, and psychological meaning. This section will explore and define color terminology in words and in images by offering color analyses of professional design.

C 0
M 100
Y 100
K 5

C 0
M 10
Y 100
K 0

C 100
M 10
Y 0
K 0

visual |3–15|

Versions of the subtractive primary hues are accompanied by the CMYK percentages for each.

Color Terminology

Hue is the same as color. It is the inherent color referred to by a name or formula. It is valuable to be able to learn as many color names as possible. It is also practical to learn which CMYK percentages are used to build basic primary and secondary hues (see Visual 3–15).

Saturation refers to the purity of a color. Pure hues that are fully saturated are at their highest level of intensity (see Visual 3–16). Intensity roughly corresponds to the value of primary and secondary hues. The lighter hues, yellow and orange, are more intense than the darker hues, blue and purple. Red and green have similar values and fall in between. Adding black, white, or midtones contaminates a pure hue and affects the intensity level (see Visual 3–17). When black or gray is introduced, pure hues immediately lose their brilliance. The smallest amount of black mixed with yellow dulls the impact of yellow, changing it to a somber green. Black has a similar affect with each of the primary and secondary hues—it changes their color name, red to maroon, green to olive drab, blue to indigo, orange to sienna, and purple to puce. Gray is not as profound but has a similar effect making the hues murky. White has a lively affect on blue and purple as it brings them out of the dark value range.

Chroma is similar to saturation. Munsell describes chroma as the amount of colorant present in a pigment.[2] The more colorant, the more saturated the hue. There is a subtle distinction between

[2]Ibid.

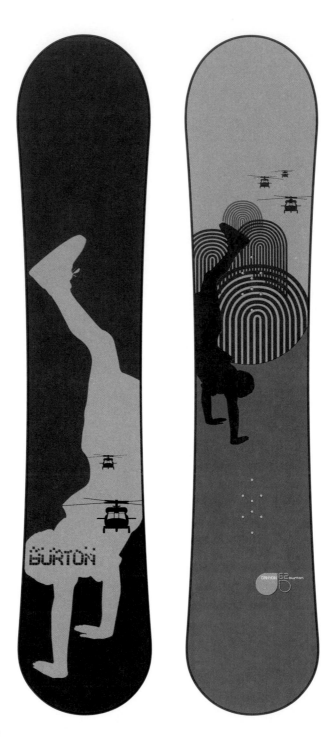

visual |3—16|

In these snowboard graphics, orange is the brightest of the colors. The figure in the board on the left is silhouetted by the red and blue background areas that are more saturated; that is, they contain more of their inherent hue but are not as bright. The somber green in the right board has lost a significant amount of saturation because of the presence of black in the color. *(Graphics by Jager Di Paola Kemp)*

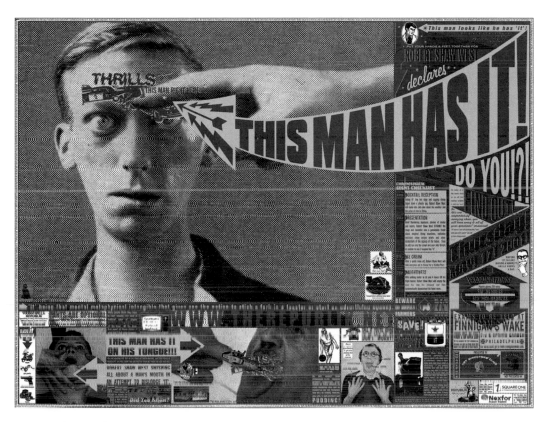

visual | 3–17 |

The photographic imagery in this design are practically colorless umber tones. They lend a retro look to the design and exist in stark contrast to the highly saturated red-orange colors in the type and border graphics. *(Self-promotion design by Brian Murry)*

saturation and chroma. The former is about dulling a pure hue by adding gray tones, and the latter is about the presence of hue in a pigment. The CMYK tool selector in graphics software illustrates the concept of chroma. The lower the percentage, the less the color presence, the higher the percentage, the higher the color presence. It's not really a matter of adding white at all.

Value is lightness or darkness. Value can exist without color in grays, black, and white, but it is also present in colors. Each hue has a value that can be compared with gray tones (see Visual 3–18a). Knowing the value of the basic hues can help in choosing a color scheme. The complements, for example, offer interesting value relationships. Red and green are very similar in value so they only contrast in their hue. Purple and yellow have the highest value contrast of any set of complements (see Visual 3–18b).

Tint is adding white to a pure hue. As most hues are tinted or lightened with white, they are also made brighter. White yields new color names when mixed with red, purple, yellow, and

visual |3–18a|

Every hue has a value. Here the primary and secondary hues are compared with their position on a 10-step gray scale.

visual |3–18b|

A checkerboard arrangement of four colors is translated to corresponding gray values.

visual |3–19|

The arrangement of cups glazed in tinted colors dominate this photo design. These tints are deeper in color than pastels, which produces an appetizing and festive color scheme. *(Exhibition catalog by Chronicle Books)*

blue. The results are pink, lavender, citron, and azure, respectively (see Visual 3–19). Orange and green are made brighter as more white is added to each, but they hold their color integrity. A high ratio of white added to the hues yields a category of colors referred to as pastels (see Visual 3–20).

Shade is the mix of black with a color. The term *shade* is often misused to describe hue. A shade of blue is a mix of blue and black, not a variation in its hue. Adding black to the hues yields dramatic color changes. In small amounts black has an insidious effect on yellow and orange. But in higher proportions black produces handsome, deep earth tones in these hues. Blue, green, and purple seem to be most compatible with black, holding their color identity as they are mixed (see Visual 3–21).

Tones are grays, also referred to as midtones. Achromatic gray is mixed from black and white and is the same as tone. Tones run the range from light to dark values in the gray scale. Grays deaden the brilliance of pure hues. Darker grays have a similar effect on hues as black and lighter grays have a similar effect on hues as white. Tones mixed with yellow produce rich, colorful earth browns that resemble ochre and umber. When tones are added to hues that match them in value, you can observe an absolute shift in saturation without a shift in value (see Visual 3–22).

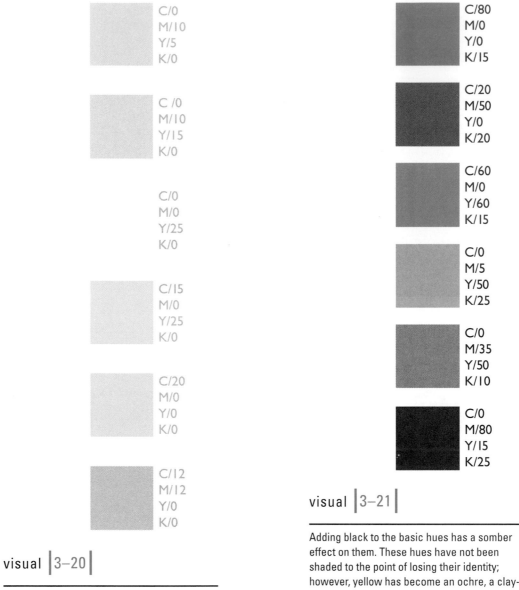

C/0
M/10
Y/5
K/0

C /0
M/10
Y/15
K/0

C/0
M/0
Y/25
K/0

C/15
M/0
Y/25
K/0

C/20
M/0
Y/0
K/0

C/12
M/12
Y/0
K/0

C/80
M/0
Y/0
K/15

C/20
M/50
Y/0
K/20

C/60
M/0
Y/60
K/15

C/0
M/5
Y/50
K/25

C/0
M/35
Y/50
K/10

C/0
M/80
Y/15
K/25

visual |3–20|

This arrangement of primary and secondary hues is tinted to pastels. CMYK percentages indicate the negligible quantities of actual color in each.

visual |3–21|

Adding black to the basic hues has a somber effect on them. These hues have not been shaded to the point of losing their identity; however, yellow has become an ochre, a clay-colored earth tone.

C 0
M 0
Y 0
K 32

C 0
M 35
Y 95
K 0

visual |3–22|

The orange and gray match in value demonstrating the effect of a mid tone as it blends into a pure hue.

visual |3–23|

This ad contrasts a monochromatic photo image with a subtle full-color element. The cold, blue tint enhances the feel of metal in the tool. *(Broadsheet promotional design by Design Guys)*

Monochromatic is a single color mixed with tints, shades, or tones. In printing, a monochromatic color scheme can be attained with a process called duotone, which is a gray scale and one hue. Monochromatic color schemes can effectively simulate the presence of other hues by virtue of the effect tints, shades, and tones have on individual colors (see Visual 3–23).

Color Theory and Application

Anyone serious about a career in the visual arts needs to invest some study time learning the theories and understanding their impact on practical application. Of all the color concepts, there are

two that profoundly and commonly affect the color decisions we make everyday. Knowing these two theories and their applications will help you to order and manage color decisions intellectually.

The first theory is that color can be examined in regard to a set of contrasts. In particular are the seven contrasts explored and defined by Johannes Itten.[3] The second theory advances the idea that the appearance of a color depends on the influence or interaction it has with other colors. This theory is thoroughly explored by Josef Albers.[4] I examine both theories and their application to design.

Much of what has already been presented about color in this chapter lays the groundwork for a discussion of Itten's seven contrasts: value, hue, saturation, complement, temperature, size, and simultaneous contrast.

Contrast of value is the most basic color relationship. Designers often work in black and white by necessity or aesthetic choice. Black-and-white imagery offers a high degree of contrast surpassed only by black and yellow, the color choice for many retail businesses and signs

[3]See J. Itten. *The Elements of Color* (New York: John Wiley & Sons, 1970).
[4]See J. Albers, *Interaction of Color* (New Haven, CT: Yale University Press, 1963).

visual | 3–24 |

The simplified and streamlined use of type and illustration has a high degree of legibility with a black and yellow color scheme. *(Poster design by Duffy Design)*

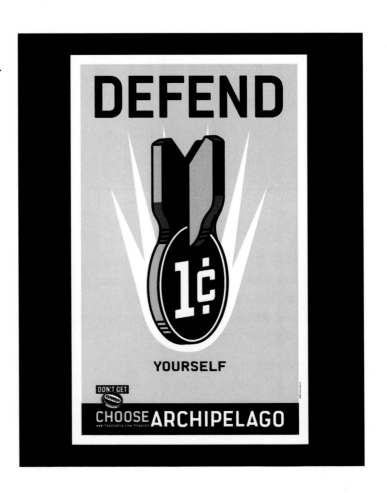

(see Visual 3–24). As has been discussed, each of the hues has a value. Some combinations of pure hues have little value contrast. For example, orange, green, and red are very similar, whereas purple, yellow, and green have a broader value range.

Contrast of hue is what distinguishes one color from another (see Visual 3–25). Often logos, advertisements, and brands need to function in black and white and in color. If a color image relies exclusively on contrast of hue it will be ineffective when translated to black and white.

Contrast of saturation is a juxtaposition of hues with varying purity. Adjusting the value of pure hues can only be done by adding white, black, or gray. To make purple lighter, you need to add white or light gray. In doing so, you lighten the color and weaken its saturation. Saturated colors tend to appear closer compared with weak colors, which recede. Using a color scheme of saturated to weaker hues creates depth through the effect of atmospheric perspective (see Visual 3–26).

A complementary contrast is based on any two hues directly opposed on the color wheel. In some ways, true complements can only exist in theory, especially where pigments are concerned.

visual |3–25|

The immediate response to this illustrated design is the bold use of color. The bold energy is achieved by using a variety of saturated, contrasting hues. The playful quality of the illustration is supported by the variety of colors. *(Phone card design by Metzler & Associates)*

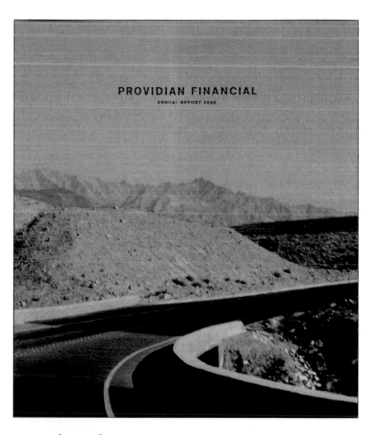

visual |3–26|

Landscape photographs are good examples of aerial perspective. Colors weaken as they recede into space, losing their contrast to surrounding shapes. *(Annual report cover design by Cahan & Associates)*

The requirements for a true, perfect complement is that when mixed, they produce an absolute neutral (see Visual 3–27).

A complement is composed of a precise mix of two primaries and the opposing secondary, for example, green (yellow and blue) and red. Complementary contrast is the simplest relationship for the basis of a color scheme. The relationship is curious because complements are vivid opposites that, when placed adjacent one another, bring out the full potential of each (see Visual 3–28).

Contrast of temperature is the relative warm-cold relationship between hues. Color temperature is psychologically linked to conditions in nature—the hot yellow-orange of the sun, the cool green grass, the cold blue sky, or the warm reds and oranges of autumn leaves. It is gener-

C 90 C 0
M 45 M 10
Y 0 Y 80
K 0 K 0

visual |3–27|

A complementary blend of blue-purple and yellow illustrates the difficulty in achieving a true complementary relationship in pigments. The (chromatic gray) area in the center of the blend is influenced by the parent colors, making it difficult to identify an absolute neutral.

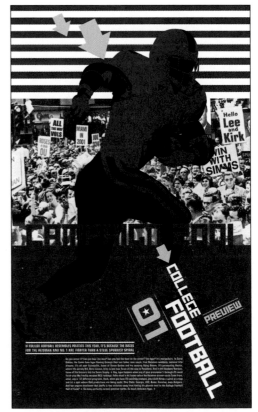

visual |3–28|

Complements such as this orange-red/blue purple color scheme produce a high-contrast energy that is fitting for the subject. *(Magazine spread design by Barbara Reyes and Peter Yates; illustration by Phil Mucci)*

ally accepted that red, orange, and yellow are warm colors and blue, green, and purple are cool colors. The warm colors advance and cool colors recede, again taking their cues from nature.

Within any hue range of analogous colors, a relative shift between warm and cool can be observed (see Visual 3–29). It is worth noting now that most color pairs contain aspects of more than one contrast effect.

Blue and orange are complements. They differ in value and present a warm-cool contrast. If you want to limit the coexistence of contrasts, adjust colors with regard to their complementary nature, value, or temperature (see Visual 3–30).

C 10 C 0
M 80 M 50
Y 0 Y 95
K 0 K 0

visual |3 29|

All of the colors in this study are considered warm. But when the parent colors are compared, a relative shift in temperature can be seen. The magenta-red is relatively cooler than the orange.

visual |3–30|

The blue-orange color scheme is both complementary and contrasting in temperature. *(Catalog design by Herman Miller Inc.)*

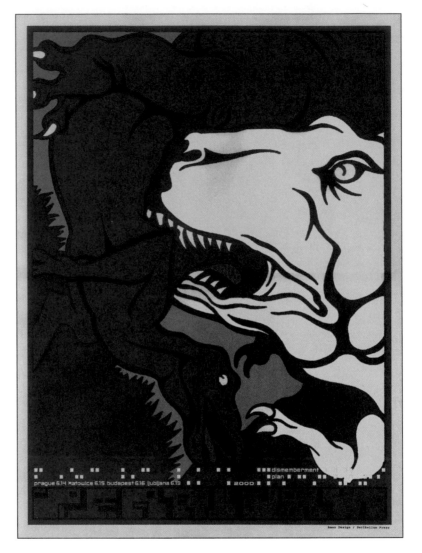

visual |3–31|

The green area of color reinforces the scale of the dinosaur in the foreground helping it to dominate the composition. *(Poster design by Ames Design)*

Contrast of extension is the comparison of quantities of color. It is a judgment of how much of one color to another is needed to achieve harmony or balance. In the contrast in Visual 3–31, the design mantra coined by Meis van der Rohe, "less is more," can be vividly observed. Often the impact and intensity of smaller color elements can be more profound than larger elements.

Certain color combinations can cause color vibrations because of a combination of their size and value. The visual effect causes certain colors to expand beyond their edges (see Visual 3–32). Other color relationships can cause hues to remain contained within their edges, for example, a black square in a yellow color field.

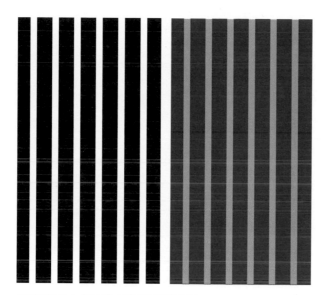

visual |3–32|

In this figure the black and red stripes are physically equal in size and the white and green stripes are also physically equal. Yet the black appears wider than the red, and the white appears wider than the green. This optical effect is due to the nature of the color relationships. The red/green study shows a relationship in which the edges dissolve because the colors are complements that have a similar value. Black always stays contained within its edges and white tends to expand optically outside its edges.

Simultaneous contrast is perhaps the most subtle and subjective of the seven contrasts. It is no doubt because the phenomenon is dependent literally on the "eye of the beholder." The eye is ever searching for color harmony through color complements. When a complement is not present, the eye attempts to provide one. This occurs as an optical illusion but it affects the way we process color. There are numerous figures that effectively illustrate this phenomenon. It can be experienced by staring at a color that "burns" it onto the retina of the eye. Looking away at a neutral or white space produces the sensations of the opposing complement (see Visual 3–33). Simultaneous contrast also occurs in color relationships in which the interaction of colors affects how we perceive them (see Visual 3–34).

No color can exist in nature or visual art in a vacuum. As just discussed, gazing at a single color field or a deep blue sky finds the eye compulsively searching for complementary resolution. Effective color decisions in design are critically dependent on managing color interaction. No one has advanced our understanding of color influences and optical deception more than Albers.[5] His work is actually an illustrated application of the seven contrasts as they interact, producing remarkable effects.

Albers conducted most of his investigations using painted color and screen prints. Geometric figures and shapes are arranged in studies that function as basic design compositions. They lend themselves naturally to electronic media. The studies can be easily replicated and worked

[5]Ibid.

visual |3–33|

Stare at the center of the illustration for 30 seconds. Move your eye over to the dot to the right and blink quickly. You should see the black and white reversed and flashes of cyan in the red areas. *(Card announcement design by Kathleen Burch and Michael Bortolos)*

visual |3–34|

Notice the significant change in the green circle as it is influenced by the four different-colored squares.

visual |3–35|

This study is in the manner of Josef Albers, illustrating the effect of color interaction making two colors appear as the same.

using digital color. The premise for the studies is that color creates a context, and controlling the color environment affects the perception of the color. To make green look greener, place it in a red color field. To make a color appear darker, place it in a lighter context.

The essence of the color interactions demonstrates how one color can change its complexion appearing as two, or how two colors can be independently influenced to appear as the same, or how color identity can be affected by surrounding colors (see Visual 3–35).

The ability to achieve the effect depends on the color choices and the size or the amount of color undergoing change. At some point, as the size area of a color increases, it will exert its identity over the influence of its surroundings (see Visual 3–36).

visual |3–36|

The complexion of the yellow in this design is profoundly different as it is independently influenced by white and red. *(Book jacket design by Jennifer Norton, Jerry King Musser)*

Applying the knowledge found in color contrasts and color interaction can enhance figure-ground relationships, make type more legible, create harmony and balance, and enhance visual depth in design compositions (see Visual 3–37).

Color Psychology

Psychology plays an essential role in deciphering the meaning of color in visual communication. Color psychology involves the affective nature of color—how color makes us feel, and this is a powerful dimension of color in all the visual arts. Color psychology encompasses symbolic and cultural associations that also affect how we feel about certain colors (see Visual 3–38). Color has been associated with the sounds of musical instruments, the energy centers of the body, basic shapes, musical notes and basic emotional responses. It is certain that color is more emotional and subjective than intellectual and objective. In fact,

visual |3–37|

The visual hierarchy and communication in this poster are enhanced by the color scheme. It contains some classic color devices such as warm colors advancing and cool colors receding. It uses a complementary palette and strives for high legibility in the type using effective color contrast. *(Poster design by Sayles Graphic Design)*

visual |3–38|

The vibrant color scheme in this CD design communicates the same message in color and words. *(CD designs by Stoltze Design)*

the standard color wheel was developed more from views of human perception and psychological response to color than any scientific theory.

The trick is to learn how to use color psychology as a determinant in making effective color decisions. Each of the basic colors embodies a distinctive set of associations that can be translated into words. Knowing these associations will inform your color choices. Let's examine some of the basic hues with regard to their universal meanings.

Purple is royal, sophisticated, cultivated, and, because of its deep value, has an enigmatic quality (see Visual 3–39). It is associated with valor as in the Purple Heart. It is a hue that is associated with distinctive aromas derived from fruits such as plums, grapes, and berries. Purple can have ominous qualities especially when mixed with gray or black.

Blue is expansive, serene, and reliable, as in "true blue." It is used extensively in business as a color for banks and brokerage firms. IBM's nickname in the financial world, for example, is "Big Blue." The sky and water are its most familiar associations. Psychologically speaking, when a person is blue, they are sad, lonely, or depressed (see Visual 3–40). In most surveys blue is the top pick for favorite color.

Green is growth, nature, and life giving. Forests, fields, and farms are dominated by green. On the other hand, it also is the color of money as in "greenback." It has been studied as the easiest of all colors to live with, especially as a shade or

THE DESIGNER AT WORK

jerry kathman

You're on a learning journey that will never end. Learn to love the ride. Commitment to learning and personal development is the only thing that will give you the career you're looking for.
—Jerry Kathman

Jerry Kathman is president and chief executive officer of Cincinnati-based Libby Perszyk Kathman (LPK). Recognized as one of the nation's largest independent design firms or consultancies dedicated to brand identity and package design, LPK initially built its business on local clientele, including corporate giant Procter & Gamble. The company's long-standing relationship with Procter & Gamble includes ongoing and recent work for megabrands Olay, Pringles, Pantene, and Pampers.

During the 1990s, the company expanded into developing and managing brand identities on a global basis. It now serves other Fortune 500 companies and includes among its clients well-

known brands such as IBM, Microsoft, Valvoline, and Heinz. Expanding into these markets resulted in rapid growth for the firm. LPK now employs a staff of 200 that includes graphic designers, copywriters, production specialists, industrial and product designers, and brand and marketing specialists, as well as accounting, finance, and administrative personnel.

Shortly after receiving his bachelor of fine arts degree in graphic design from the University of Cincinnati in 1976, Kathman joined what was then called Cato-Johnson, a Young & Rubicam company. Kathman and four other partners purchased Cato-Johnson from Young & Rubicam in 1983 to form LPK. His managerial and team-building skills quickly led Kathman to a point where he was managing important client relationships and forming creative teams within LPK.

As president and CEO, he's challenged now with the task of running the company. In addition to assuring there's enough revenue to support the firm and talent on hand to satisfy client needs, Kathman has other responsibilities and concerns. "I have to anticipate what the client will want," he states. "I also need to make sure that this is a nuturing and supportive environment where ideas thrive and designers want to work."

LPK partnered with Hallmark to create a brand identity that reinforces the greeting card company's reputation for delivering emotional messages to consumers. A component of its brand strategy is imagery that stresses loving connections.

In creating a brand identity for Pantene haircare products, LPK developed a logo, packaging, and imagery that have helped to position Pantene as the world's number one haircare brand.

visual | 3–39 |

(Poster design by Design Ranch)

visual |3–40|

(Poster design by Mires Design)

visual |3–41|

(Publication design by Aufuldish & Warinner}

a tint. When it leans toward blue, it becomes aqua, the color of the sea in tropical environments (see Visual 3–41).

Yellow is sunlight, citrus, and energy. It is often associated with gold and subsequently wealth. It suggests intelligence and reason. As we mentioned earlier, yellow and black are the highest color contrast combination. Yellow can be acidic in its pure form but appealing with the addition of a

visual |3–42|

(Poster design by Art Chantry)

small amount of red. It is a fragile color. Small amounts of any other hue, black or gray, have a significant effect on yellow (see Visual 3–42).

Orange is active, appetizing, and hot. It is made from two warm colors that make it a transitional color associated with sunsets and autumn leaves. It has a diverse association with smells that comes mostly from sweet, tangy, and hot foods. Many exotic foods are orange, such as mangoes, melons, papaya, seafood, peppers, and yams (see Visual 3–43).

visual | 3–43 |

(Product/package design by Turner Duckworth)

Red is festive, exuberant, and romantic, and it is associated with danger, blood, and imagination. Although it covers a range of seemingly contrasting associations (festive and danger), all of its suggestive qualities can be described with the word *passion*. It is used extensively in packaging and advertising because it brings unrestrained attention to itself (see Visual 3–44).

visual |3–44|

(Poster design by Luba Lukova Studio)

richard palatini

Richard Palatini is Senior vice president and associate creative director at Gianettino Meredith Advertising. Rich is also an instructor of Visual Communication at Kean University in New Jersey.

People are affected and influenced by color in many obvious and not-so-obvious ways. We use color to describe feelings: "I'm in a blue mood, "She's green with envy," and "He's got me seeing red." It's used to identify everything from military organizations (navy blue), to businesses (IBM, "Big Blue"), to life stages (baby blue). Beyond words and images, color communicates instantly and powerfully. A world without color would be a world without emotion.

THE "LIFE" OF COLORS

People develop feelings about color that change and evolve as they reach different life stages and they also relate to color in different ways during each stage. For example, red and blue are colors to which young children are most responsive. Adolescents are drawn to colors that are most outrageous, intense, and used in unusual ways (think green catsup!). The same red that children are drawn to is the color that adults perceive as danger.

THE WIDE WORLD OF COLORS

When considering use of a color, we also need to understand how well it "travels." And, more specifically, how does a specific culture perceive a color or color combination? Historically, white has been associated with mourning by the Chinese, yet, in America, white is the color of wedding gowns. Because each culture has its own color symbolism, perceptive designers I know will often research countries and regions of the world to more fully understand what specific colors represent to them.

Be aware that in today's mobile global society, people will bring their color "baggage" with them on their travels. Still, individuals can also seek to assimilate into their new societal environment by emulating the new colors they find there. It's most important to consider all these factors when making color decisions that have "international travel" on their itinerary.

COLOR WITH FEELING

Think of the emotional response you want to elicit from your audience. Is it serene, sensual, exciting, powerful? Whatever it is, there are colors and color combinations for each and every one. Using light to mid tones of greens, lavenders or blues and in combination will communicate that peaceful, serene feeling. Dense purples, deep reds and intense pinks are sensually provocative. Combining them with black will only increase the sensation. And, while black is THE power color, combining it with another hue can be even more powerful, such as black with a regal purple or royal blue. Many colors can bring feelings of excitement, but these should be warm and vivid. If your audience is young, consider vibrant warms and cools from every color family especially in combination.

CRIMES OF COLOR

Sometimes, breaking the laws of color can be the right thing to do. In creating a distinct identity it's better to be different than to use the right symbolic color. Car rental companies are a perfect example of this. Hertz's color is yellow, Avis is red, and National is green. Each has created it's own distinct, yet appropriate color personality. Remember, it's OK to be different but it must be with a clear purpose in mind.

Color can be the most direct and memorable way of making your communication, whatever it may be, effective and successful. Consider your audience, their emotions, and culture and life stage. Understand how colors communicate your message best, and when necessary, break the rules.

DESIGNING WITH COLOR

Because color appeals so strongly to our emotions, we tend to choose colors based on preference. In design, colors must be selected for their ability to enhance communication and composition (see Visual 3–45). Relying on an understanding of how color is perceived, color systems, color terms, theory, and psychology provides a basis for exploring options for application. Researching color from an informed stance results in a sound rationale for your color choices.

Establishing a Palette

To establish a palette or color scheme, you must establish the theme and content of the design. Color may be limited by budget or aesthetic concerns depending on whether you use process color or match color.

Color must support the communication message. Determine what needs to be said and support it with an appropriate palette. Content determines color. Often, designers must use supplied photographs or illustrations. Colors found within these subjects can enhance and unify other design elements such as type and other graphic elements.

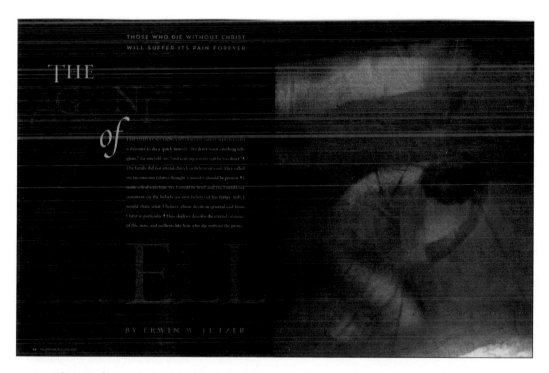

visual |3–45|

Bright, warm colors are enhanced in a black background. The color of the type reflects the color of the image. Both are communicating the same message. *(Magazine spread design by Tyler Darden)*

If you are building a color scheme from scratch, work with a color triad. Triads should be built from two related colors such as yellow and orange, and one contrasting color, such as blue (see Visual 3–46). As you explore your palette, adjust the contrast of the original colors using Itten's seven color contrasts as a guide.

Accents can be added to the triad depending on the nature of the design, but avoid having too many colors competing for identity in the design. Establish a hierarchy for color with regard to quantity and quality of its use (see Visual 3–47).

visual | 3–47 |

This simple color scheme exemplifies the effective use of a color hierarchy. The color of typographic elements echoes the color of bands in the background. A thoughtful juxtaposition of colors found in the top and bottom create strong unity and communication. *(Poster design art direction by Stewart Pack)*

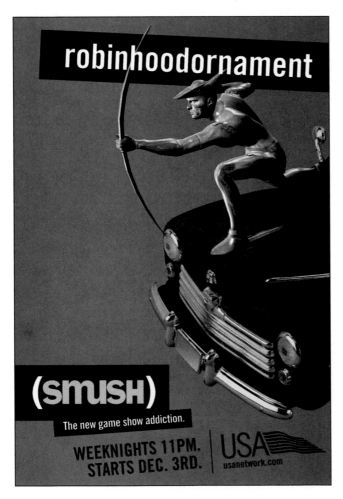

visual | 3–46 |

The color triad of yellow, orange, and blue heightens the clean use of imagery and type. *(Poster design by Bird Design)*

Color and Composition

Most design can function in black and white. Black and white can be the right aesthetic choice in some cases. The majority of design images, however, are produced in full color. Color intensifies and embellishes shape, line, texture, and type in a composition, and color can enhance depth and help direct eye movement through a composition (see Visual 3–48). It is used to classify, identify and code, helping to distinguish one thing from another (see Visual 3–49). Color also creates variety, supports balance, and establishes pattern, unifying all of the design elements as in Visual 3–50.

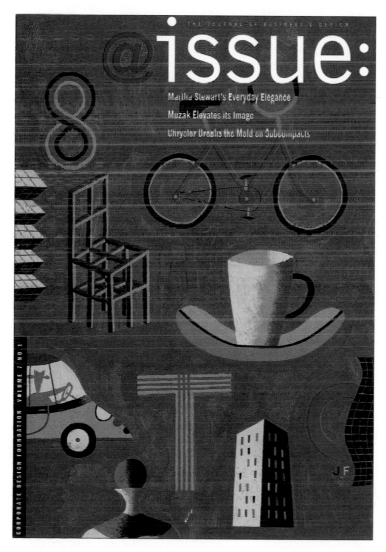

visual |3–48|

The playful use of shapes and content is embellished by the curious color scheme, dominated by deep earth tones and magenta hues. *(Cover design by Pentagram)*

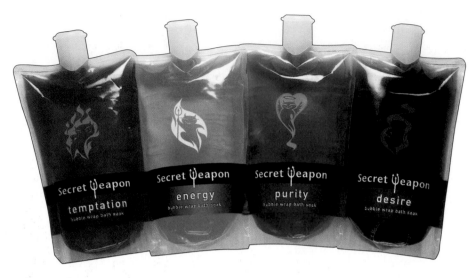

visual |3–49|

The color of the product is visible through the transparent package and differentiates varieties of a line of bath soap. The word concepts for each variety correspond to a color association code. *(Package design by Turner Duckworth)*

visual |3–50|

In this 24-compact disc set, a recurring circle motif and bold, cropped type and imagery are supported by a rich color scheme of red, orange, black, white, and off-white. Color and graphic continuity have an equal hand in unifying the series. *(CD design by Red Herring Design)*

> ## Color Tips
>
> - Chromatic gray is a gray or neutral color achieved by mixing complements. You can determine the integrity of the parent color complements by seeing if, when mixed, they make a neutral gray or if the mix is a muddy, brownish color. Often to achieve a neutral gray, the parent colors need to be modified with magenta or cyan pigments.
> - In some cases a fully saturated complement is too strong for a design. You can dull complementary hues by adding black or gray to achieve a more subtle, somber color scheme. Adjusting the hues in such a way is often necessary to strike an appropriate color balance.
> - Consider using imperfect complements such as a green and purple, an orange earth tone with a violet, or a maroon with olive green as the basis for a color scheme.
> - When mixing tints and shades, begin by adding the black or white in small amounts to the color. You will conserve paint and gain better control in achieving an accurate color mix.
> - Choose whole percentages of CMYK when working with graphic software. They're easier to remember and tenths and one hundredths of a percent don't translate in print production

SUMMARY

There is much to learn about color. This chapter serves as an orientation to essential building blocks for continued study of color and its use. Although most of the information presented here is basic, it is the same information that experienced artists and designers use in their work. The accumulated knowledge of color systems, terminology, and theories changes very slowly. In fact, nothing significant has been added to the study of color in this regard for several decades. What does continue to change is our attitudes about color as influenced by our culture and changing technology.

You have learned that color is the visual element that profoundly appeals to human emotion. But personal feelings must be tempered with good research when choosing color in design. The use of color in the images presented in this chapter appeals to us on an emotional level but it does so by design. The color choices are carefully determined to support or enhance content, composition, and communication.

projects

Project Title Color and Season

Project Brief Design a color collage composition for one of the four seasons. Research the season and select a color scheme of a triad and one accent color. The design consists of graphic elements that depict the season and the word name of the season.

The name can be incorporated with other graphic elements to create the essence of the chosen seasonal theme in the abstract design. Work with scale changes, economy, and directional changes to enhance the composition. Establish a visual hierarchy and use color to create depth.

Materials Select the color from sheets of high-quality color aid. Use the computer or any printed source for the type, but trace and transfer it to the color paper to be cut and incorporated into the collage. Cut or tear the paper for the appropriate visual effect. The final size is 11″ × 14″. Mount the design on a black board with 3-inch borders.

Objectives

Work thematically with a color scheme.

Explore different triadic color schemes that communicate a theme.

Work with a palette that offers a variety of color contrasts.

Arrive at a color scheme through a process of researching the subject.

Project Title Ugly Colors, Splendid Colors

Project Brief Design two identical cut paper compositions, with exception to the color schemes. For one, use a palette of ugly colors, and the other, a palette of splendid colors. Choose four colors from color aid for each work. The design can be abstract or representational, as able you are to represent an image in cut paper. Keep it fairly simple as you only have four colors to work with.

Materials Color aid paper, adhesive

Work on a 6" × 9" image area, vertical or horizontal. Mount on black board with a 3-inch border.

Objectives

Manage a color scheme that is subjectively influenced.

Engage in a discussion about color preference in design.

Explore the impact of extension of color area in composition.

in review

1. Colored light is the basis for what color system?

2. In what way are the additive and subtractive color systems interdependent?

3. What two terms describe the hues found between the primary and secondary colors?

4. What is the name of the industry standard for specifying match color?

5. What is the distinction between chroma and saturation?

6. What are the two color theories that have profoundly affected our understanding and use of color in design?

7. Discuss the effects associated with contrast of extension and simultaneous contrast.

8. Define what a color triad is, and discuss how it is used in design to devise a color scheme.

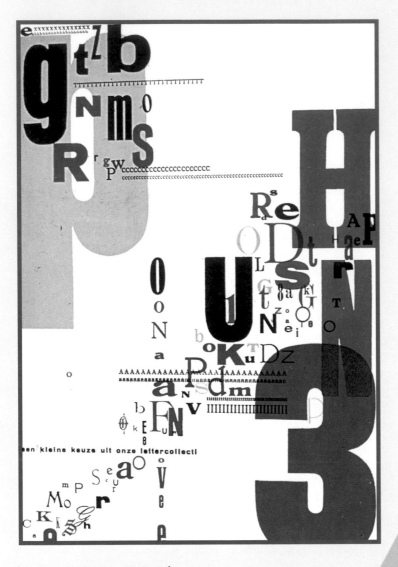

| typography in design |

objectives

Understand typographic terms and measurement systems.

Learn how to select typefaces appropriate to a project's design and communication goals.

Explore ways that type can lend expression to a design.

Examine harmonious combinations of type with imagery and other design elements.

Learn how to use type judiciously when legibility is a factor.

introduction

We are surrounded by type. Everyday we encounter it on billboards, in newspapers and magazines, on the Web, and in our mailboxes. Although type allows us to communicate complicated messages to other people, it doesn't ensure that the intended audience will notice, read, or respond to the content. In fact, when you think about it, relatively few of the printed word messages we are bombarded with on a daily basis hit their mark and make a memorable impression. To a large extent, our perception and comprehension of the printed word is influenced by how it is presented. Designers who know how to use type effectively use it to enhance text—to engage an audience and create visual appeal while communicating the intended message in a clear and compelling manner.

Using type effectively requires an understanding of its communication and visual possibilities. In Chapters 1 and 2 I introduced some of these aspects by discussing how type can function as much more than just a means of communicating content. Type can work to satisfy several design objectives at once, serving as text to read and a means of adding expression to a message while simultaneously functioning as a composition element.

Some features of working with type that were addressed in Chapters 1 and 2 included how styling type or handling it in a certain way can enhance the meaning of a word or phrase. I also showed how type can work as a design element by presenting examples that demonstrate how typographic forms can function as shape, line, or texture. In this chapter I discuss these aspects in more detail by examining additional examples and other ways where type works to support content and composition.

Because a knowledge of basic typographic terms and measurements is essential to understanding and working with type, this chapter also introduces the basic terminology and the rules that govern how designers work with type.

TYPOGRAPHIC CONVENTIONS

Type is measured and described in a language that's unique to the world of the printed word. In fact, many of the typographic terms and conventions in use today have their roots in the days of Gutenberg when type was set in metal. Because designers, graphic arts professionals, and the equipment and computer programs they use make use of this unique terminology and measurement system, it's important to understand their meaning.

To start with, typographic nomenclature can be divided into two categories:

• Terms that identify type and typographic forms
• Terms associated with sizing and adjusting type

Terms That Identify Type and Typographic Forms

Typeface—The design of a single set of letterforms, numerals, and punctuation marks unified by consistent visual properties. Typeface designs are identified by name, such as Helvetica or Garamond.

Type style—Modifications in a typeface that create design variety while maintaining the visual character of the typeface. These include variations in weight (light, medium, or bold), width (condensed or extended) or angle (italic or slanted vs. roman or upright).

Type family—A range of style variations based on a single typeface design (see Visual 4–1).

Type font—A complete set of letterforms (uppercase and lowercase), numerals, and punctuation marks in a particular typeface that allows for typesetting by keystroke on a computer or other means of typographic composition.

Letterform—The particular style and form of each individual letter in an alphabet.

Character—Individual letterforms, numerals, punctuation marks, or other units that are part of a font.

Lowercase—Smaller letters, as opposed to capital letters, of a type font. (a, b, c, etc.).

Uppercase—The capital or larger letters of a type font (A, B, C, etc.) (see Visual 4–2).

Helvetica Medium

Helvetica Bold

Helvetica Bold Italic

Helvetica Narrow

Helvetica Extended

Figure |4–1|

In a type family such as Helvetica, style variations based on the design include (from top to bottom) medium, bold, bold italic, narrow, and extended versions.

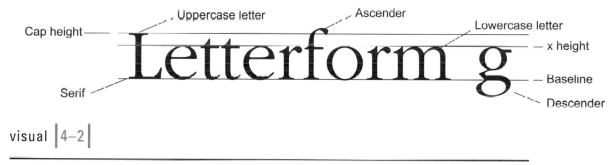

visual |4–2|

Terms associated with letterforms include *uppercase* (which describes capital letters) and *lowercase* (used to describe small letters). The height of a typeface's lowercase letters is called its *x-height*. *Ascender* refers to the parts of a lowercase letterform that ascend the typeface's x-height, and *descender* refers to the parts of a letter that fall below the baseline.

Terms Associated with Sizing and Adjusting Type

Point size—A unit for measuring the height of type and vertical distance between lines of type.

Line length—Horizontal length of a line of type, traditionally measured in picas but also in inches.

Leading—The amount of space between lines of type, measured in points. The term is derived from metal type where strips of lead were inserted between lines of type (Alternative terms: line spacing, interline spacing). (see Visual 4–3).

Letterspacing—The distance between characters in a word or number and between words and punctuation in a line of type (see Visual 4–4).

Type size: 21 points
Leading: 24 points

Type can be timeless or trendy.
It can express a mood or an attitude.
It can function as shape or line in a
composition, or as pattern or texture.

Line length: 28 picas

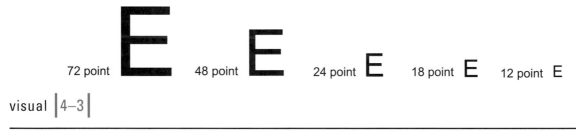

72 point E 48 point E 24 point E 18 point E 12 point E

visual |4–3|

Points are used to measure the height of type and leading, the vertical distance between lines of type. The horizontal length of a line of type is measured in picas or inches.

LETTER SPACING

LETTER SPACING

visual |4–4|

Letterspacing refers to the distance between characters and words in a line of type.

Typeface Design

In addition to graphic designers, there are designers who specialize in type design. These typeface designers (also called typographers) design the typefaces we see all around us that are manufactured as fonts and installed on computers. These fonts allow designers to set and style type as they desire.

Although many of the more traditional typefaces we use today have been in use for more than a hundred years, others are fairly recent. Typefaces generally reflect the aesthetics of the era in which they were produced. In fact, many of the typefaces that have been designed and manufactured in recent years reflect the visual trends of our times (see Visual 4–5).

Avant Garde

Suburban

Modula

visual | 4–5 |

Contemporary typefaces include (from top to bottom) Avant Garde, which was designed by Herb Lubalin in the 1970s, and typefaces designed more recently, such as Modula *(designed by Suzanna Licko of Emigra)* and Suburban *(designed by T-26).*

Secrets of Kerning

The letterspacing that occurs between letterforms in most fonts is usually adequate for small type. However, it often appears uneven in headlines or other large-type applications. Seasoned designers know that it's their responsibility to manually adjust or *kern* the letterspacing in these instances. This can be especially important in situations where certain letters come together, such as adjusting the space between the A and Y and the P and L in the example shown in Visual 4–6. After making these adjustments, the letterspacing between the two words appears to be more balanced.

TYPE PLAY

Before

TYPE PLAY

After

visual | 4–6 |

LEGIBILITY VERSUS EXPRESSION

You've probably noticed that typefaces come in a broad range of styles. Some are easy to read, whereas others present a challenge. Glancing at a newspaper will likely reveal examples of both. Because it's important to get time-sensitive, newsworthy information to readers as quickly as possible, most newspapers use typefaces that are bold, clear, and highly legible for articles and headlines. However, a newspaper's masthead or logotype may be set in a typeface that's not quite as easy to read. When it comes to presenting a newspaper's name, sometimes it's more important for that typeface to project an attitude or image that readers will associate with the newspaper. When making an impression is important, legibility is often sacrificed for the sake of expression (see Visual 4–7a and Visual 4–7b).

Another factor designers take into consideration when weighing legibility versus expression is the length of the text. In the case of a company or product name, legibility isn't such an important factor because reading a few words at a glance is far less taxing to the eye than reading long passages of text.

(a)

Choice of typography, the layout and organization of information, the paper stock, etc., all contribute to my impression of you as a designer and your design capabilities.

(b)

visual | 4–7a and b |

(a) *The New York Times* is a good example of a newspaper that makes use of a simple, easy-to-read typeface for its headlines and fine print. (b) The calligraphic look of *The New York Times* logotype projects a sense of tradition and stability—attributes that are important to the credibility of a newspaper. However, this typography is too decorative to be used as a text typeface. Its lack of legibility becomes apparent when several lines of text are set in Old English, a typeface with a similar look.

In addition to selecting a legible typeface, other considerations guide designers in sizing and styling type so that it's easy to read (see Visual 4–8, Visual 4–9, and Visual 4–10).

IT MAY SEEM AS THOUGH ALL UPPERCASE
OR CAPITAL LETTERS WOULD BE LIKELY
TO CATCH A READER'S ATTENTION, BUT ITS
LACK OF LEGIBILITY IS MORE LIKELY TO ALIENATE
THAN ATTRACT READERS.

It may seem as though all uppercase
or capital letters would be likely
to catch a reader's attention, but its
lack of legibility is more likely to alienate
than attract readers.

visual |4–8|

You can see how much easier it is to read this text sample when it's set in upper- and lowercase. That's because the eye reads words at a glance more easily when upper- and lowercase letters are used. An all-caps treatment is best reserved for short passages of text.

This Can Work for Short Lines of Text

But excessive letterspacing can
cause problems in long passages
of text where word groupings
become harder to separate from
surrounding space.

visual |4–9|

Wide letterspacing in short lines of type can create an interesting graphic effect but can affect legibility when applied to a block of text. Adjusting the space between letterforms may be necessary in logo design and other applications that involve large-scale type.

(continued)

Making Type Reader Friendly (continued)

Short lines of text are hard to read, because they create unnecessary hyphenation and awkward line breaks.

Long lines of text are hard to read because they cause the eye to track back to the beginning of the next line. Readers forced to read long lines of text often find themselves starting to read the line of text they have just read, instead of tracking down to the next line. Sometimes designers compensate for this factor by increasing the amount of leading between lines of text. Although adding space can help the eye to differentiate one line from the next, this option may be impractical when space needs to be saved. To save space and ensure reader-friendly text, set up a column width that allows for no more than fifty characters per line.

Above sample set in Garamond 8/10 at 25 picas.

Sample at left set in Garamond 18/21 at 10 picas.

visual |4–10|

Long lines of text are hard to read because the eye has difficulty tracking back to the beginning of the next line. Short lines of text are hard to read and often unsightly because they can result in lots of hyphenation and awkward rags in a rag-right configuration. For best legibility, line lengths should be approximately 50 characters long.

WAYS OF CATEGORIZING TYPEFACES

Over many years, designers and others who work with type have developed several ways of breaking down and organizing typefaces into categories based on style and practical application.

Text Versus Display Typefaces

Because designers need to differentiate between legibility and expression, it's helpful to think of type as falling into two basic categories. In fact, font manufacturers often make this distinction by sorting their typefaces into two groups:

- Text typefaces—Used where legibility is an issue, typically, for small print and long passages of text.
- Display typefaces—Used where projecting a mood or attitude is important, typically, for names, logos, titles, and other short passages of text (see Visual 4–11a and Visual 4–11b).

Although there's a distinction to be made between typefaces that are reader friendly and those that are not, it's important to realize that text typefaces can work equally as well in large-scale applications. On the other hand, there are very few situations where it's a good idea to use a display typeface for setting lengthy content. Inappropriate use of a display font as a text application is likely to discourage rather than encourage readers (see Visual 4–12).

Ariel
Garamond
Times New Roman

visual |4–11a|

Text typefaces are used for long passages of text and other situations where legibility is a factor.

Old English
Impact
Sand

visual |4–11b|

Display typefaces are usually reserved for short passages of text and when projecting a mood or attitude is important.

For the past 18 years, Tippecanoe & Typer Too has designed the Candid Corporation's annual report. And for each of those reports, the design firm has commissioned a fine artist to produce work that supports each report's central theme.

For the past 18 years, Tippecanoe & Typer Too has designed The Candid Corporation's annual report. And for each of those reports, the design firm has commissioned a fine artist to produce work that supports each report's central theme.

visual |4–12|

When you compare a text passage set in Brush Script, a display typeface (top), and Times New Roman, a text typeface (bottom), it becomes apparent how important it is to choose a typeface with high legibility.

Additional Typeface Classifications

There are literally thousands of typefaces from which to choose. Selecting a typeface from the vast array of possibilities can seem like a daunting task if you don't have a clue as to what distinguishes one typeface from another. Fortunately, there are ways to help designers narrow down their selection.

To help them organize and choose typefaces, designers and typographers have identified characteristics typefaces have in common and grouped these typefaces accordingly. For instance, most text typefaces can be classified as either serif or sans serif. Serif typefaces originated with the Romans who identified their stone shrines and public buildings with chisel-cut letterforms. To hide the ragged ends of these letterforms, they would cut a short, extra stroke on the ends of their letters. This extra cut was called a serif, a term still in use today.

Sans serif literally means *"without serif."* These typefaces originated in the early twentieth century in response to the Industrial Revolution. As a result, sans serif typefaces project a more streamlined and contemporary aesthetic (see Visual 4–13).

Serif Sans serif

visual |4–13|

Serif typefaces such as Garamond (left) are characterized by short strokes or serifs at their ends. They tend to convey a traditional look. Sans serif typefaces such as Helvetica (right) tend to project a more industrial look.

THE DESIGNER AT WORK

jennifer sterling

Do what makes you happy. Be persistent about going after what you want to do.

—Jennifer Sterling

Sterling Design is an award-winning design firm based in San Francisco. Its principal, Jennifer Sterling, founded her firm in 1995, after serving five years as art director for Tolleson Design, another award-winning San Francisco–based design firm. Before moving to San Francisco, Sterling attended the Art Institute of South Florida where she received her degree in graphic design.

Sterling's primary concern is doing work she feels good about. She has purposely limited her studio's staff to three people so that she's not in the position of taking on work just to assure enough revenue to meet the payroll. By assuming ultimate responsibility and producing all of the design with the help of an assistant, Sterling can control the quality of the work the firm produces and the type of clients she serves.

The variety of projects the firm tackles is far reaching, ranging from print to interactive to product and package design. Sterling's clients are just as diverse and include well-known names such as Yahoo and Nokia. The firm has even done brand design for a coalition under the direction of Hillary Clinton and Madelaine Albright.

Although Sterling is doing the type of work she enjoys, she doesn't believe designers need to be self-employed to be fulfilled in their work. "It's all about the quality of the work you produce," she states. "If you can work in a place that allows you to do that, I think that's just as good as having your own firm."

Sterling's CD design for the band Bhoss combines letterpress printing with a cover of etched stainless steel. The use of unusual materials and textured surfaces have become signatures of Sterling's design style.

This paper promotion Sterling designed for Consolidated Paper showcases the stock's printing capabilities with photos by photographer John Casado. Designing a paper promotion is an honor reserved for award-winning designers with a reputation for producing cutting-edge work.

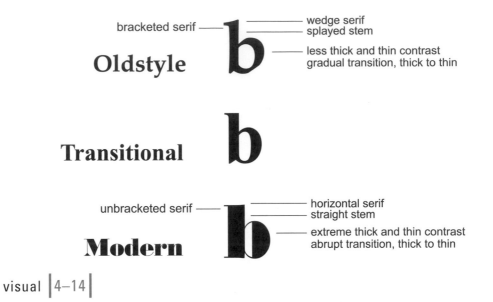

visual |4–14|

Old style typefaces (top) are direct decendents of the chisel-edge Roman letterforms. They're characterized by angled and bracketed serifs and less thick and thin contrast. Examples: Times Roman, Garamond, Caslon. Modern typefaces (bottom) are a style of Roman type characterized by extreme thick and thin contrast and straight, unbracketed serifs. Examples: Bodoni, Caledonia. Transitional typefaces (center) exhibit characteristics of both modern and old style typefaces. Examples: Baskerville, Century Schoolbook.

Beyond serif and sans serif typefaces, there are other typeface classifications that designers and typographers have traditionally relied on to help them organize typefaces:

Old style, transitional, and modern—These style categories refer specifically to serif typefaces and reflect modifications that have taken place over time from the original Roman or old style serif letterforms (see Visual 4–14).

Script—These typefaces most resemble handwriting and run the gamut from elegant to casual.

Egyptian/slab serif—These typefaces (also called square serifs) are characterized by heavy, slablike serifs.

Decorative—Many typefaces, by default, fall into this category. Most are highly stylized and suitable only for display use (see Visual 4–15).

Brush

Zaph Chancery

Serifa

Lubalin Graph

Capone

visual |4–15|

Script typefaces such as Brush can resemble hand-painted signage or, in the case of Zaph Chancery, calligraphy. *Egyptian* or *slab serif* typefaces such as Serifa and Lubalin Graph are characterized by slablike serifs. Other typefaces that are highly stylized and suitable only for display use fall into the decorative category. These typefaces include period looks such as *Capone,* which resembles typography of the 1930s.

USING TYPE EXPRESSIVELY

Earlier in this chapter I mentioned that typefaces that convey a mood or tone are more likely to be used for company or product names or logotypes. Typefaces that project an attitude are also commonly used to headline magazine articles, for book and movie titles, product packaging, posters, and other applications where communicating an immediate impression or eliciting an emotional response is important.

It could be said that typefaces, like people, have character and personality. Some are playful, whereas others are serious. They can even be divided into gender classifications—some display feminine characteristics and others are distinctly masculine (see Visual 4–16).

Feminine

Masculine

Like people, typefaces have gender characteristics. Some, such as Garamond Italic (top), have a distinctly feminine look whereas others, such as Arial Black (bottom), appear masculine.

ugly

frilly

grungy

FINGER PAINTED

Calligraphy

Ornate Script

Many typefaces have "voice" and can express a broad range of attitudes and cultural sensibilities. If there's a mood or emotion you want to project, chances are good that there's a typeface that captures it.

Typefaces can also convey period looks as well as an ethnic or cultural sensibility. They can express a broad range of moods (see Visual 4–17).

Choosing a font with an attitude that enhances the message you're trying to convey is probably one of the most important components of effective typography (see Visual 4–18).

visual |4–18|

Razer is the brand name for a highly sensitive computer mouse, marketed to hard-core gamers. The slashed and degenerated look of the typography used for its logotype suggests an aggressive, cutting-edge attitude appropriate to the product and its market.

Type can also be altered to express an attitude or concept. It can be configured to suggest an image or shape (see Visual 4–19).

Type can also be distressed or manipulated to convey movement or motion. It can be layered or otherwise configured to suggest a sense of depth or perspective (see Visual 4–20).

visual |4–19|

This article about dining out on a shoestring uses text formatted in the shape of a half circle to echo the image of the bowl on the opposite page. The formatted text not only reinforces the article's message, it serves as a strong compositional element in the page's layout. *(Design by Charles Stone and Melanie Fowler, American Airlines Publishing)*

visual |4–20|

In the examples here, the meaning of each word is enhanced through type manipulation. A sense of space and perspective is achieved in the top example by superimposing different sizes and grayed values of the word *layered*. For the word *fast,* a blur filter in a photoediting program was applied to an italicized typeface to achieve a sense of foward motion . Strategic positioning of letterforms was used in the words *flip* and *jumble* to convey an appropriate sense of movement.

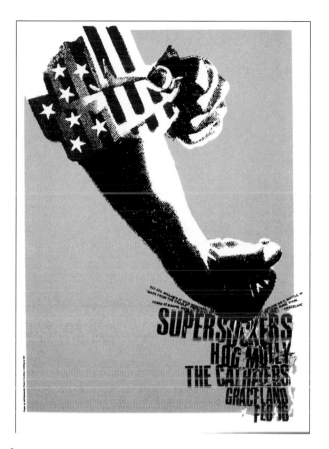

visual |4–21|

Distressing the typography on this poster adds clout to the message by helping viewers imagine the potential impact of the fist. *(Design by Jeff Kleinsmith, Patent Pending)*

Physically manipulating type is one of the easiest and most obvious ways of adding expression (see Visual 4–21).

TYPE IN A COMPOSITION

In a design composition, type works as a design element, just as shape, line, color, and texture serve as design elements. So all of the principles that guide decision making in a design composition also apply to typography. How to style type, what typeface to use, and what size and color the type should be are all dictated by the overriding principles of hierarchy, unity and variety, proportion, balance, and scale.

In Chapter 2 you learned that format, venue, and audience constitute the psychological foundation that guides designers when they begin a design project. In addition, when designers begin a job, they are given a message, typically, verbal content to communicate. It's the designer's job to determine what kind of typographic form this content will assume and how it will be handled relative to the other elements in the composition.

Hierarchy

Many designers find it helpful to start by determining the hierarchy or most important element in a composition. From there, they organize type and other elements around this focal point. Designs composed entirely of type make the hierarchy clear—the most important part of the verbal content is given the most prominence. If you examine a page layout that's composed entirely of type, it's easy to see how headlines and blocks of text can assume predominant and subordinate roles in a design composition.

As with any other design elements, size, color, and surrounding negative space all affect the degree of prominence a typographical focal point will assume. Often, a compelling sentence, word, or phrase will be the predominant feature in a layout. Once the reader is hooked, it will be followed by information of secondary or supplementary importance (see Visual 4–22).

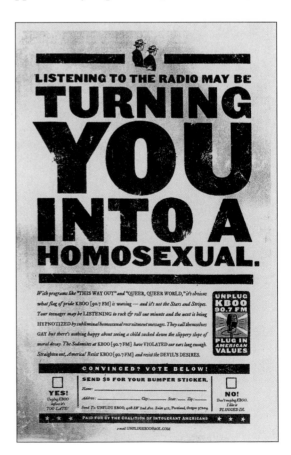

visual |4–22|

In this poster promoting a radio station, a clear hierarchy is established with the size and prominence of the type. To catch the viewer's attention, the word *you* is largest and most prominent. From there, supplementary copy draws the eye to additional information. *(Design by Tom Cheevers)*

In many cases, type needs to be combined with imagery such as illustration or photography. Often, the quality of an image, nature of the message, or the overall concept will determine whether imagery or type will play the leading role. It's not unusual for type to assume a supporting role when a compelling image deserves center stage (see Visual 4–23).

Imagery and type should be combined in a synergistic manner. Graphic elements such as lines, pattern, and texture may also be involved in the composition. It's up to the designer to determine what the hierarchy and balance between all design elements will be as well as how the viewer's eye will travel from image to text and loop around a design composition (see Visual 4–24).

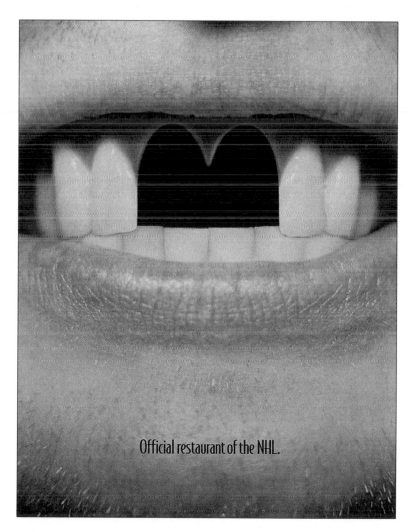

visual |4–23|

The message in this ad is clearly communicated by the toothless gap echoing the shape of McDonald's golden arches. In the hierarchy of the composition, the viewer is attracted to the image and then reads the message, which is perceived as a subtle reminder. A large headline for the sponsor information would have detracted from this powerful image. (*Design by Palmer Jarvis DDB*)

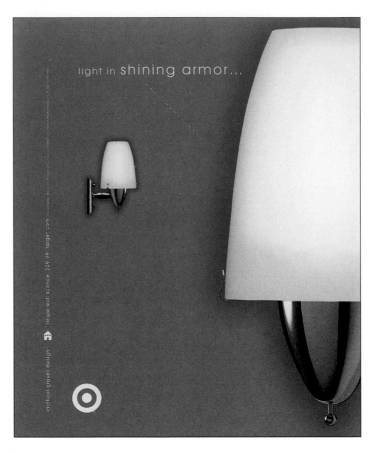

light in shining armor...

single wall sconce $29.99 target.com

michael graves design

visual |4–24|

This ad for Target uses type as a linear element to guide the viewer's eye from the large lamp shape at the right, across the top of the ad, and down the left side, so that the eye loops around the entire composition taking in all of its visual components. *(Design by Design Guys)*

Using Type to Create Theme and Variation

Type can also play an important role in unifying a composition or creating variety within it. When various visual elements need to be incorporated into a cohesive visual scheme, using the same typefaces will help to unify it. This can be an important factor in magazine and brochure design where visual continuity needs to be established over many pages. Sticking with a single typeface family will ensure rhythm as well as theme and variation (see Visual 4–25).

Although using a single typeface family in a design is a foolproof way of achieving typographic harmony, in some instances too much of the same thing can result in a design that's repetitive and boring. Sometimes a mix of typefaces may be more appropriate to the theme or message of a design and may be necessary to achieving graphic interest or an even richer sense of theme and variation. However, care should be taken to combine typefaces in a way that's harmonious and appropriate to the message or theme (see Visual 4–26).

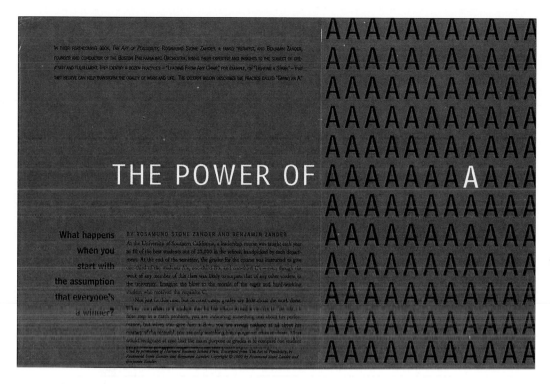

visual | 4–25 |

Varying weights of the font Bell Centennial add variety and interest to this magazine spread. *(Design by Keith A Webb, Boston Globe Magazine)*

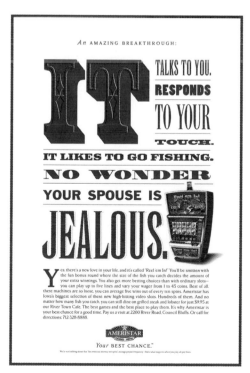

visual | 4–26 |

A mix of typefaces lends character and a festive look to this poster promoting a casino. *(Design by Eleven Inc.)*

Mixing Typefaces Effectively

The trick to mixing typefaces is to make the difference look obvious and purposeful by using opposites—typefaces that have different but complementary typeface characteristics, or are radically different. In the top example shown in Visual 4–27, a sans serif typeface (Arial Black) is contrasted with a serif typeface (Garamond). The second example contrasts two versions of the same typeface (Modula). Setting one word in extra bold all caps and the other in all lowercase provides visual interest and variation. The third example contrasts a delicate, feminine typeface set in upper and lower case (Centaur) with a more masculine typeface (Arial Black) set in all caps. Avoid combinations that use similar typefaces such as the pairing shown in the bottom example of Frutiger and Helvetica. Mixing typefaces that are close but not quite alike can have a disturbing effect on viewers who sense, rather than see, the subtle disagreements.

TYPE LOGIC

TYPE logic

Type LOGIC

TYPE LOGIC

visual |4–27|

Proportional Systems and the Grid

When considering proportional relationships in a composition, it's useful to think of text as a design element as configured into columns within a grid. As you learned in Chapter 2, a grid is a modular compositional structure made of verticals and horizontals that divide a format into columns and margins. This underlying structure helps to maintain clarity, legibility, balance, and unity—aspects that are especially important in publication design where consistency needs to be established over many pages. In addition to serving as a unifying element and a means of organizing text and visuals, a grid will automatically set up a system that creates blocks of text that can be easily arranged as elements in a composition (see Visual 4–28).

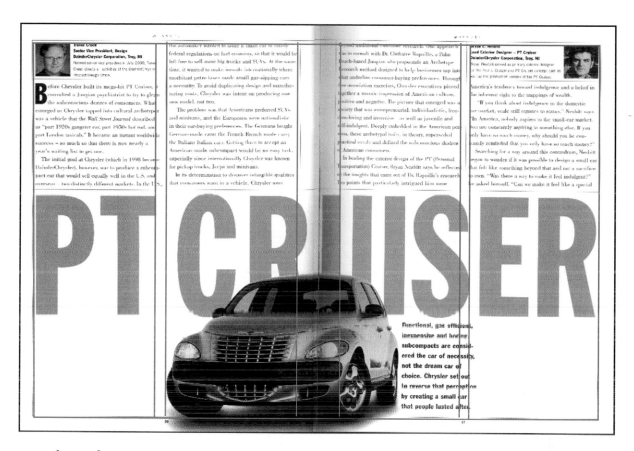

visual |4–28|

The underlying structure for this spread is a two-column grid. All of the spread's text is aligned to this format as well as its photos. (*Page layout from @ issue: Design by Kit Hinrichs, Pentagram*)

Type Alignment

Arranging type so that it conforms to a grid requires aligning it to the imaginary axes that form the grid structure. Arranging or styling type this way is called *type alignment.* Type alignment options designers frequently use are as follows:

Flush left/ragged right—Text or lines of type aligned to a left vertical axis that is uneven on the right side.

Flush right/ragged left—Text or lines of type aligned to a right vertical axis that is uneven on the left side.

Justified—Text or lines of type aligned to both left and right sides.

Centered—Text or lines of type centered on a central vertical axis (see Visual 4–29).

Type can be timeless
or trendy. It can express
a mood or an attitude.

Flush left, rag right

Type can be timeless
or trendy. It can express
a mood or an attitude.

Flush right, rag left

Type can be timeless
or trendy. It can express
a mood or an attitude.

Centered

Type can be timeless
or trendy. It can express
a mood or an attitude.

Justified

visual | 4–29 |

Text as Line, Shape, and Texture

As you learned in Chapter 1, type can also be set to assume the role of line, pattern, or texture in a design composition. In fact, type is frequently used to lead a viewer's eye through a composition or to connect elements in a composition by the linear direction it assumes (see Visual 4–30).

Typographical forms can also function as shape in a design composition. In fact, letterforms in a word or name can be used to create a dynamic composition (see Visual 4–31).

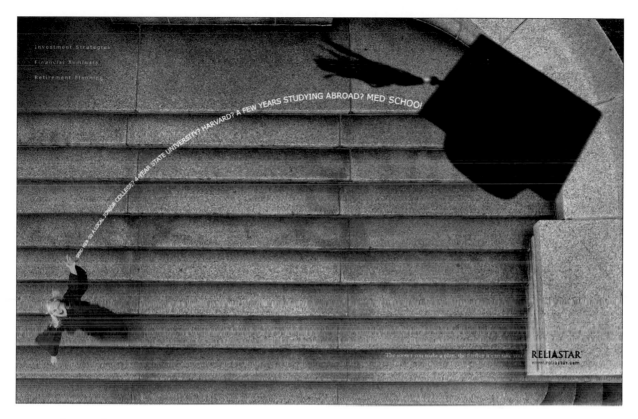

visual |4–30|

Type does double duty in this ad, providing content and serving as a link between the graduate and the cap she has tossed into the air. *(Design by Clarity Coverdale Fury)*

Just as large-scale type and letterforms serve as shapes in a composition, small-scale type lends textural richness to a composition. The perception of texture is largely controlled by the weight or variety of weights of the typefaces used and degree of negative space interjected into the text through line or letter spacing as well as layering (see Visual 4–32).

Again, contrast, balance, and scale and the manipulation of graphic space to create illusion dictate how type is handled relative to other design elements in a composition, although it's possible to use type alone to create an exciting composition where all of these factors come into play (see Visual 4–33).

visual |4–31|

In these designs, the letterforms of the names and the negatives space between them are all that's necessary to create a dynamic composition. *(Rage CD design by Aimee Macauley, Sony Music Creative Services; Mortensen Design logo design by Gordon Mortensen)*

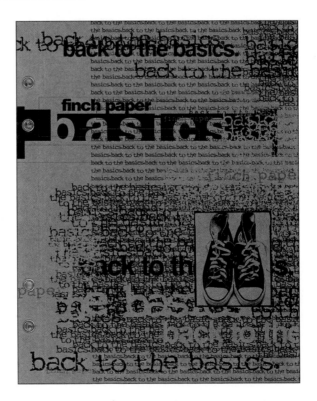

visual |4–32|

A variety of sizes and weights and layering create typographical texture in this cover for a paper promotion. *(Design by Robert DeLuke, Finch Paper)*

visual |4–33|

This page from a type specimen book, design by Piet Zwart in 1930, demonstrates how type alone can be scaled, colored, and arranged to create a sense of depth and movement in a dynamic composition.

SUMMARY

Type's role in design is communicating content, but type can also add expression to a design and function as a compositional element. To work with type, it's important to understand basic type terminology and the typographical systems designers and other graphic arts professionals use when working with and classifying typefaces. Expressive typography can add emotional emphasis to a design's message but may interfere with legibility. It's important for designers to make judicious choices between typefaces that are legible versus those that are expressive. The role type will play in a design involves determining hierarchy and using type so that it works synchronistically with imagery and other design elements. Type needs to work effectively as an interesting visual element in a design composition by functioning as shape, line, or texture. It can also serve as a unifying element in a composition as well as a means of adding theme and variation.

projects

Project Title Expressive Type

Project Brief Select a typeface that is expressive of each of the following words and manipulate it a in a way that further enhances the meaning of each:

- stodgy
- crush
- ornate
- sludge

Select one of the words you have manipulated and incorporate it into a two-color design composition that includes an image that supports the meaning of the word. Use color judiciously and apply the principles you have learned in previous chapters, such as repetition, rhythm, and scale to create a dynamic composition.

Objectives

Gain practice at selecting typography that enhances meaning.

Experiment with type manipulation to enhance meaning.

Explore type possibilities through browsing font libraries and other typographic resources.

Combine type and imagery in a harmonious manner.

Project Title Type Collage

Project Brief Make three collages composed entirely of type using type cut from magazines or other printed materials. Each composition should be well balanced and in a square format. Compose each design to show how type can function in each of the following roles:

- Type as line
- Type as shape
- Type as texture

Objectives

Understand how type can function as a purely compositional element.

Experiment with type as a design element by using it as a means of creating line, shape, and texture.

Project Title Creating Hierarchy with Type

Project Brief Pick a letter of the alphabet and a word that begins with that letter. Using a square format, make a composition incorporating that letter and word, using a typeface that communicates the meaning of the word and any other graphic elements that you feel enhances the word's meaning or the composition. With this composition, establish three focal points in a succession of hierarchy so that the viewer's eye travels from the most important, to that of secondary importance, and finally to that of least importance. Apply what you've learned about creating hierarchy, organizing visuals in a composition, and leading the viewer's eye so that it loops through all of the elements in the composition.

Objectives

Explore ways of scaling and working with type as a compositional element.

Develop an appreciation of letterforms as shape in a composition.

Understand how type can be used to guide and lead a viewer through a composition.

in review

1. What is the difference between a typeface and a type family?

2. What do the terms *uppercase* and *lowercase* mean?

3. What units are used for measuring the height of type and the vertical distance between lines of type?

4. What does the term *leading* mean?

5. When is it appropriate to use a display typeface? When is it appropriate to use a text typeface?

6. What is the difference between a serif typeface and a sans serif typeface?

7. How does type work to unify a composition?

8. What does the term *alignment* mean? What types of alignment options are there?

Lick it up.

After rock and rolling all night, we need nourishment. And every
drop of chocolate milk has the same vitamins and minerals regular milk has.
All the more reason to have a really, really long tongue.

got milk?

KISS © 1999 NATIONAL FLUID MILK PROCESSOR PROMOTION BOARD.

| imagery in design |

objectives

Gain an understanding of the differences among symbols, logos, and representational and informational imagery and how they function in design and communication.

Appreciate the differences between photographs and illustrations and how they can be fully exploited to best serve and enhance a communication message.

Understand how iconographic symbols differ from other types of imagery and how they communicate visual information at a glance.

Understand how logos are designed and how they identify brands in the marketplace.

Examine ways in which identity and wayfinding systems are developed.

Develop a knowledge of the basic types of charts and graphs and how they put statistical information into a visual context.

introduction

You've no doubt had the experience of thumbing through a magazine and getting involved in an article because an arresting photograph or illustration caught your eye. We've all had this experience, as well as similar ones such as being drawn to an image on a billboard or poster. Because "a picture is worth a thousand words," designers often use imagery to grab attention and establish an immediate connection with their audience.

Representational imagery such as photographs and illustrations do a good job of arousing curiosity, luring a viewer, and eliciting an emotional response. However, a photograph or illustration is often too complex to serve as an effective means of communicating universally understood information at a quick glance. Airport signage, for instance, guides travelers with simple iconography or symbols that are understood by all individuals, regardless of language or culture.

Simple, iconographic symbols called logos are also used in the marketplace to identify products and services. Think of a product brand you've grown to trust. If you're like most consumers, you associate that brand's symbol or logo with quality and consistency. So when you're considering purchasing a new product or service, you're more likely to look for one bearing that brand's logo than to choose one with which you're unfamiliar.

In the design process, it's important to distinguish between these different image types and to produce or select appropriate imagery for each application. The right image can help you connect and communicate with your audience, whereas the wrong image can confuse and alienate them.

REPRESENTATIONAL IMAGERY

Think of how a picture of a sunny tropical beach can transcend you into a more relaxed state of mind. That's probably because, on some level, you're experiencing what it's like to be on that beach. Representational images rely on creating the illusion of a reality that only exists in the minds eye.

When designers want to communicate a mood or affect viewers on an emotional level, nothing speaks more clearly than a photograph or an illustration. In the case of the tropical beach scene, part of the appeal lies in seeing the blue sky, sunny beach, and water and imagining how that feels. Being able to see details such as tropical foliage helps us distinguish this beach from one in a more northerly climate. The realism in a representational image is what helps to convince us that what we're seeing is or could be within the realm of our experience.

Photography

Because most people assume the camera never lies, photographs are generally regarded as the most credible type of imagery. This visual assumption sets up a situation in which the viewer is likely to accept a photograph as being real, without question—a premise that supports the visual power of photography. Photographs are often used in a photojournalistic way to support newsworthy editorial or to document informative content. They're also used when accuracy or recognition is important(see Visual 5–1).

visual |5–1|

In this ad for milk, a photograph of the rock band Kiss ensures viewers will recognize the band and relate to the ad's message. *(Ad concept and design by Bozell New York; photograph by Annie Leibovitch)*

Food manufacturers and retailers are well aware of how a photograph with strong appetite appeal can prompt a purchase. In fact, the temptation to alter a photograph of a product to enhance its appeal prompted legislation that now requires all food manufacturers to use un-altered product photographs on product packaging.

Practically everyone has had the experience of buying ice cream or a cold drink on a hot day because a photograph of a cool, icy treat made the product seem irresistible. Photographs of food and beverages are often used to promote restaurants as well as point-of-purchase displays at food service establishments (see Visual 5–2).

Photographs can also be extremely effective at eliciting an emotional response or to help the viewer visualize themselves in a specific situation. They are frequently used in advertising to portray scenarios where the viewer can easily identify with the individuals or setting that's depicted (see Visual 5–3).

Until recently, most photography was done traditionally with a camera and darkroom development. But digital cameras are increasingly being used because they bypass the photographic development process and can immediately be incorporated into computer generated designs.

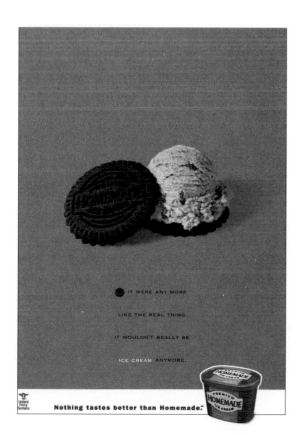

visual |5–2|

The refreshing qualities of a cool treat are highlighted in this ad for ice cream. Seeing the real product helps convince the audience of the ice cream's cool sweetness. *(Ad concept and design by Northlich)*

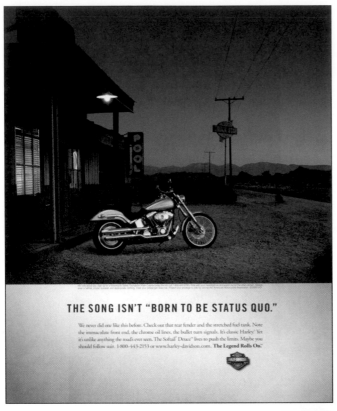

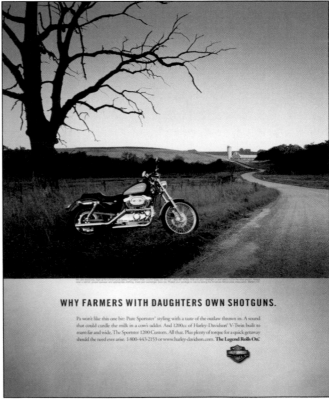

visual | 5–3 |

The realism of photography helps the reader identify with a situation or setting as well as clearly identifies a product. In this case, the romance of the road calls to those who would like to imagine themselves engaging in the lifestyle of a motorcyclist. *(Ad concept and design by Carmichael Lynch; photographs by Paul Wakefield and Chris Wimpey)*

Choose the Right Photographic Option

Here is an overview of the different options from which to choose when finding, commissioning, or otherwise producing photographic imagery. Each imaging option has its advantages and disadvantages.

Slides and transparencies—Pros: Slides shot with a 35-mm camera and other transparencies offer excellent color reproduction because they offer greater tonal range than color photographic prints. A good-quality transparency can be enlarged up to around seven times its size, or 700%. Cons: Slides and transparencies need to be scanned or digitized to be brought into computerized design and production.

Digital photos—Pros: Digital photographs can quickly be incorporated into the digital production process. Cons: Image quality depends on the quality of the camera. Inexpensive digital cameras tend to produce unreliable results, particularly where detail and color are concerned.

Photographic prints—Pros: Color and black-and-white prints can be easily examined and evaluated for quality. Because the tonal range in a print is already compressed, they're easier to match on press. Cons: Photographic prints can't be enlarged much from their original size without losing clarity. They must be scanned or digitized to be brought into computerized design and production.

Judicious Cropping

When working with a photograph, your first impulse may be to use all of it, including the entire background. However, seasoned designers understand that removing portions of a photograph that detract or distract the viewer's attention from its central focus can draw attention to what's most meaningful about it. Knowing where and how to crop an image involves studying it and singling out its best part, including the portion that works best compositionally (see Visual 5–4a and Visual 5–4b).

There may be occasions when a photograph's central image should be featured without any background at all. Isolating a subject from its background is called *outlining* or *silhouetting*. This technique may be your only option if the photograph is poorly composed or the background is so distracting it needs to be entirely removed. It is also appropriate and used frequently when the image works well as a compositional element (see Visual 5–5a and Visual 5–5b).

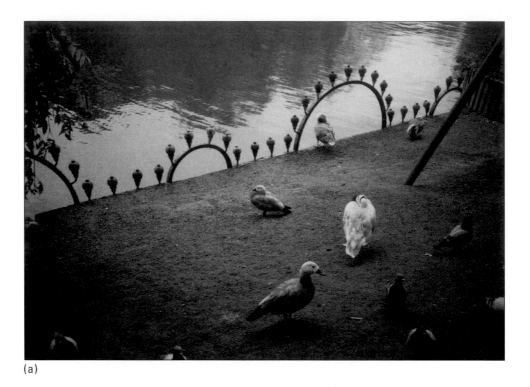

(a)

(b)

visual |5–4a and b|

(a) The original photograph of the birds isn't poorly composed but can be improved. The birds with the most visual interest are in the photograph's center. (b) A square crop eliminates the photo's slightly underexposed edges and yields a much more interesting image.

(a)

(b)

visual |5–5a and b|

Removing an image from its background allows the designer to use it more freely in design compositions. In this cover photo composite for a slipper catalog, the slippers and the mirrored ball were shot independently (a) and assembled into the final composition (b) in a photoediting program. *(Design and photography by Gregory Wolfe Associates)*

PACK YOUR BRAIN

rose gonnella

Rose Gonnella is an educator, artist, designer, and writer. Rose has exhibited her art nationally and internationally in collections such as Smithsonian National Museum of American Art. She has also written numerous books and articles on creativity, art, and architecture.

Why are some professional artists and designers or students of the arts bubbling fonts of creativity that flow with a seemingly endless stream of ideas? Energetically creative people weren't born with minds filled with visual and mental information. Ideas spring from a brain (and heart) packed with experience and knowledge. Creative people are curious and passionate about learning. Curiosity is the foundation of creativity. Creative people fuel their brains everyday by absorbing as much mental and visual stimuli as can be tolerated before passing out at the end of an evening. Even in sleep, creative people find ideas. Upon waking, a creative person will jot down the weird and wacky juxtapositions of imagery and dialogue that comes during a dream.

Inspiration and ideas are a product of proactive mind. Creative people are listeners, doers, hobbyists, collectors, museum goers, travelers, scavengers, revelers, searchers, adventurers—with the exploring done through far-reaching experience or simply by reading books. Creative people are hunters and gatherers who constantly look and fill their living space with interesting scraps of paper, all sorts of printed matter, oddly shaped paper clips, doodads, gadgets, and, of course, books. Creative people take notes yet understand that what they accumulate on any given day probably has no particular immediate purpose. Creative people invest in learning and searching for its own sake. The search for inspiration and ideas is an investment. Time is needed to sponge up information from a myriad of sources. Time is needed to experience. And, in time, your brain fills up with all manner of stimulation. The stored information, images, and ideas are calmly waiting to be reordered, reconfigured, refreshed, and put to creative use. The stockpile lies dormant until a spark ignites it: you are asked

Your Photograph Should Dictate Its Role in Your Design

Novice designers often try to make a photograph fit their composition. However, in practice, the opposite should happen—your composition should be dictated by the quality and size of your photograph. Follow these guidelines when working with photographs:

- Section off the best part of the photo. Use two L-shaped pieces of paper or card stock to help you determine the best part of the image and then determine how the design will best work with this cropped image.
- The quality of the photograph should determine its size, not the size of the area you've chosen for it in your design. Don't try to enlarge a photograph of marginal quality to make it fit your design.
- Great photographs with strong emotional or aesthetic appeal deserve first-class treatment. Give them the attention they deserve by giving them prominence in your design.

to find a solution to a creative problem. And BANG!, stored information explodes and ideas pop.

But you can't pull out of your head what is not in your head. Creativity does not happen in a vacuum. You have to pack your brain (fortunately there is always room for more). When you ask the question, "How do I get a great idea?" The response is: reach into your brain and yank it out OR get up, get out, and gather what you need. Research. Excellent ideas come from what pre-exists in your brain from previous research, discovery, and exploration or from what you actively put there for the instance. If you are designing a brochure to save the whales, it is time that you (a) went on a whale watch, (b) watched a documentary about whales, (c) visit a public aquarium that has whales, or (d) read and search the Web. But don't rely on the Web alone. Experience comes best with personal field experiences.

WHAT DO TEETH HAVE TO DO WITH TEA BAGS?

Nothing. Isolated visual and intellectual information gathered for the pure joy and pleasure of savaging, searching, research, observation, or accidental dis-

covery (such as, visiting a flea market, reading a book on Northwest Coast Indian masks, poking through the Japanese bookstore near Rockefeller Center in New York City, birdwatching, or coming upon a mural by Thomas Hart Benton at the city hall in Jefferson City, Missouri) will not be useful until the material is compared, related, combined, synthesized, and composed. Meaning comes from relationships. Keeping your mind wide open to comparing and combining disparate objects, ideas, and imagery creates visual poetry and fresh ideas. A design found on the ceiling of the Uffizi Gallery in Florence might make a great composition juxtaposed with an image of clouds.

In isolation, an image of clouds is seen as itself. Seen together, an image of a floral tapestry and clouds may suggest an entirely new and evocative meaning. Some people look into the night sky and see stars. Creative people look at the stars and also see horses, crabs, lions, and warriors. Now, what do teeth have to do with tea bags? Open your mind and let the possibilities pour in.

Copyright Rose Gonnella 2003

Illustration

The expressive quality of illustrations makes them valuable when a mood or feeling needs to be enhanced. A case in point is romance novels, which for years have depicted posed models on their covers in illustrations but rarely in photographs. That's because illustration is the more expressive of the two mediums (see Visual 5–6).

The mood projected in an illustration is largely controlled and dictated by the illustration technique as well as the medium. Pen and ink, scratchboard, pastel, gouache, and digital drawing programs are just some of the media possibilities available (see Visual 5–7a, Visual 5–7b, and Visual 5–7c).

visual |5–6|

Although the media and rendering technique in this poster illustration promoting a road race make it appear photographic, its unusual lighting, vantage point, and exaggerated perspective have resulted in an image that's more surreal than real. *(Illustration by John Maggard; poster design by Cliff Schwandner)*

(a)

(b)

(c)

visual |5–7a to c|

Black-and-white illustration can include a range of media possibilities. Shown here (a) are a scratch board illustration by Greg Dearth, (b) a charcoal rendering by Mark Lawrence of Gil Schuler Graphic Design, and (c) a digital rendering by Cosmic Debris for Chronicle Books.

Each medium has a unique look and sensibility and, in the hands of different artists, can convey additional nuance and feeling (see Visual 5–8).

Illustrations can also help an audience visualize something that can't be seen or better understand something that's complex. For instance, medical illustrations give those who study medicine a fuller understanding of how the body works. Diagrammatic illustrations help us assemble or maintain complex equipment.

visual |5—8|

This series of posters for the French Paper Company demonstrates how different the same individual can look when depicted by different illustrators. Shown are portraits of company president Jerry French by various staff members of Charles S. Anderson Design.

Illustrations, like photographs, are usually chosen or commissioned with output in mind. It's important to select or commission black-and-white media for output in black and white, as opposed to converting a color illustration to black and white.

> ## Image Terminology for Production

Bringing an image into the design and production process requires digitizing or scanning it so it can be printed in a way that will result in the best possible reproduction of the original. To determine the best way of scanning an image, it's important to know how prepress houses and scanning manufacturers classify imagery and the terminology they use.

- Continuous tone—A photograph or illustrated image that's composed of a series of gray or color tones with gradations from one tone or color to the next, as opposed to color or tonal areas that are flat and distinct from one another.
- Grayscale—A continuous-tone black-and-white image.
- Halftone—Reproducing a continuous-tone image by photographing it through a fine screen to convert the image into a series of dots. If it is a color image, it's called a CMYK halftone.
- Line art—Refers to a black-and-white image that does not have continuous tones such as a logo, a graphically reduced image, or a pen-and-ink illustration. Also called *bitmap*.

Sources for Imagery

Many designers generate their own imagery, shooting pictures or creating drawings, paintings or digital art for their designs. However, if you are not able to generate your own imagery, the following are some resources commonly used:

- Royalty-free collections—Collections of illustrations and photographs can be purchased on CD-ROM as an inexpensive source of imagery. Their only drawback is that some of these images have a generic look. And, because they're available to anyone willing to purchase them, there's always the chance that a image from a royalty-free collection will appear (or may have already appeared) someplace else.
- Stock agencies—These agencies grant limited rights use of their photographs and illustrations for a fee. The drawbacks are similar to royalty-free collections in that there's no guarantee an image hasn't or won't appear elsewhere.
- Commissioned—Hiring a photographer or illustrator will yield an original piece of art. Professional photographs and illustrations will typically, but not always, cost more than stock or royalty-free collections.
- Found imagery—Small or flat objects such as leaves or coins can be directly scanned and incorporated into designs (see Visual 5–9).

Uncredited illustrations and photographs found in printed materials at least 75 years old can be used. These images fall into a category called *public domain,* meaning they are no longer protected by copyright (see Visual 5–10).

visual |5–9|

Small, flat objects such as the pearls shown here can be photographed by placing them on a scanner.

visual |5–10|

Uncredited photographs and illustrations at least 75 years old are no longer protected by copyright laws and can be freely incorporated into designs and layouts.

SYMBOLS AND LOGOS

Because they need to be easily and often universally understood as well as recognizable in both small- and large-scale applications, symbols and logos are images or words that have been stripped down to their simplest form. Understanding how to simplify an image or series of letterforms and making them symbolic is based on many of the design principles you've already learned. Creating a well-balanced design with pleasing proportions is important and, in a logo design, communicating the character or essence of a brand or business.

Graphically Reducing an Image

Taking an image down to its simplest form while preserving its ability to be recognized is called making a *graphic reduction*. The simplicity and legibility of a graphically reduced image makes it especially suitable for pictograms or logos.

Graphic reduction is a process of image translation. Most often, the translation is an edited, simplified version of the original subject. Logos, symbols, marks, pictograms, and ideograms need to be quickly deciphered to communicate successfully. Reducing subjects to their essential parts yields images that fulfill this requirement (see Visual 5–11).

To achieve unity and harmony, it is important that the visual attributes of a graphically reduced image have a structural as well as an aesthetic relationship. Through the process of editing and translating, careful consideration must be applied as the subject is drawn and redrawn. Working toward a final graphic translation of the original subject requires visual aligning and tuning of the feature parts. Width, length, and sizes of visual attributes can be based on a constant unit of measure.

The transformation of a continuous-tone image to a graphic reduction can be accomplished in many ways: describing the contours of an image with an outline, converting the basic form of an object to a silhouette or simple shape, interpreting shadowed contours of a form into a series of shapes, or using a combination of these methods. To successfully reduce an image, the designer should concentrate on emphasizing essential qualities—a process that involves retaining some details of the image while eliminating others. Contours may be converted to simple curves. The designer's role in the process is one of judicious decision maker—deciding what features of an image will go, what will stay, and how the elements that are retained will take on new meaning within a new, more simplified context (see Visual 5–12).

visual |5–11|

A graphic vocabulary based on graphically reduced panda images serves as the basis for this flexible identity system used to promote the UPS shipment of pandas from China to the Atlanta Zoo. The identity was applied to crates, a jet fuselage, and other vehicles. *(Identity design by Deep Design)*

visual |5–12|

In this example, a photograph of a key (left) is converted from a continuous-tone, grayscale image to a black-and-white icon (right). In the process of graphically reducing this image, important attributes were retained, including the key's basic shape and the contours of its ridges. The background was eliminated along with unnecessary details such as the manufacturer's inscription

Simple Image Terminology

The following terms will help you differentiate among the different types of simple image applications.

- Pictogram/pictograph—A pictorial image that depicts a simplified representation of an object or activity.
- Ideogram/ideograph—A pictorial image or symbol that represents an idea or concept, for instance, a representation of a lightening bolt to symbolize a thunderstorm warning.
- Symbol—Letter or sign that represents an activity, idea, or object that can be used within a cultural or commercial context. Effective symbols are universally understood and transcend language and cultural boundaries.
- Logotype—Letters, words, or a name formed in a distinctive way and used symbolically to represent a product, brand, company, or group.
- Mark—Symbol used to represent a product, brand, company, or group.
- Logo—Logotype, mark, or a combination of logotype and mark used to represent symbolically a product, brand, company, or group.

Logos and Trademarks

If you're shopping for athletic wear, spotting the logo of well-known brand helps you immediately identify the price range and quality level of the merchandise. If you're loyal to that brand, you're more likely to look for and buy merchandise bearing that logo. The term *logo* is used describe whatever symbol a company uses to identify its brand in the marketplace.

A logo can be more than a symbol or a mark. As you learned in Chapter 3, it can be a distinctive, typographic treatment of a company name, called a *logotype*. Or it can be a combination of mark and logotype. A logo that includes both offers a degree of versatility. Name and mark work well together but can function independent of each other, if necessary (see Visual 5–13).

visual |5–13|

This combination of mark and logotype allowed for flexibility in the development of a corporate identity system for the OneWorld Challenge team that competed for America's Cup. The two components work well together on letterhead and packaging but function equally as well independent of each other. *(Identity design by Hornall Anderson Design Works)*

visual |5–13| (continued)

Make Images Part of a Logotype

Logotypes and images are typically paired up so they can work together or apart from one another to identify a firm or organization. However, images can also take the place of a letterform or part of a letterform in a logotype as demonstrated in Visual 5–14.

visual |5–14|

The Kazi Beverage Company logo uses a silhouette of a martini glass to fill in the open area of the A. *(Design by Hornall Anderson Design Works)*

Manufacturers recognize the importance of consumer loyalty and brand devotion and work hard to develop a logo that captures and communicates the spirit or essence of their brand. If they are successful, their logo is a unique identifying mark that can't possibly be confused with any other. In fact, logos are so important to brand recognition, most manufacturers trademark their brand's logo, a process of legally registering it with the government's trademark registry. When a logo becomes a registered trademark, it is the exclusive property of the trademark holder. Nobody else can apply that logo to their product or merchandise without suffering legal consequences.

In addition to developing a unique design that expresses the character of a company or brand, another important factor of a logo's design is its ability to be easily recognized in many applications. Because logos often appear on apparel labels, in newspaper ads, and in other situations where there is little control over the size and color of its reproduction, their design is typically clean and simple so they can be easily recognized and understood regardless of scale or color.

Logos and Identity Systems

Once an organization's logo has been determined, business materials, such as stationery, shipping labels, and business cards, are designed bearing that logo. Beyond these basic identity needs, most companies have other situations where their logo needs to appear such as on their Web site, promotional literature, merchandise, packaging, signage, and even vehicle and uniform applications.

Although it may initially seem as though these identity applications would require little more than scaling and positioning a logo, an organization's identity is often based on more than just its logo. A distinctive color palette and typography as well as other identifying elements may also be involved in the identity. To provide a means of applying these elements across a broad range of materials, designers develop what is called an identity system. The overall goal in designing an identity system is to provide a unified presentation based on the image established with the logo. Identity systems are often sophisticated, modular schemes that provide a flexible means of applying recognizable features of a company's identity to a variety of design venues.

The Making of an Olympic Identity

The identity for the 2002 Winter Olympics in Salt Lake City involved developing a sophisticated visual vocabulary that could be flexibly applied in a broad range of venues that included banners, flags, sports equipment, signage, uniforms, interior and exterior architectural graphics, and a variety of vehicle applications.

In 1995 the International Olympic Committee (IOC) awarded the 2002 Olympic Winter Games to Salt Lake City. In 1997 the Salt Lake Organizing Committee (SLOC) hired Landor Associates, San Francisco to develop the Salt Lake Olympic brand (Visual 5–15a). A key element of the logo, the "crystal emblem" (Visual 5–15b) was created to symbolize specific aspects of the games: athletic courage and the Olympic flame (Visual 5–15c), Native American cultural heritage (Visual 5–15d), and the Utah landscape with its snowcapped mountains (Visual 5–15e and Visual 5–15f). Landor expanded upon the crystal emblem to create a more detailed icon (Visual 5–15g) which was extended into a pattern and cropped (Visual 5–15h) to create a rich and flexible graphic vocabulary.

The Salt Lake Organizing Committee (SLOC) built an internal design team to create the Look of the Games. Art directed by Bob Finley, Amy Lukas and Cameron Smith, the Look of the Games in-house design team developed the graphic guidelines of the Salt Lake 2002 Games. The team developed standards further used within the system, which included the use of color, typography, patterns and photography. The kit of parts included many elements, such as banners, flags (Visual 5–15i) and uniforms (Visual 5–15j). To create a rich and varied color palette for the identity, the design team expanded upon the fire-and-ice theme of the crystal emblem's colors (Visual 5–15k).

(continued)

The Making of an Olympic Identity (continued)

(a)

(d)

(b)

(e)

(c)

(f)

visual |5–15a to f|

(g)

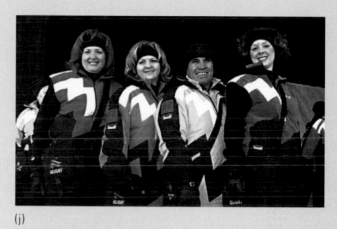

(j)

(h)

(i)

REDROCK	704	SUNSET	165
WILDFIRE	186	SANDSTONE	144
SUNSET	165	AMBER	1235

MT SHADOW	2726	TURQUOISE	212
LAPIS	2746	DARK TURQ.	3145
DECO BLUE	2716	LAKE	319

(k)

visual |5–15g to k|

visual |5–16|

To ensure there would be consistent treatment of the Novell identity wherever it needed to appear, Hornall Anderson Design Works developed a graphics standards manual. Specifications for logo and color applications, typography, and other aspects of the identity were detailed in this extensive manual.

To ensure that a company's identity is applied consistently across the board, designers often develop graphics standards manuals to serve as a guide for others in implementing an identity system. With a graphic standards manual, the arrangement and application of the logo in a variety of situations is assured as well as the consistency in the use of the identity's colors and typographic requirements (see Visual 5–16).

Stationery and Business Card Design

Any individual or organization doing business needs to produce correspondence on stationery bearing its identity. Business stationery includes important contact information such as the business address, phone and fax numbers, and e-mail or Web site address. The business's logo is typically placed at the top of the letterhead, but any arrangement is acceptable as long as enough space is left for the correspondence. The letterhead design should never overpower the message it contains. Because postal regulations limit the amount of space that can be designed on an envelope, an organization's logo, return address, and other identity elements containing imagery or type should be confined to the upper left corner of the envelope.

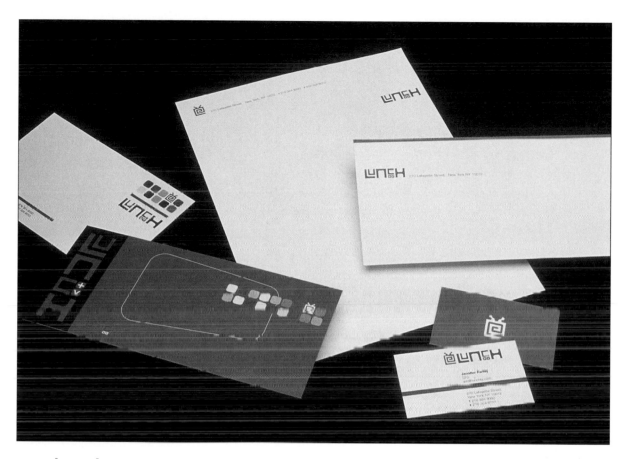

visual |5-17|

This suite of business materials for Lunch TV, a television and video production company, features a logotype and mark that work well as a team and independent of each other. Other unifying elements of the Lunch TV identity include a palette of red, blue, and violet hues and round-cornered squares that mimic a television screen. All of the identity elements work together in a modular way that allowed for a variety of design options. Even the logotype is modular with letterforms that work equally as well stacked vertically as they do horizontally. *(Design by Stoltze Design)*

Business cards are handed out when professionals want to exchange contact information. That's why the name of the individual needs to be featured prominently on the card along with the business name and contact information that appears on the letterhead. The business card should be visually coordinated with the stationery system, using the same typefaces, color palette, and other identity elements so that there is a unified presentation (see Visual 5–17).

Because stationery and business cards are handled and require close inspection, the tactile qualities of the paper that's used play an important role. Many paper companies manufacture paper lines in a variety of textures and colors that include standard letterhead and business card weights as well as coordinated envelopes.

INFORMATIONAL IMAGERY

Informational imagery guides and informs us in situations where words don't do an adequate job. Maps, for instance, help us find our way in unfamiliar situations. Diagrammatic illustrations, such as those used in textbooks, enable us to understand better how things work by showing us what we can't see or easily visualize. Instructional diagrams often help us operate, maintain, assemble, or install complex or unfamiliar equipment or technology.

Beyond these needs, designers are often involved in creating sophisticated wayfinding systems composed of directional symbols and pictograms that can be universally understood. Designers also work with charts, giving informational data visual form so that it can be more easily understood. In this section I discuss each of these design applications in more detail.

Symbols and Wayfinding Systems

If you've ever traveled to a destination where you're unfamiliar with the native language, you know how important symbols can be when finding your way around an airport. Signs with pictograms of luggage direct you to the baggage claim area. Other symbols guide you to places where you can exchange money and find ground

THE DESIGNER AT WORK

ingsu liu

Learn about the business and financial as well as the creative side of the design profession. You will need it in everything you do.

—Ingsu Liu

A native of Taiwan, Ingsu Liu grew up loving comic books and drawing. She moved with her family to the United States when she was 14. When they eventually settled in New Jersey, Liu enrolled at Pratt Institute in nearby Brooklyn, New York.

After graduating with a degree in design from Pratt in 1988, Liu took a job as a junior designer in the mass marketing department at Penguin Books. The position gave her an opportunity to get acquainted with the world of book publishing and form many friendships with Penguin's young cover designers, including Paul Buckley, whom she mar-

ried nine years later. Liu left Penguin and continued doing promotional and advertising design for several years, serving as senior designer and then associate art director for William Marrow Publishing Company. She also took on freelance assignments from Buckley designing covers for Penguin.

Liu eventually found the freelance book cover design to be more satisfying than any of the promotional design she was doing and decided to take on a position as a cover and jacket designer for Vintage Books (a division of Random House) in 1994. She has continued to design book covers ever since and now serves at art director for W.W.

Norton and Company, where she oversees the design of the company's trade paperback imprint.

Some of the challenges Liu faces in book cover design concern legibility. Cover typography must be easily understood and read from a distance in a bookstore, as well as on the Internet. Book covers also must function as effectively as packaging design, drawing consumers for closer inspection and, it's hoped, a purchase. Liu enjoys meeting these challenges in her role as a cover designer, and more. "Each cover feels like designing a little poster," she explains, "and the best part is you get to read the book."

When Liu designs a book cover, she often needs to work with existing imagery such as the photograph of Freud that appears on this cover. The colors, border treatment, and typography she chose convey an academic, period look that's appropriate to the serious tone of this biography.

Liu's cover design for *The Chinchilla Farm* projects a light-hearted, warm sense of nostalgia. When she designs a cover, Liu tries to give the reader a sense of what the book is about by capturing the flavor and setting of its content.

transportation. And if you're totally confused and need help finding your way around, chances are you'll be looking for signs bearing the ? symbol.

Pictograms and symbols convey information that's universally understood. They are especially helpful to anyone navigating unfamiliar territory and are often incorporated into the design of wayfinding systems—a configuration of symbols, typographic applications, and signage that help to guide visitors in parks, airports, museums, and other situations that need to accommodate a cross-cultural audience. For instance, when developing the symbols and wayfinding system for a zoo, a designer typically gets involved in developing pictograms that involve reducing an image of an animal species or family to its simplest and most recognizable form and making it part of a visually unified system. These pictograms are combined with directional symbols such as arrows and strategically placed at path intersections and other places within the zoo to help guide visitors (see Visual 5–18).

Designers often need to incorporate a wayfinding system and its symbols as well as other informational graphics into a broader identity scheme so that visitors receive an overall impression that's conveyed in everything they see and experience. For instance, the symbols that are used to guide visitors in a zoo are more likely to be rendered with a more casual or playful spirit than those used in an airport. A well-coordinated and unified wayfinding system will be stylistically in tune with other aspects of an identity system and will make use of the same color palette.

Charts and Graphs

Nothing seems so boring and can alienate a reader more quickly than a page of statistics. That's where charts can help. They're more likely to engage a viewer's attention. They also help us visualize how the numbers look in a more meaningful and visually dynamic way.

Although there are many ways of plotting information or data, the types of charts that are most commonly used are pie charts, bar charts, and graphs. Pie charts demonstrate how a population segment or lump sum can be broken down into portions. They work well for showing how a group voted or how it is composed in terms of demographic or opinion groups, how budget money was allocated, or where funds came from to arrive at a total (see Visual 5–19).

Bar charts work well for comparing data. Whether it's sales or snow, they show us how things literally stack up when comparing what happened in one defined period with another. The bars in bar charts can run vertically or horizontally. They're often represented as stacks of coins, as pictograms, or as other symbols (see Visual 5–20).

Graphs do a good job of plotting trends. They are particularly effective when showing dramatic growth or when comparing growth in several areas. They can be dressed up with pictorial representations or become eye-catching visual additions to a layout when color is applied to their lines (see Visual 5–21).

visual |5–18|

Brooklyn's Prospect Park Wildlife Center uses an identity and wayfinding system based on colorful animal cutouts. The animal iconography, which appears on signage throughout the park, helps visitors immediately identify areas of interest. *(Design by Russel Design Associates)*

visual |5–19|

Pie charts show how a total is a sum of its parts or how it can be broken down into portions. This example shows what portion of public education is funded by state, local, and federal governments. *(Design by Nigel Holmes and Meredith Bagby)*

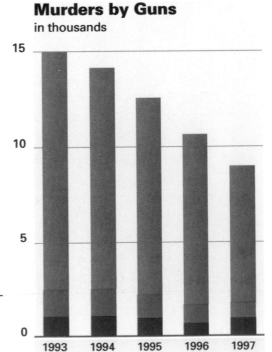

visual |5–20|

Bar charts give a visual representation of how data stack up on a comparative basis. In this instance, a bar chart is used to plot a decline in gun murders over a five-year period. *(Design by Robert Greenberg)*

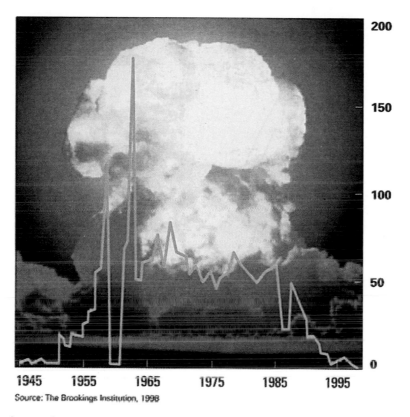

200

150

100

50

0

1945 1955 1965 1975 1985 1995

Source: The Brookings Institution, 1998

visual |5–21|

Graph charts help readers visualize trends. In this chart, the number of nuclear weapons detonated since 1945 and when most occurrences took place is plotted over a 50-year period. *(Design by Kit Hinrichs)*

SUMMARY

Representational imagery can enhance a message and helps draw attention to content. It's important to use photographs when recognition, documentation, and accuracy are important. Illustration offers a range of looks and media possibilities and can lend expressiveness to representational imagery. Graphically reduced images are those that are visually represented in the simplest possible way. They work well as universal symbols and in logo applications and are often used as trademarks for identifying brands. Logos and trademarks are typically extended into a broader context where they serve as part of a visual scheme of coordinated color, typography, and other graphic elements that constitute an identity system. Identity systems are applied to stationery, business materials, products, product packaging, architecture, signage, and other situations that need to display a company's name and identity. Symbols and visual themes are also used in an informative way as environmental graphics that guide individuals in unfamiliar situations. Charts and graphs are another means of informative imagery and are used to make statistics more visually engaging.

projects

Project Title Photo Crop

Project Brief Find a photograph or snapshot that has not been professionally shot or composed. Make two L-shaped pieces cut from black poster board or construction paper. Crop the photo by positioning these pieces so that the areas of the photo that don't improve its composition are eliminated and the best portion of the photograph is preserved. When you've found a crop that works, tape the L-shaped pieces together, mark off, and trim your final selection.

Objectives

Determine which portions of a photograph are worth salvaging and which are worth saving.

Develop a judicious eye for photographic composition.

Project Title Graphic Reduction

Project Brief Find a photograph of a single object from a magazine or other resource. Render a new version of this continuous-tone image using three shades of paper: black, white, and a midtone of gray. Decide, as you proceed, on which areas can be converted to black, white, or gray. When you've completed this image, create a new one using the same process and working with just black and white paper.

Objectives

Understand how much visual information is necessary to retain when reducing a continuous tone image to its simplest form.

Make decisions on converting gradated tones into flat tonal areas.

Translate three-dimensional form, highlights, and shadows into simple, black-and-white shapes.

Project Title Name Logo

Project Brief Make a logo of your name. Find a typeface for your name that you feel conveys an attitude appropriate to who you are and combine it with a symbol that does the same. Use the technique you learned for graphically reducing an image in the previous project to develop an appropriate symbol. Using no more than two colors, experiment with different ways of combining the two using layering, scale changes, and other ways of combining these elements in a harmonious manner. Keep your design simple so that it can be easily read and understood on small- as well as large-scale applications.

Objectives

Use typography in a meaningful way.

Design a symbol that supports a message.

Combine typography and a symbol in a simple composition that is easily read and understood.

in review

1. When is it more appropriate to use an illustration as opposed to a photograph?

2. How is a graphically reduced image different from a continuos-tone image?

3. What are the differences between a mark, logotype, logo, and trademark?

4. What is a graphics standards manual and how is it used?

5. Why are symbols an important part of designing wayfinding systems?

6. What are the differences between pie, bar charts, and graphs, and how are they used?

KEITH AND KYLE'S

RND

RAW NATURAL DIET

GIVE THEM WHAT THEY WANT

| finding a position in the design industry |

6

objectives

Understand how the field of graphic design developed and what it encompasses today.

Explore career options in the graphic design industry.

Find out what will pique the interest of a prospective employer and help land a job interview.

Learn how to prepare and present a portfolio of your design samples.

introduction

Students of graphic design are often in the dark about what lies ahead after they've received their degree. For those of you right out of school, it may at first seem prudent to take the first design job that comes your way. But because so many professional opportunities exist in the design industry, it may be worthwhile to consider getting involved in an area of design that speaks to your personal interests and can make best use of your capabilities. So that you can better determine where your best fit may be, this chapter explores some specialized areas of design, the places they are practiced, and the kinds of skills these design disciplines require.

In addition to having a career direction in mind, you'll also want to develop a portfolio and strategy for finding a job. The design industry is very competitive. Unlike some professions, where prospective employers come to campus to recruit graduates, employers looking for designers have traditionally relied on recent or soon-to-be graduates to come to them. A portfolio plays an important role in the recruiting process by demonstrating what you've learned and how that expertise has manifested itself in prototypical design solutions. By looking at your portfolio, prospective employers can determine if and how your design capabilities can be used by their organization.

In this chapter you will also find out what employers look for in a portfolio and learn how to present your work in a way that demonstrates your problem-solving and communication skills—assets for anybody seeking a salaried position but especially important for someone wanting to be a successful designer.

HOW GRAPHIC DESIGN FUNCTIONS IN BUSINESS AND COMMERCE

The field of graphic design initially grew out of the need for businesses to promote their goods and services. In the early part of the twentieth century, this promotion was fairly straightforward and limited to newspaper ads, billboards, posters, handbills, packaging, and signage. Designers were also hired by publishers of books, newspapers, magazines, and sheet music.

Over the years, as marketing and communication became more sophisticated and media options expanded, design grew to encompass an ever-widening range of venues. Today, graphic design touches us in so many ways it's almost impossible to avoid. When you pay a bill, the invoice you're responding to and the postage stamp you use to mail your payment involved a designer. Turn on the TV and you'll find many design applications: commercials, the opening credits for a film, or a network logo, to name just a few. The interface of your computer software, search engines, and the Web sites you encounter on the Internet involved designers. At the supermarket, the product packaging, store signage, and magazines at the checkout counter all required design expertise. Even the currency and coins you use to pay for your purchases required the involvement of a designer.

Graphic Design: An Evolving Discipline

The activity of design has evolved over many centuries. The wall paintings in the caves of Lascaux, ancient writing systems such as the Sumarian pictographic writing and cuneiforms, and the Belleville Breviary, illuminated manuscript, are all examples of visual communication through the millennia. These, and many other forms of communication throughout history, have played a profound role in defining the contemporary notion of design.

But the idea of graphic design as a discipline, driven by process and problem solving, was born in the twentieth century. The Industrial Revolution spawned the need for market-driven communication and the Bauhaus school provided a model. Since then, education, industry, society, culture, and technology have helped shape the field of design. These forces have also contributed to the nomenclature or designations that have been used to describe the areas in the field. It seems that the field is continually defining what it does by defining the various functions within it.

The field of design is a hierarchy composed of a group of disciplines that include graphic, fashion, industrial, and interior design. Each of these disciplines, in turn, is composed of specialty niches that constitute service to specific markets or industries. Graphic design encompasses work produced for print and digital communication. Some niches are exclusively in the domain of one or the other, whereas some can be served by both.

For example, package, poster, catalog, and most publication design is exclusive to print production, whereas Web design, "e"zines, and television graphics obviously function in the electronic realm. But other design categories

Design Firms

When individuals or organizations need design expertise, they will usually seek the services of a design firm. Design firms provide graphic design services to all types of businesses. They are hired by other providers of creative services, such as advertising agencies, financial institutions, manufacturers, retailers, and service providers.

A design firm can consist of one person or many individuals, and the services a design firm provides can be far ranging or specialized. For instance, some design firms may limit their practice to environmental graphics or focus exclusively on brand development and package design. Design firms offering specialized services frequently serve a clientele that extends beyond the firm's regional area. Other design firms provide a broad range of services to local clients.

In addition to doing different types of design, design firms sometimes differ from one another in the aesthetic approach they take. In fact, it's not unusual for clients to select a design firm based on a look they know is a specialty of that firm. When adding to their staff, design firms sometimes seek designers whose aesthetic sense is in tune with their own standards. Other design firms seek to diversify, looking to add employees who bring design sensibilities and areas of expertise they may not currently have on staff.

function in both. Advertising, mail order, magazines, corporate identity, information, and promotional design all rely on both print and electronic media.

Environmental, display, and exhibition design are dependent on a variety of fabrications, and they are three dimensional in nature. Signage systems, theme parks, trade shows, transportation systems, events, and educational exhibits are included in the three-dimensional design arena. Industrial or product design is dependent on graphic design where surface graphics and product identification are concerned.

In the advent of technological advances at the end of the twentieth century, namely, electronic media, and the move toward a service-dominated economy rather than an industrial-based economy, graphic design became more driven by information and communication. New professional titles such as information architect and communication designer place a special emphasis on the conceptual nature of the work.

Visual communication is a term that is used interchangeably with graphic design but is, in a sense, more comprehensive. Visual communication and communication arts encompass a full range of graphic art that includes graphic design, illustration, multimedia, photography, television, film, and video and a variety of hybrid media. It is difficult to pinpoint the origin of this terminology, but it likely has evolved from the advertising industry and design education.

In-House Design Departments

Because of the large volume of design they need to produce, publishing houses, retailers, and large corporations often hire their own designers. An in-house design department may consist of one designer or a staff of designers who work with other company personnel to develop design concepts and implement them.

In-house design departments offer designers a chance to work in an area of special interest. For instance, a designer who is drawn to fashion may want to work for a clothing retailer. Other businesses needing in-house designers include manufacturers of sports equipment, record companies, and a wide range of nonprofit organizations such as museums, charities, and political groups.

Because their size allows them to put together health and profit-sharing plans that may be unavailable to smaller firms, corportions can frequently offer their in-house designers generous benefits packages and other perks.

SPECIFIC AREAS OF DESIGN

Let's examine some specific areas of design, the kinds of expertise they require, and how a designer functions in these venues.

Advertising

Advertising agencies typically handle all aspects of marketing and promotion for their clients, developing a strategy and then implementing a plan that involves a variety of media applications. Ad agencies hire designers to work as part of a team that involves sales and marketing personnel, copywriters, production coordinators, and media specialists.

Advertising-related print design typically includes magazine and newspaper ads, point-of-purchase displays, billboards and transit ads, sales and promotional brochures, posters, fliers, direct mail, and coupons. Ad agencies also use designers to develop other media advertising, including Internet marketing, Web sites, and radio and television ads. Designers involved in television advertising often help brainstorm concepts, produce story boards, and design elements for television commercials. The ability to come up with creative and innovative concepts and good verbal skills are important to designers in this field.

Although advertising agencies hire designers to work as part of their staff, they also hire other creative personnel and firms to help them in their work, often subcontracting copywriters, photographers, illustrators, design firms, and other suppliers in implementing their projects.

Brand Design and Development

Branding is the consistent application of a brand's logo or trademark and visual identity on all of its products and services. Brand designers are contracted by a client to conceive an overall look for their product line or services and implement it across the board on packaging and promotional venues that may include a variety of media as well as vehicle, building, and uniform applications. In addition to designing a look that will work in a range of situations, brand designers are often involved in the early stages of a brand's inception, helping to develop a name as well as a logo and visual scheme. The ability to develop a flexible design scheme that works in two- and three-dimensional applications as well as packaging is important to success in this field.

Design firms specializing in brand design and development are sometimes called brand consultancies and are often larger than most design firms, staffing anywhere from 20 to 200 people. In addition to designers, writers, and administrative personnel, they hire production experts who understand the materials and processes unique to packaging. Clients are typically large corporations needing to promote and market their products across a broad constituency.

Interactive and Web

Firms specializing in interactive and Web design typically get involved in CD design as well as Web site and Web banner ad design. In addition to design personnel, firms specializing in this type of design often staff marketing and promotional personnel as well as technology experts who are responsible for doing intricate coding and staying on top of current technologies. Firms involved in this type of high-tech work often get involved in creating motion graphics and other special effects for television and film.

Because interactive multimedia involves animation and sound, designers specializing in this field need to have technical aptitude, an understanding of animation, and interactive and Web design software as well as the ability to think beyond purely visual terms. Understanding how to organize information and visualize it in terms of flow charts or navigational maps is also an asset.

Editorial

Editorial designers work with editors and publishers in the design of books, magazines, and newsletters. They range from independent freelancers or design firms contracted to do newsletter or cover designs to in-house designers employed by publishers.

Book and magazine design require cover design as well as working with text and imagery within a design theme that involves many pages. However, magazine and book design differ in that books represent a one-time design challenge—when a book design is completed, a designer can

move onto a new project. Because they are periodicals, magazines require a designer to work within an established design structure over many issues.

A knowledge of typography, aptitude for organizing information, love of the written word, and enthusiasm for a specialized area that a magazine addresses can be assets for designers considering this field.

Environmental Graphics

Environmental graphic designers design and develop systems of words and iconography that help guide others in identifying and finding what they need in unfamiliar surroundings. Firms offering this expertise understand how to organize information and make it user friendly and accessible, as well as how to work with signage materials and sign fabricators. Environmental graphic designers generally work as part of a team with architects, interior designers, landscapers, and other professionals involved in creating indoor and outdoor spaces. They are often brought in at the inception of a project to help in the development of an overall look and visual theme for an environment.

Applications for environmental graphics may be institutional such as universities or hospitals, or recreational venues, such as museums, sports facilities, and parks. Environmental graphics are also an important component in all kinds of transportation terminals as well as business and retail complexes such as corporate centers and shopping malls.

THE DESIGNER AT WORK

adam waugh

My goal is to never turn into one of those designers who just comes in and hits "command design" and then goes home.
—Adam Waugh

Adam Waugh's love of art and drawing began early on. He can recall creating a comic strip in the fourth grade and drawing in sketchbooks as early as first grade. By the time Waugh enrolled at the Art Academy of Cincinnati, he had accummulated numerous sketchbooks filled with his renderings.

Waugh entered the Art Academy not knowing whether he would major in fine arts or communication arts. He started to gravitate toward design when he felt the need to involve himself in a discipline that was "more quantifiable." As Waugh describes it, "The line between 'good' and 'bad' design is far more decisive than the line between 'good' and 'bad' art. Graphic design seemed a bit more scientific and logical."

In addition to studying at the Art Academy of Cincinnati, Waugh did a mobility semester at Ringling School of Design in Sarasota, Florida. His experience at Ringling helped him land a summer internship working at Juicy Temples Creative, an Orlando-based design firm. Juicy Temples Creative gave Waugh an opportunity to tackle a variety of projects, work as part of a team, and learn much about how the graphic design business operates.

During Waugh's senior year, he worked on developing a portfolio and a plan for getting an interview with potential employers. After looking at the Web sites of a variety of design firms, he singled out those whose work he admired the most and targeted them for a self-promotional mailing that gave them a taste of his design capabilities. Waugh sets high standards for himself and hopes to land a job in a design firm with the same design philosophy and level of ambition. "I never want to work for a firm that does design just for the money," says Waugh. "I want to work for a firm that pushes for creating the kind of design they believe in."

Waugh's senior thesis project is based on a calendar design concept promoting goodwill, positive values, and business ethics. The tongue-in-cheek attitude is complemented by charming, early 1960s illustrations that Waugh appropriated from his mother's grade school report cards. The type and graphic treatment is on a level of sophistication that presents a dynamic stylistic contrast to the illustrations.

Finding Work

Those involved in hiring designers say that proven capability is probably the single most important factor in landing a job. Your letterhead, resume, and other self-promotional vehicles you have designed promote your capability when you contact a prospective employer for an interview. At your interview, your portfolio serves as additional proof of your design and production capability, and the way you present it shows your pride in your work and ability to package and display it professionally.

Career Tips

- Subscribe to one or two industry publications to stay current on design trends and directions in the field. If you can't afford them, make a regular trip to the library periodicals or a bookstore.
- Keep a planner to help you manage time and projects. Establishing the good practice of time management will keep you organized and in a curious way, being liberated from having to remember dates and deadlines, will allow you to use your brain for creative thinking.
- Visit design studios and firms in your city or plan to visit them when you travel. While you are a student, professionals tend to be very open to sharing their time, expertise, and work. Once you are a peer, you are perceived as competition and have less doors open to you.
- Join professional organizations or local groups of professionals in the graphic arts field. Some organizations have student chapters that offer events and services at a reduced cost. It's the best way to meet other young designers and professionals who can give you invaluable advice and direction on your work and leads for jobs.

Getting Your Foot in the Door

Showing your portfolio to prospective employers is critical to landing a job. However, gaining access to those in a position to hire you is often difficult. Competition for design jobs is fierce, and sometimes a resume sent with a cover letter requesting an interview just isn't enough to prompt someone to respond, especially if you're right out of school and your resume shows little or no professional design experience.

To attract the interest of prospective employers, recent graduates and others new to the profession often create a self-promotion piece—something that demonstrates their design and conceptual capabilities in a single mailing. If it is successful, it will act as a lure by piquing the interest of its recipient and prompting him to want to see your portfolio.

To develop a successful self-promotion piece, base your strategy and concept development on these considerations:

- Visual unity–A self-promotion piece typically has several components: an envelope or other shipping container and something that's inside. Think of your self-promotion piece as a packaging assignment and come up with a visual theme that works for all components. Color coordinate your self-promotion piece with your letterhead and resume.
- Intrigue–An effective self-promotion piece needs to be packaged in a way that will engage and prompt a response from your recipient. Think about what's most likely to catch their attention. It's probably something that deviates from their usual business mail—something large or colorful or three dimensional.
- Surprise–Something that surprises or makes an impact is more likely to leave a memorable impression than something that meets your recipient's expectations.
- Staying power–A self-promotion that remains on a recipient's desk or gets used is more likely to serve as a reminder of your design capability. That's why coffee mugs, pens, and calendars are popular self-promotional vehicles.

Your self-promotion piece should also reflect the type of work you want to do. For instance, if you're interested in Web design, it should be an interactive CD or other device that leads recipients to your Web site. If you want to do packaging, it should involve a three-dimensional container (see Visual 6–1a, Visual 6–1b, and Visual 6–2).

Preparing a Portfolio

It's best to start by determining what size and type of a portfolio case you need. Portfolio cases come in sizes ranging from 8-1/2 × 11 inches to 34 × 42 inches. Pick a size that's large enough to accommodate your biggest piece and an appropriate size for carrying or shipping.

Portfolio styles can be broken down into three basic categories: clam shell boxes, binders, or attaché cases. Clam shell boxes are most suitable for shipping. But for one-on-one interviews, binders with acetate sleeves or attaché cases are your best options for portability. Which type you choose depends on your need for flexibility (see Visual 6–3).

If you want to be able to customize or rearrange your portfolio, samples mounted on illustration or matt boards are far easier to shuffle and rearrange than sleeves in a binder. Mounted samples should be displayed on neutral-colored mount board with a 2- to 3-inch margin. Gray is usually better than black or white because it works equally as well as a back drop for light- or dark-colored work. It's important to keep the board size and color consistent. Nothing can detract from your work more than samples mounted on boards that are of varying color and size.

Limit your boards to one or two sizes. It's best to start with the largest board that will fit within the dimensions of your attaché case. From there, come up with a smaller size that's

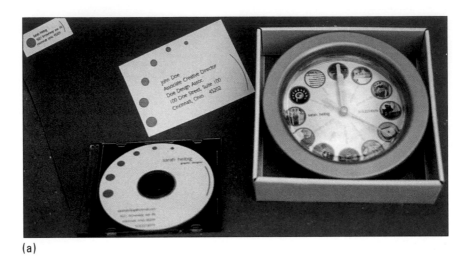

(a)

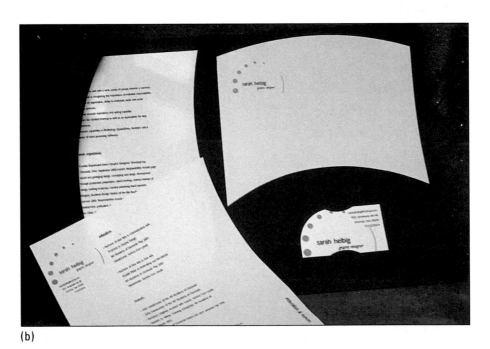

(b)

visual |6–1a and b|

Design major Sarah Helbig found an inexpensive clock at a discount retailer that inspired her time-themed self-promotion piece. After purchasing 20 clocks at $3.00 each to send to the firms to which she was most interested in applying, Helbig replaced the face of each with a clock face of her own design. (a) The clock was sent to prospective employers, (b) followed up a day later with a folder containing Helbig's resume, business card, and a cover letter requesting a portfolio interview. The motif that appears on her letterhead and business card echoes the clock theme but works equally as well on its own. The color-coordinated letterhead, folder, and envelopes Helbig used echo the silvery gray of the clock's casing, offset by a rich, heathery green.

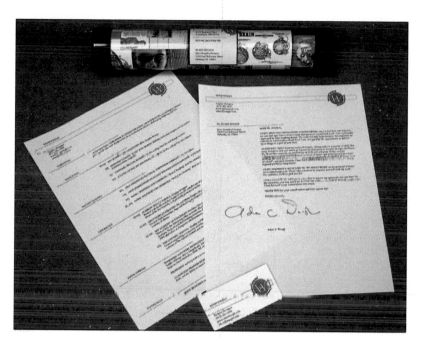

visual |6–2|

Adam Waugh's self-promotion consists of a clear plastic mailing tube retrofitted with a printed representation of pieces from his portfolio. The recipient gets an immediate impression of Waugh's work. Inside the tube is a letter requesting an interview, a business card, and Waugh's resume. All materials bear Waugh's distinctive logo.

visual |6–3|

Binders that display design samples within acetate sleeves and attaché cases containing samples mounted on boards generally work the best for one-on-one interviews. They come in a variety of materials including vinyl, leather, cloth, and the leather and metal finishes shown here. (*Portfolio photos furnished courtesy of Pina Zangaro.*)

proportioned to fit within this area so that the smaller boards can be stacked to fill the same area. (For instance, if your largest boards measure 12 × 16 inches, your smaller samples could be mounted on boards half this size, or 8 × 12 inches). Although mounted samples offer flexibility, their downside is that they tend to show wear and tear. You can protect samples by covering them with a flap or protect samples and boards by wrapping them in acetate or inserting them in vinyl sleeves.

Avoid the temptation to include everything you've ever done in your portfolio. Instead, narrow down your selection to 10 to 15 samples of your best work. Beginners tend to want to include lots

The Student Portfolio: An In-Depth Look

Student portfolios should show the breadth of experience and include samples that demonstrate capability across a broad range of disciplines: logo and letterhead design, brochures, packaging, ads, one- and two-color work, as well as four-color work. Including work that demonstrates capability in other areas, including Web or interactive design and illustration, is also advised. Visual 6–4, Visual 6–5a, Visual 6–5b, and Visual 6–5c provide a look at a portfolio of a graduating senior in graphic design, Adam Waugh, and some of its key components.

visual |6–4|

Adam Waugh's portfolio case contains samples mounted on matt board. The case comfortably houses his largest sample, a poster design. For consistency, other samples are mounted on boards the same size and color. Waugh chose an aluminum attaché case with a vinyl slot for his business card— a feature that allowed him to easily customize his portfolio.

visual |6–5a|

Because work that has been selected for publication by a professional association is an invaluable asset to a student portfolio, Waugh took an opportunity to compete with area design students to design a newsletter for the local chapter of the American Institute of Graphic Artists (AIGA). His layout and cover design were chosen for *Touch,* the chapter's quarterly newsletter. The stylish parentheses set in italics is a recurring theme throughout the newsletter. Waugh's clean, classic typography is contrasted with the intentionally degenerated photo illustration that echoes the style of Art Chantry.

of what they've done in the belief that prospective employers will be impressed with the volume of work they've produced. In the process, they include some mediocre work, which tends to water down the overall impression or create a sense of inconsistency. It's far better to limit your portfolio to just 8 or 9 high-quality samples, as opposed to adding 1 or 2 that fall beyond the level of the rest.

Because viewers tend to remember what they saw first and last, start and end your portfolio presentation with your strongest and most vivid samples. Bold, colorful work tends to make the most lasting impression. Balance the rest of your portfolio by mixing up four-color work with limited color pieces.

visual |6–5b|

This poster showcases Waugh's versatility as a designer and illustrator. The design was for a local nonprofit organization to be used as a promotion for an annual fundraiser. His idea to combine a da Vinci style illustration with classic type spoke directly to the audience that patronizes the annual event. His use of color in the illustration resonates in the type, creating a strong unity. Work for nonprofits and charitable causes demonstrates his civic-mindedness.

visual |6–5c|

Waugh produced this label design during an internship. His concept is playful and bold and has the feel of label design from the mid-twentieth century. The rich brown and cream colors reassure the consumer that the product has quality and taste for their pet. Work from an internship provides the opportunity to talk about design experience in the workplace.

Presenting Your Portfolio

Before your interview, you should know something about the firm's work. Prospective employers want to feel as though you're interested in what they do. But, more important, you'll want to know about a prospective employer's clients and the types of projects the firm takes on to determine whether the situation is a good fit for your skills and career goals.

When you arrive at your interview, try to position yourself at the corner of a conference table or desk so that you and the viewer are looking at the portfolio together, with you sharing rather than showing your work. You want to create an environment that's conducive to establishing rapport.

Prepare a list of questions about the position and the company's policies, such as how you will be evaluated, areas of growth for the firm, and its expectations of employees. Remember that you, in a sense, are interviewing the firm as much as it is interviewing you. Taking this mind-set to the interview can give you a measure of confidence that will show in your presentation.

At the onset of your interviewing, it's also a good strategy to secure one or two interviews at companies in which you are not as interested. You will have had these experiences as practice for that benchmark job you really want.

It's often hard for students to think of their work beyond the realm of a class project. But in a portfolio interview, you need to describe your work in real-world terms. When you talk about each piece, describe the communication goal and how your design strategy—the imagery, color, or typography you chose—work in support of this goal. Be sure to mention if any restrictions were imposed and what they were. It's important to let a prospective employer know how you solved a communications problem in spite of outside constraints.

Supplement your presentation with a loose-leaf binder that shows some of your process sketches. Prospective employers want to understand how your design concepts develop and see what kind of alternative solutions you may have come up with.

Before you leave, give the person with whom you met your business card or resume. And, perhaps most important of all, don't forget to send a letter or an e-mail thanking your interviewer for his time.

Resources

GRAPHIC ARTS ORGANIZATIONS

ACM SIGGRAPH

www.siggraph.org

A diverse organization of researchers, artists, developers, filmmakers, scientists, and other professionals who share an interest in computer graphics and interactive techniques. They sponsor the annual SIGGRAPH conference, focused symposia, chapters in cities throughout the world, awards, grants, educational resources, online resources, a traveling art show, and the SIGGRAPH Video Review.

American Center for Design

www.ac4d.org

A national association for design professionals, educators, and students that supports design education and promotes the value of design in the business community.

The American Institute of Graphic Arts (AIGA)

www.aiga.org

Founded in 1914, the AIGA is a nonprofit organization that promotes excellence in graphic design. With more than 30 local chapters, the AIGA holds a national conference and sponsors annual competitions.

Association of Graphic Communications

www.agcomm.org

Devoted to professional development and networking in the graphic arts field including designers, educators, and students and those in the printing industry.

Graphic Artists Guild

www.gag.org

A national advocacy organization that represents designers, art directors, illustrators, photographers, and others in the industry. It publishes *The GAG Handbook: Pricing and Ethical Guidelines,* a valuable resource for professionals and students.

Society of Illustrators

www.societyillustrators.org

The New York headquarters houses the Museum of American Illustration, which promotes monthly exhibits and traveling exhibits of premier illustration. The group also sponsors an annual student and professional competition that recognizes the best in illustration in the United States.

Society of Publication Designers

www.spd.org

Offers a monthly newsletter and an annual design competition, and it sponsors a biennial conference that alternates between new media and convention publishing.

(continued)

Resources (continued)

DESIGN PUBLICATIONS

CMYK

www.cmykmag.com

This quarterly publication is a showcase of the freshest design, illustration, photography, and advertising, featuring work by students from across the United States. Students can have work submitted by instructors.

Communication Arts

www.commarts.com

Published eight times per year, this journal features the best of the year's graphic communication. Student subscription discounts make it an affordable, quality publication.

Émigré

www.émigré.com

A quarterly magazine that showcases work by type designers, illustrators, and others whose work is on the cutting edge of creative graphic communication. *Émigré* also produces typefaces that it sells from a directory and online.

Graphis

www.graphis.com

A bimonthly graphic design magazine that showcases premier design from around the world in a lavish publication.

HOW

www.howdesign.com

A bimonthly graphic design magazine the covers ideas, techniques, and other aspects of the trade. HOW sponsors an annual conference and competition.

Print

www.printmag.com

Covers the graphic design industry and sponsors annual competitions and national seminars.

STEP inside design

www.dgusa.com

A bimonthly magazine that focuses on how designers, illustrators, photographers, and other graphic professionals create projects from beginning to end.

Wired

www.wired.com

A monthly magazine that promotes and reports on technologic innovation in digital communication, computer publishing, multimedia, and graphics. Social commentary and trendy graphics reflect current pop culture.

U&lc Magazine

www.itcfonts.com/ulc/

This online magazine dedicated to typography and the graphic arts. Published by the International Typeface Corporation, U&lc's Web site offers valuable information on type, type history, and use. Fonts can be purchased from the Web site.

SUMMARY

Most of this book has been devoted to presenting design essentials, theories, and strategies. I hope it has been useful to see them illustrated with visual diagrams and actual work by professional designers. This chapter, on preparation for a career in the field, focuses on practical information that you may not need to consider in the near future. However, it is the goal of your study of design to become a professional in the field. Visualizing yourself as a working designer can be challenging at the beginning of your studies, but there are things you can do now to help you assume the role of a professional. The portfolios in the professional profiles presented throughout the book, and the student portfolio and self-promotion in Chapter 6 are meant to provide a window into the profession and some real inspiration and motivation.

Continue to work on developing your design sensibilities but also study the work of designers, photographers, illustrators, and artists. Study art and design history to provide yourself with an understanding of the world of visual communication in which you are working.

THE JOURNAL OF BUSINESS & DESIGN

@issue:

Martha Stewart's Everyday Elegance

Muzak Elevates its Image

Chrysler Breaks the Mold on Subcompacts

CORPORATE DESIGN FOUNDATION VOLUME 7 NO.1

| glossary |

abstract Images that resemble the physical world but are a simplification or distortion of the things in it.

achromatic gray A mix of black and white.

additive color system Color system of white light.

ambiguous figure/ground An arrangement that presents an uncertain relationship between shape and space.

analogous hues Color found adjacent to others on a color wheel.

anomaly The presence of an element or visual relationship that is unlike others that dominate a composition.

asymmetric balance Sometimes referred to as dynamic symmetry, the art of creating balance using uneven numbers, sizes, or kinds of elements.

balance The visual distribution of elements in a composition.

chroma The amount of colorant present in a pigment.

closure The condition of being closed, a dependent relationship of relative position or the relational distance from one object or shape to another.

CMYK Cyan (blue), magenta (red), yellow, and black.

color Inherent hues found in light and pigment.

complementary hues Any two hues found directly opposed on the color wheel.

continuous tone Gradations of a series of values or grays blending from one to another.

contrast A juxtaposition, a relational, comparative placement of two or more similar or unlike elements.

dominance The prevailing influence of one element over another, and a function of hierarchy.

dynamic symmetry Managing the relationships between negative and positive space and form and counter form.

elements of design Shape, space, line, size, color, texture, and typography.

emphasis Stressing the importance of one element over another.

figure/ground reversal A graphic affect where figure can function as ground and ground as figure.

format The surface area that contains the design composition; the arrangement of the design components as they will be printed, cut, scored, and assembled.

gestalt Translated from German to mean "form" or "the way things come together."

graphic design The art of arranging pictographic and typographic elements to create a communication message.

grid A device used as a means of scaling smaller images to larger works; to break down the observed world into smaller, more manageable sections.

halftone Conversion of continuous tones into a dot pattern.

hierarchy An arranged order, hierarchy is the established order, importance, emphasis, and movement given to visual elements, from the dominant ones to those that are subordinate.

hue The same as color, it is the inherent color referred to by a name or formula.

line The moving path of a point.

line art Black and white art that has no continuous tones.

logo A symbol that represents an organization or institution.

monochromatic A single color mixed with tints, shades, or tones.

motif The appearance of the overall image in a design; there are three general kinds of overall images—non-objective, abstract, and realistic.

non-objective/non-representational Images having no resemblance to anything recognizable in the real world.

orientation The point of view determined by the designer; the way the viewer is meant to visually relate to a design or image.

primary principles Affect the design as a whole and include unity, variety, hierarchy, and proportion.

proportion Size relationships in a composition that serve as the image area and "surface" design.

proximity The position and space given to the placement of elements in a composition.

realism/representation Imagery that replicates the real world in a descriptive manner using objects that have defined and namable referents to the real world.

repetition A pattern of related or juxtaposed elements.

rhythm An alternating repetition of shape and space, or a planned movement of elements in a composition.

saturation The purity of a color.

scale Size comparisons of the internal parts of a composition—the visible elements that can be seen on the surface; scale is the relationship of size or a comparison of size from one element to another.

shade The mix of black with a color.

shape A figure or mass.

simple figure/ground The coherent, independent presence of a shape juxtaposed in a space that serves as the ground.

simultaneous contrast An illusory effect where the eye provides a complement based on a sensory response.

size The physical dimensions of an element or format.

strategy How you plan to produce the design.

subtractive color system System based on mixing color pigments.

support principles Affect internal relationships of the design and include scale, balance, repetition, rhythm, and proximity.

symbol An image that stands for something else.

symmetric balance Elements that are arranged the same or very similar on either side of a central axis.

target audience The group toward whom you are directing your message/communication.

tertiary hues Colors found between primary and secondary.

texture The tactile quality and characteristic of a surface.

theme A subject or topic being represented; the quality or character of a represented idea.

tint Adding white to a pure hue.

tones Grays, also referred to as mid-tones.

typography The arrangement and aesthetics of letterforms. (See the expanded list of terms for typography in Chapter 4.)

unity Overriding principle that is served by all others; unity is the control of variety.

value Lightness or darkness.

variety Visual contrast.

venue The place where the communication occurs or the place where the user engages the communication.

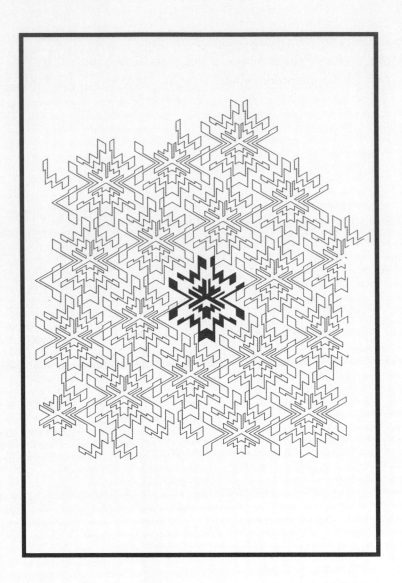

| index |

INDEX